GHENT

GHENT

John Graham's Dream
Norfolk, Virginia's Treasure

AMY WATERS YARSINSKE

Charleston London

History
PRESS

Published by The History Press
Charleston, SC 29403
www.historypress.net

Cover image: Norfolk's annual Cape Henry Day celebration was held on April 23, 1944, on The Hague. This photograph was taken by Charles S. Borjes. *Courtesy of the Sargeant Memorial Room, Norfolk Public Library.*

First published 2006

Manufactured in the United Kingdom

ISBN-10 1.59629.187.7
ISBN-13 978.1.59629.187.4

Library of Congress Cataloging-in-Publication Data

Yarsinske, Amy Waters, 1963-
 Ghent, Virginia : John Graham's dream, Norfolk, Virginia's treasure / Amy Waters
Yarsinske.
 p. cm.
 Includes bibliographical references and index.
 ISBN-13: 978-1-59629-187-4 (alk. paper)
 ISBN-10: 1-59629-187-7 (alk. paper)
 1. Ghent (Norfolk, Va.)--History. 2. Norfolk (Va.)--History. 3. Graham,
John R., Jr. 4. City planning--Virginia--Norfolk--History. 5. Ghent
(Norfolk, Va.)--Economic conditions. 6. Norfolk (Va.)--Economic conditions.
7. Ghent (Norfolk, Va.)--Biography. 8. Norfolk (Va.)--Biography. I.
Title.
 F234.N8Y35 2006
 975.5'521--dc22
 2006024624

Notice: The information in this book is true and complete to the best of our knowledge. It is offered without guarantee on the part of the author or The History Press. The author and The History Press disclaim all liability in connection with the use of this book.

CONTENTS

Author's Note

G hent is more than just a pretty place," wrote *Norfolk Compass* writer Mary Adams-Lackey on April 11–12, 1990, as Ghent turned a century old. "Shaped by her creators, her abusers and those who finally rescued her, Ghent is a gritty Southern belle." Ghent, perhaps more than any other Norfolk suburb, has a story to tell that transcends its historic port city lineage, reaching national importance in its planning and execution. That this gritty Southern belle remains is a testament to her good genes. The people who populated Ghent during its early years generally rebuilt the city of Norfolk after the American Civil War, rebuilt the trade on which much of the city's power and influence rested—and still does—and were instrumental in transforming Norfolk from a regional to a national city during the prosperous years between the Civil War and the end of World War I. This was a great accomplishment requiring a concerted team effort. The team lived in Ghent—and what a team it was, its legacy extending long after those whose collective achievements have passed into time and memory.

Bringing Ghent, that "gritty Southern belle," to life was achieved with the gracious assistance of many who, over time, provided information, photographs and their ever-important encouragement, but none was as gracious as Robert B. Hitchings, archivist and librarian in the Sargeant Memorial Room, Norfolk Public Library, who remains as dedicated as ever to providing his expertise. Preservation of the many priceless historical artifacts, paper ephemera, photographs and maps in the Sargeant Memorial Room is essential, else we lose critical tethers to our past—to who we are as a city in the

context of Virginia and national history. Wealth, real wealth, is knowledge, and where better to begin than preservation of the records of our past.

There is a note, too, that as readers peruse this volume, there is occasional mention of pre-1913 and post-1913 addresses next to many of the properties cited herein. Street numbers changed in late 1912, and were reflected in the following year's city directory, which today is perhaps the most well-worn such book in the Sargeant Memorial Room as researchers to residents search for tangible bits of information on family members, famous personages and their own homes. The change in street numbering, particularly in Ghent, was often dramatic, thus it is important to note such changes where needed to alleviate confusion.

INTRODUCTION

The first electric streetcars were in use by the end of the 1880s. The years that followed were energized by their appearance, sparking a period of intensive land speculation across America witnessed best by the large number of newly planned residential suburban developments dubbed "streetcar suburbs." This suburbanization driven by streetcars, also called trolleys, would last through 1930. Streetcars were faster and larger, but most importantly, they would help push development past old city centers, elongating the profile and appearance of traditional retail and commercial activities along their routes. These suburbs ranged in size from five or ten blocks of residential development to completely planned suburban communities providing commercial, recreational and educational facilities. Popular plans in this period were based upon romantic landscape theories derived from Andrew Jackson Downing, Alexander Davis and Fredrick Law Olmsted, such as the exploitation of the natural landscape, including subdivision of land into large building sites and the laying of roads in curvilinear patterns that appear to follow the natural contours of the terrain; the continuation of the existing grid plan with provisions for tree-lined avenues and regularly spaced parks, and, after the Chicago World's Fair in 1893, City Beautiful plans founded on Beaux Arts theories—usually a grid plan diagonally cut by broad avenues visually terminated by civic buildings and monuments. Downing's work was much admired—and used—in the late nineteenth century. Downing, one of the most important pre–Civil War designers and writers in America, promoted scientific agriculture through his magazine *The Horticulturist*, which was widely read and respected during his lifetime. Downing and Olmsted, drawn

"Broad boulevards, wide streets and small parks would also be incorporated into the design of Ghent."

This 1885 photograph shows Ghent, then a farm area of roughly ten acres owned by Richard Drummond, whose home is pictured here. The name Ghent was derived from the Belgian city in which the peace treaty ending the War of 1812 was signed. Ghent was laid out in 1890, and the name retained. A new bridge replaced the old Drummond footbridge. *Courtesy of the author.*

together by their mutual interest in horticulture, advocated the use of inner-city gardens, examples of which are Beechwood Place and, later, Stockley Gardens in Norfolk's Ghent.

Late nineteenth century planners, those in Norfolk being no exception, were also influenced by French civic planner Baron Georges-Eugene Haussmann, whose name is associated most closely with the rebuilding of Paris earlier in the century. Haussmann, who died in 1891, laid out the Bois de Bologne and made extensive improvements in Paris's smaller parks. The baron was renowned for sweeping changes brought about by his use of boulevards and wide streets, a move away from the typically narrow European streets and alleyways of an earlier time. Broad boulevards, wide streets and small parks would also be incorporated into the design of Ghent. By 1910 virtually every major American city could claim at least one style of aforementioned suburban development, whether in the spirit and style of a Downing, Davis, Olmsted or Haussmann.

The earliest true Norfolk, Virginia, suburb was Brambleton, where homes were built for the moderately well-to-do and which came into existence in an earlier era of suburbanization called the "town and country" period. These suburbs

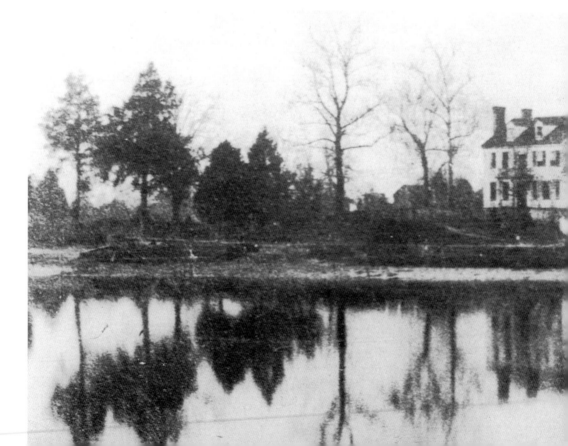

were extended relatively short distances from city centers and were typically accessed by horse-drawn carriages and streetcars. Today, it is difficult to envision Brambleton with magnificent rose gardens, wooded lots and chicken yards, just as it might be difficult to picture Church Street from an 1853 description, which observed "a handsomely paved street from the lower termination near the courthouse to the Town Bridge, with fine residences on the north." But in the mid-nineteenth century, just as there would be in the century that followed, there was a need by old-time Norfolk residents to "escape" the city, where historically significant residential areas were periodically allowed to dwindle into senescence.

Brambleton began to develop in the early 1800s, when there were more homes than shops on Church Street and when Main and Holt Streets were high on the list of desirable residential districts. Brambleton was thus developed ahead of Ghent by nearly a century. Atlantic City, which would play an important part in Ghent's story, had already come into being from the cotton industry, which took up its entire waterfront, but it was considered principally a suburb for cotton factory employees.

The overflow from the city brought many newly married couples who built and owned their own homes on an

"...Ghent was of prime significance in Norfolk's development beyond its downtown city center."

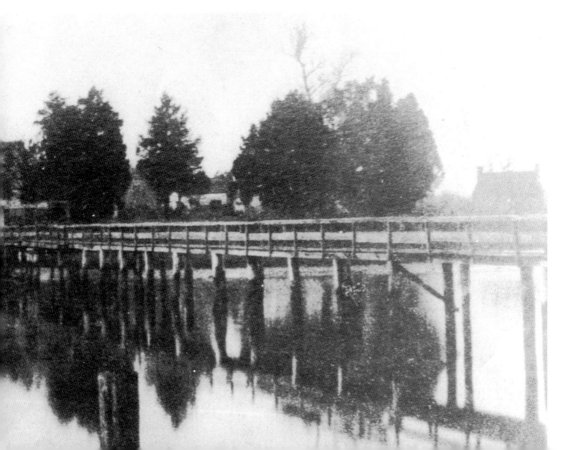

South Ghent development was just getting underway when this image was included as part of a turn-of-the-century photographic essay titled *Art Work: Norfolk, Virginia, and Vicinity,* published in twelve parts, the first time in 1895 and the second in 1902, by H.W. Kennicott and Company. Albert B. Schwarzkopf was president of the South Ghent Land Company. Note the four-masted topsail schooner barely visible far left. *Courtesy of the author.*

individual scale. There were no tenements, no homes for rent; neither was there running water, sewerage or other modern conveniences. There were no streetlights until gas mains were laid in 1900, and by that time Brambleton's four thousand residents had been annexed by the city, as had Atlantic City.

Suburbanization, at any given time and place, depends wholly on transportation and the length and breadth of the suburban ring from the heart of the city. This process is evident in the history of Norfolk's earliest residential sections. In 1815 there were nice homes on Main Street and in 1836 Freemason Street was the fashionable part of town. But until 1869 it appeared that residences would continue to be scattered about downtown as there was no public transportation and only businessmen who could afford a horse and carriage dared build farther than a mile from city's center. In that year, 1869, the Norfolk City Railroad Company laid down tracks over the length of Main Street and streetcars drawn by horses or mules soon jogged along Church and Granby Streets. When they moved out along Park Avenue, Brambleton came into its own.

By the early 1890s trolley cars went into operation and new territory for suburban expansion was explored.

Like Brambleton in its earlier days, Ghent was of prime significance in Norfolk's development beyond its downtown city center. The Ghent suburb of Norfolk came closer to reality in April 1890, when Richard B. Tunstall and Alfred P. Thom, prominent Norfolk attorneys who held the options to various parcels of land in Atlantic City, toured the land on April 22 with Everett S. Gray of the British banking house Vivian, Gray and Company; John H. Dingee, a Philadelphia banker; and Fergus Reid and Theodore H. Price, cotton merchants. Located blocks west of Norfolk's bustling downtown commercial and financial district, Ghent originally covered only about 220 acres composed of eight parcels designated as Pegram, Nye, Armstrong, Ghiselin, Colley, McDonald, DeBree and one small tract known as Ghent, the surnames of property owners recalling important families in the city's history. The *Norfolk Journal of Commerce* would announce the sale of land with some fanfare, remarking that the persons forming the syndicate

The construction of 317 Colonial Avenue (pre-1913 118 Colonial Avenue) was well underway when this picture was taken in 1892. The home was completed for William M. Whaley, president of the Roanoke Railroad and Lumber Company. *Courtesy of the Sargeant Memorial Room, Norfolk Public Library.*

were largely vested in the Norfolk and Western Railroad; the railroad had, at that time, invested large sums of money in improvements in the vicinity of Norfolk, which was now to include their acquisition of land that would be developed as Norfolk's first *planned* suburb. Most construction would eventually occur between 1892 and 1907.

A *Norfolk Landmark* editorial shortly after the land purchase remarked that over one million dollars would be spent for land and improvements—quite a bit of money in 1890. "This is the largest investment of foreign capital that has been made in this locality," said *Landmark* editors. "Active capital, energy and earnest cooperation of the people are the actors which will, within a wonderfully short period of years, make Norfolk a great and beautiful city." In actuality, the land cost the syndicate $164,416, and using current boundary names as points of reference, the 220 acres was wrapped by Botetourt Street on the east, Orapax Street to the west, West Princess Anne Road on the north and Mowbray Arch to the south.

Although most of Ghent was laid along a standard grid plan, the siting of the south section of the suburb by Smith's Creek and a Y-shaped inlet off the Elizabeth River suggested a different planning approach. Marshlands at this area were filled and the shoreline given a semicircular shape. The resulting street, Mowbray Arch, soon became the favored location for the stately houses of Norfolk's upper-middle and upper-class residents. Ghent's plan was not particularly innovative, but it successfully exploited the area's strategic waterfront location,

Fergus Reid's house, completed, is on the left, and John Graham's home on the right at 502 Pembroke in this 1892 photograph. The home at 530 Pembroke Avenue is visible just beyond Reid and Graham's distinctive residences. *Courtesy of the Sargeant Memorial Room, Norfolk Public Library.*

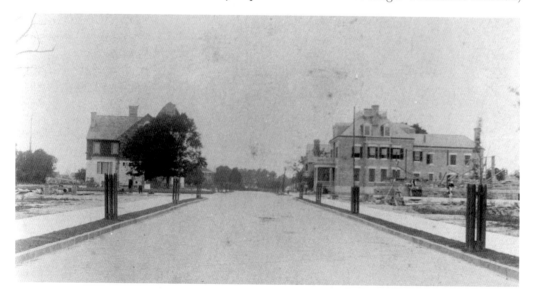

providing views over the creek to the grass banks on the opposite shore. While Ghent originally covered more than thirty blocks in area, the Mowbray Arch section displays, even today, the highest concentration of houses built during the late nineteenth century. This area is contained by Smith's Creek, commonly called The Hague, and Olney Road, a four-lane traffic artery connecting the two arms of the creek and providing east-west access to Norfolk's downtown. The development of Ghent, interestingly, was quite similar to the development of Roland Park, located outside of Baltimore, Maryland, in 1891, by an English real estate syndicate.

Before its late nineteenth-century development, Ghent was a large farm covering what was known first as Brushy Neck, later Pleasant Point. Dr. William Martin deeded his land to Jasper Moran, who acquired it, ultimately, in 1812 from Martin's estate. Tradition goes that Moran soon renamed the area Ghent to commemorate the signing of the famous

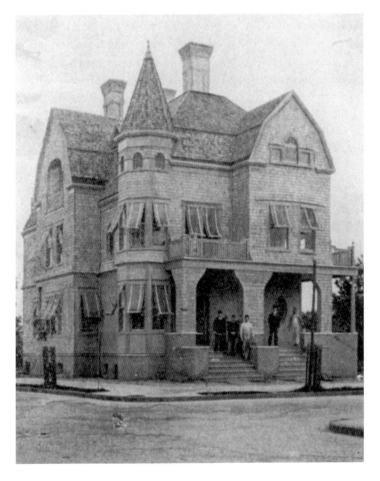

These twin houses at 210–212 Drummond Place were brand new and among the first built in Ghent when this picture was taken in 1893. The cross street in the foreground is Warren Crescent. But these homes also share another distinction— they were among the first to be torn down in Ghent. In 1927 John W. Grumiaux of Leroy, New York, built a boxy apartment building on this site. Proud of his New York background, Grumiaux named the apartment building the Leroy. *Courtesy of the Sargeant Memorial Room, Norfolk Public Library.*

15

"The decision by the Norfolk Company board of directors to develop the Ghent farm parcel was largely predicated on three factors: the projected expansion of trolley car routes west of Smith's Creek, the recent construction of a toll bridge across Smith's Creek north of Duke Street, completed in 1887, and the annexation in 1890 of the Atlantic City portion of Ghent farm as the sixth ward of Norfolk."

treaty ending the War of 1812. The end of the war, in 1815, had significant economic impact on Norfolk, resulting in the reopening of sea lanes after years of embargo by the British. In 1830, two years following Moran's death, Commodore Richard Drummond purchased the plantation, but also retained the name Ghent. The area remained farmland until 1890, at which time the Norfolk Company, a newly formed land company, purchased Ghent as a speculative venture. The chartering of the Norfolk Company in May 1890 for the purpose of buying, selling, improving and developing real estate in Norfolk represented the synthesis of several interests, both local and national, in the future of the city. Repeatedly across the country smaller companies were being formed for similar purposes, largely in cities and towns with aspirations akin to those of city fathers in Norfolk. Some of these speculative ventures succeeded; others did not. The Norfolk Company would be among the former.

The late nineteenth century was heralded a period of opportunity and expansion. It was a time of technological and social change brought on by the Industrial Revolution that followed the American Civil War. The post–Civil War period was a time for empire building, of the captains of industry described and analyzed by Norwegian-American economist, sociologist and leader of the Efficiency Movement Thorstein Bunde Veblen. Financiers, railroad barons, real estate magnates, steel and oil men were born in this era. The South, slowed somewhat by the war and subsequent Reconstruction period, was only slightly behind the rest of the nation in its enthusiastic adulation of progress. Norfolk, as many other Southern cities, had experienced the hardship of war and the humiliation of Reconstruction. By the 1880s the city was just beginning to come back financially and socially. Family fortunes lost during the Civil War and depressed in the years that followed were gradually being rebuilt. Influential citizens of mid- to late-nineteenth century Norfolk were back in seats of power and influence.

But also present in the city, adding to the reborn vigor of the community, was a group of citizens considered newly settled to Norfolk in the post-war years. Though once called carpetbaggers, by the 1880s many had found a place in the business and social circles of Norfolk and had been accepted into the city's establishment. Closing in on Norfolk and other cities from the outside was the technological revolution,

going on at rapid pace, and the empire builders seeking new opportunities. Financiers were certainly willing and able to orchestrate and stimulate investor interest in a Southern port city with strong potential. More often than not, however, financiers were not from the United States. Much British and other foreign capital had been invested in the United States during this period. In one context this was merely another form of colonialism, at its peak in the late nineteenth and early twentieth centuries, particularly vis-à-vis the European capitals. All of these elements were present in the Norfolk Company. All were to tie their hopes and dreams to a calculated gamble—the development of approximately 220 acres of real estate on Norfolk's west side.

The decision by the Norfolk Company board of directors to develop the Ghent farm parcel was largely predicated on three factors: the projected expansion of trolley car routes west of Smith's Creek, the recent construction of a toll bridge across Smith's Creek north of Duke Street, completed in 1887, and the annexation in 1890 of the Atlantic City portion of Ghent farm as the sixth ward of Norfolk. As an added incentive for development in this area, the annexation's legislation specifically allowed for deviations from the Norfolk building code. The company was organized with less than $5 million in stock, thus promises of expanded trolley service—to draw people to their project—and special provisions in the building code were particularly important provisions framing the project. The board's first major decision was its selection of a project superintendent and engineer.

John R. Graham Jr., a civil engineer from Philadelphia, was contracted by the Norfolk Company in May 1890 to lay out the new suburb. Graham's plan proffered such amenities of urban life as sewers, gas pipes, water mains, paved streets and granolithic sidewalks. The street layout was conservative, following a grid plan across the site. Only in the Mowbray Arch section—today's historic district—did Graham deviate from the grid to exploit the aesthetic land-water relationship. The entire subdivision was traversed by Colonial Avenue, which along with Mowbray Arch was considered to be one of Norfolk's most prestigious residential streets. All streets were landscaped with silver maples and magnolias, though these have mostly been replaced by water oaks and sycamores. According to the 1900 census, there were ninety-five houses in Ghent, nearly two-thirds of which were cared for by

"Prominent Norfolk families such as the Roysters, Slovers, Wellses and, in his early career, legendary Marine Corps Lieutenant General John Archer Lejeune, would call Ghent home."

Children pause from playing by the fence around Beechwood Place, a small park between Pembroke Avenue and Warren Crescent, located at the southern end of Colonial Avenue. The photograph was taken in 1895 during Ghent's development. The large house on the right was the residence of John R. Graham Jr. Fergus Reid, a cotton merchant, owned the house in the center. *Courtesy of the Sargeant Memorial Room, Norfolk Public Library.*

live-in servants, most female and black. Prominent Norfolk families such as the Roysters, Slovers, Wellses and, in his early career, legendary Marine Corps Lieutenant General John Archer Lejeune, would call Ghent home. Lejeune was indicative of America's military aristocracy, drawn to Norfolk on assignment, but with familial and business relationships that made this port city, teeming with life and kinships, their home. As a second lieutenant, Lejeune reported for his first duty on August 31, 1890, at the Marine Barracks, New York, but he was assigned to Marine Barracks Norfolk that November. During his assignment here from October 1, 1891, to July 28, 1893, on board the USS *Bennington*, Lejeune was promoted to lieutenant. Lieutenant Lejeune was eventually assigned to duty at Norfolk's Marine Barracks again on August 28, 1893, remaining in the city until July 31, 1897. Lejeune would come to Norfolk for professional and personal reasons again. His wife, Ellie, was the daughter of Judge C.W. Murdaugh, a prominent Portsmouth, Virginia, attorney and jurist.

Work on laying the streets, filling the marshland and shaping the shoreline of Mowbray Arch into a smooth semicircle continued from 1890 through 1907. The first house

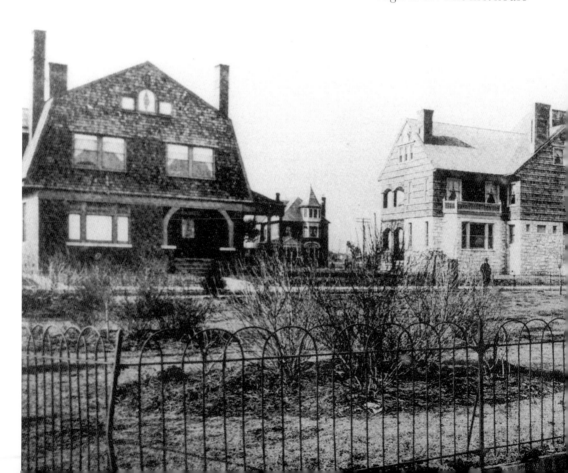

completed is said to have been built by John R. Graham Jr. in 1892 at 502 Pembroke Avenue; this became his home. By the end of 1893 only ten structures had been finished or were under construction. Among these were the Horace Hardy residence at 442 Mowbray Arch, finished in 1892; the Richard B. Tunstall residence, 530 Pembroke Avenue, built in 1892; the Fergus Reid residence, 507 Pembroke Avenue facing Beechwood Place, built in 1892; and the William H. White residence, 434 Pembroke Avenue, completed and occupied in 1892. Lots in the Mowbray Arch area originally sold for $2,500 each in 1892 and 1893. Houses sold for upward of $20,000. With the expansion of trolley car routes to the suburbs in 1894, building in Ghent exponentially accelerated. By 1900 two trolley lines serviced the area and over one hundred houses had been finished within the Mowbray Arch district alone. Numerous churches had been or were being erected along nearby Stockley Gardens, and new public schools were being planned. Development of Ghent was largely complete by 1905.

The majority of buildings erected in Ghent were detached single-family homes, although attached townhouses in the

"The Holland Apartments were constructed in anticipation of housing workers associated with the Jamestown Exposition of 1907."

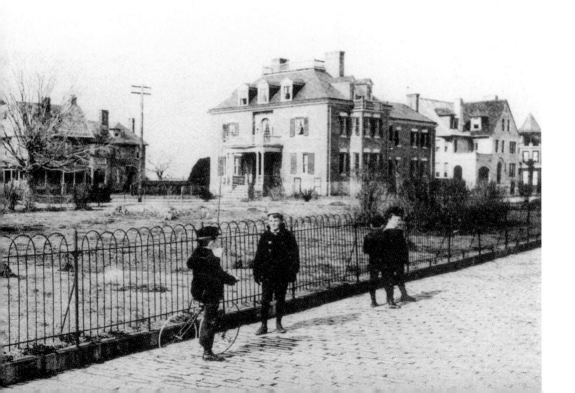

"Referring to a proposed extension of water vistas of The Hague, the Norfolk city beautification commission observed, 'Already the driveway which is to be built on both sides of the water has been christened Norfolk Way, and in a few years it ought to rank with Queen's Road of Bombay or the grand boulevards of European cities where water and land have been made to meet so attractively.'"

historic district are located at 510–516 Colonial and 340–346 Fairfax Avenues and scattered in the 400 block of Mowbray Arch. In addition to private residences and townhouses, three apartment buildings appear in the Mowbray Arch area. The Holland Apartments were constructed in anticipation of housing workers associated with the Jamestown Exposition of 1907. Later apartments included The Mowbray, built about 1914, and The Warren, completed in 1930. The Leache-Wood Seminary was the first private educational facility in the Mowbray Arch area, moving there in 1900, and located at 407 Fairfax Avenue (pre-1913 this was 335 Fairfax Avenue), but it was not alone. The Saint George's School for Boys and Girls, founded in 1900 and situated on Boissevain Avenue near Colonial Avenue, was also present. The erection of the Sarah Leigh Hospital in the Beaux Arts architectural style on Mowbray Arch in 1902 is further evidence of Ghent's prosperity, as was the building, almost simultaneously, of the Norfolk Protestant Hospital a few blocks away. A fourth story and two wings were eventually added to Sarah Leigh Hospital, which remained in operation until destroyed by fire in June 1987. The construction of Norfolk Protestant Hospital on land controlled by the Ghent Company spoke volumes as to the importance of providing medical care to meet the demands of a growing city population, one pushing further north, away from the downtown city center.

The genealogy of the Norfolk Company was complex, but not impossible, to follow. The creation of the Norfolk Company—later succeeded in 1896 by the Ghent Company—is a matter of public record. The charter, dated May 21, 1890, was recorded in the Norfolk City Clerk's Office in Charter Book I, page 457. It was later ratified, confirmed and amended by the Virginia General Assembly in 1892, reference Acts 1892, page 91. The incorporators were Theodore H. Price, a resident of New York and partner of John H. Dingee, Frederick J. Kimball, Joseph I. Doran and Harry F. West, all of Philadelphia; and Richard B. Tunstall, Fergus Reid, Alfred Pembroke Thom, C.G. Ramsey, Walter Herron Taylor and N.M. Osborne, all of Norfolk. The same persons constituted the officers and board of directors, of which Price was the president. John Dingee was the Norfolk Company's general counsel, but both Price and Dingee were nonresidents of Norfolk. The principal work done by the company, however, rested with its Norfolk directors.

The Norfolk Company was a subcorporation of Blake, Boissevain and Company, itself a merger of Dutch, New York and London interests. While the primary activities of Blake, Boissevain and Company concerned the financing of railroads in America, it formed three subsidiary land companies to develop land and industrial subcorporations. A major objective of these subsidiaries (the Virginia Land Company, the Virginia Investment Association and the Consolidated Coal, Iron and Land Company) was to develop lands from Norfolk, Virginia, to Columbus, Ohio. In Norfolk, the local subsidiaries were the Norfolk Company, eventually the Ghent Company and the Portsmouth Company.

The developers retained the farmstead's name of Ghent because of its historic and romantic European associations. Though no architectural controls existed at this early date, many builders picked designs thought to be suggestive of European architecture. Architects of Ghent's Queen Anne houses undoubtedly took inspiration from drawings by the English architect Richard Norman Shaw, reproduced in popular architectural publications. Further attempts to solidify the ties between Ghent, Norfolk, and its European namesake occurred in 1897, when the western arm of Smith's Creek was christened The Hague. Ceremonies at the renaming celebrations paid honor to the Dutch roots of the Norfolk Company, such as Boissevain, and the parent company's early representative to Norfolk, J.P. Andre Mottu. Even as late as 1911, promoters sought parallels between Ghent and European prototypes. Referring to a proposed extension of water vistas of The Hague, the Norfolk city beautification commission observed, "Already the driveway which is to be built on both sides of the water has been christened 'Norfolk Way,' and in a few years it ought to rank with Queen's Road of Bombay or the grand boulevards of European cities where water and land have been made to meet so attractively."

The 400 block of Mowbray Arch presented the most romantic view of Ghent at the turn of the twentieth century. Embodying the suburb's most appealing characteristics of water, greenery and European-inspired architecture, this view of Ghent was seized upon by local land promoters, the Board of Trade and the Norfolk Chamber of Commerce in their city booster efforts. This block was reproduced on postcards and numerous trade and souvenir publications for tourist and promotional consumption as representative of Norfolk's

"More contemporary descriptions of Ghent note that the area possessed 'Norfolk's brand-newest, tastiest, and costliest, most stylish and attractive homes. The streets in this quarter, unlike those of its older parts, are wide. The mansions, many of them, are palatial...'"

modern housing. Accompanying these views were captions extolling the area's beauty and the modernity of the city's then-new sewer, gas and water systems.

More contemporary descriptions of Ghent note that the area possessed "Norfolk's brand-newest, tastiest, and costliest, most stylish and attractive homes. The streets in this quarter, unlike those of its older parts, are wide. The mansions, many of them, are palatial, and the grounds, as a rule, are spacious and handsomely adorned with shade trees and shrubbery..." Elsewhere, this article boasted, "'Ghent' is the new swell district of Norfolk." As such, the suburb attracted Norfolk's middle- and upper-class residents from its beginning, those who were largely civic leaders, professionals and businessmen. The Mowbray Arch section was a favored location by members of the bar, with over eighteen lawyers residing there by 1905. Most prominent among these was Robert William Hughes, judge of the United States District Court for the Eastern District of Virginia from 1874 to 1898 and a noted Norfolk lawyer. The elder Hughes lived with his son, Robert Morton Hughes, who began practicing law in Norfolk in 1877 and from 1895 to 1896 was president of the Virginia Bar Association. But Robert M. Hughes was also known as an accomplished poet whose body of work is considered strongest among the

DeBree Place, named for Commodore John DeBree of the Confederate States Navy, is the focal point of this picture, taken about 1900, showing Drummond Place looking toward Warren Crescent. *Courtesy of the Sargeant Memorial Room, Norfolk Public Library.*

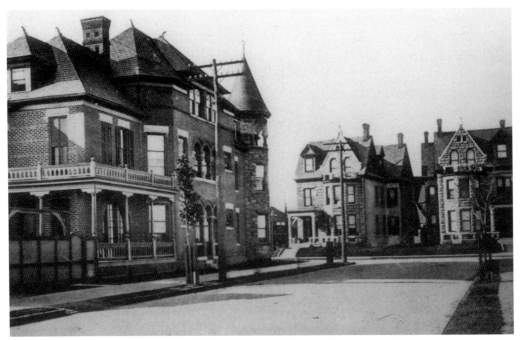

fugitive poet movement. Only a small portion of his work was published. Among Ghent residents active in Norfolk's political and administrative scene were James G. Womble, a member of the Common Council and member of the board of directors of the City Gas Company and Sinking Fund Commission; Willis W. Vicar of the Select Council; William P. Obendorfer, Select Council; Thomas S. Southgate, a member of the Common Council and first vice-president of the State Board of Trade; George L. Arps, Common Council; Richard B. Tunstall, a member of the Common Council and Sinking Fund Commission; William H. White, vice-president of City Gas Company; and Edward R. Baird of the Sinking Fund Commission. Obendorfer, who lived at 615 Boissevain Avenue, was associated with M. Hofheimer and Company and later William P. Obendorfer and Son, merchandise brokers.

Railroad interests were strongly represented. Peter Wright, Edwin C. Hathaway and Walter H. Doyle were all associated with the Norfolk Railway and Light Company, although Doyle was known, too, as one of the city's leading bankers. Edwin T. Lamb, manager of the Norfolk and Southern Railroad Company and vice-president of Norfolk National Bank, lived at 423 Fairfax Avenue, and William M. Whaley, president of the Roanoke Railroad and Lumber Company, resided at

The J.P. Andre Mottu block of Ghent in the Mowbray Arch area is shown here circa 1895; this row of townhouses was built on land Mottu owned and developed during the course of his lengthy association with the Norfolk Company. This image was originally part the photographic essay *Art Work: Norfolk, Virginia, and Vicinity*. The Mottu property photograph appeared in the first printing, section three. *Courtesy of the author.*

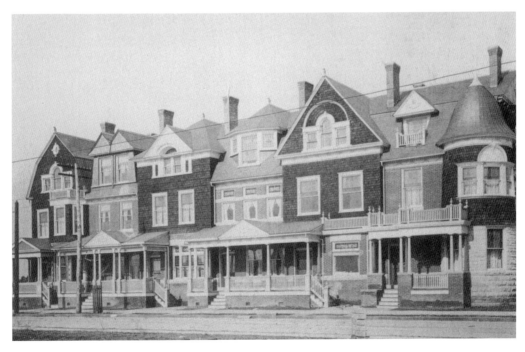

317 Colonial Avenue and, later, 524 Pembroke Avenue. Prior to the renumbering of Norfolk streets, which occurred in late 1912, Whaley's home was number 118, a good example of the dramatic differences in street numbering reflected in the 1913 directory. Other prominent residents of Ghent included Fergus Reid, president of the Norfolk-Portsmouth Cotton Exchange; Frank S. Royster, president of the Atlantic Guano Company and the Frank S. Royster Guano Company; Charles M. Barnett, affiliated with Castner, Curran and Bullitt, consul for Nicaragua, Colombia, and Costa Rica and director of both the Virginia-Carolina Trust Company and the National Bank of Commerce; Severn S. Nottingham, editor and publisher of the *Norfolk Landmark*; and Herman L. Page, a leading Norfolk realtor and land speculator. Before the Norfolk directories provided numbered street addresses for Ghent residents, Barnett's address was listed as "Graydon near Colonial Avenue" and Page, "Mary's near Botetourt," reflecting Fairfax Avenue's original naming. Nottingham, per the 1905 Norfolk city directory, resided at 314 Fairfax Avenue, but in 1913 he had moved to 404 Warren Crescent.

While the streetcar had tripled the size of Norfolk's "West End," its effect was minor compared with changes commanded

A tri-view of early Ghent (top to bottom) from 1903 shows Colonial Avenue at Fairfax Avenue, The Hague and Pembroke Avenue at Beechwood Place. *Courtesy of the Sargeant Memorial Room, Norfolk Public Library.*

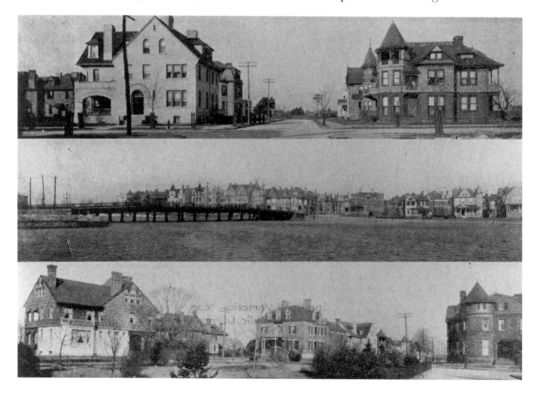

by the appearance of the automobile. By 1910 Ghent had competition as hundreds of these "motor machines" in the area had encouraged development in new suburbs like Colonial Place, Riverview, Lambert's Point, Park Place and Larchmont, which had come into being and were popular with middle- and upper-class Norfolk residents. The streetcar system's enmeshing rails had already stretched the suburban web to Sewell's Point, Ocean View, Willoughby Spit, South Norfolk, Berkley, Portsmouth and Pinner's Point. Steam engines and then an electric line had breathed life into important resort developments at Ocean View and Virginia Beach.

The speed with which these areas beyond Ghent, to the north, began to fill in with homes and commercial establishments of their own prompted Norfolk historian Thomas J. Wertenbaker to write prophetically in 1931: "The northward sweep of the city must eventually come to a halt when it fills in the area south of Willoughby Bay and Ocean View, but it still has space to advance over the county line of Princess Anne." As the automobile began to make its effect felt, the suburbs of the 1920s extended. Winona came into being and there was a buildup in Gowrie Park and Ballentine Place. In the late 1920s T. Marshall Bellamy, one of Ghent's

The Holland Apartments, photographed by Charles Borjes about 1925, was the earliest example of an apartment building in Ghent. Designed by prominent local architect Clarence Neff, the Holland Apartments, on Drummond Place at the foot of Botetourt Street Bridge, popularly called the Ghent Bridge, were built between 1904 and 1909. *Courtesy of the Sargeant Memorial Room, Norfolk Public Library.*

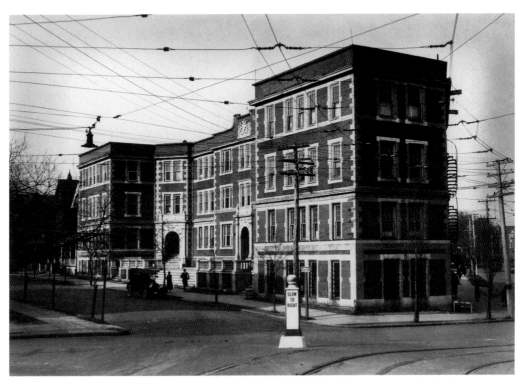

developers, began to handle much of the Margaret L. Watts property on Granby Street roughly between Taussig Boulevard and Mason's Creek. When the vast Minton Talbot property holdings north of the Lafayette River began to be released for construction, the senior Harvey L. Lindsay began developing Belvedere in 1938 and, later, Riverpoint.

Though the majority of dwellings in Ghent were completed by 1907, improvements continued on The Hague and Smith's Creek, and in-fill occurred in north, west and east Ghent on developable parcels. In 1909 the city appropriated $3,000 to purchase stone for the continuation of the western arm of the Mowbray Arch seawall. The western bulkhead of The Hague was completed in 1919. The semicircular seawall to the east was finished three years later. During the peak of the Great Depression, improvements were made to Stockley Gardens by the Works Progress Administration (WPA). Although according to one of Ghent's oldest residents the section's turn-of-the-century gardens had not been restored to their former beauty, great strides were made in that direction. The trees, with care provided by WPA workers, were described as more beautiful, and the gardens' wide walks, on which nurses still wheeled carriages, children rode their bicycles and occasionally whizzed along on roller skates, served to protect the trees and the grounds, which much resembled a formal botanical garden in many respects. Thirty-seven years before, in 1900, the gardens were first planted with beautiful roses and flowering shrubs,

This detail from a panoramic photograph, taken by Harry C. Mann about 1912, shows the northeast end of Smith's Creek, later The Hague, from the Ghent Bridge before it was filled in completely. A trestle extended across the creek from Dunmore Street over which the streetcars ran. In 1912 the city authorized the filling in of that part of Smith's Creek extending from the footbridge (center right) to and beyond Granby Street, where the bridge was located, as well as the body of water in the lower right. Maury High School, opened in 1911, is the largest building upper left and Second Presbyterian Church is center right. *Courtesy of the Sargeant Memorial Room, Norfolk Public Library.*

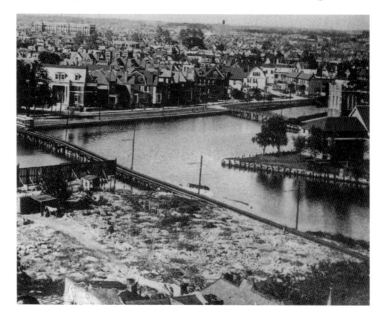

but by the late 1930s had succumbed to neglect, perishing for lack of care or vandalized by passersby. After the hurricane of August 1933, Stockley Gardens had become an eyesore, and had the WPA program not stepped in nearly four years later, it would have likely remained so for years to come. The last major building project in Ghent, evidencing its continuing prestige, was the erection of the Norfolk Museum of Arts and Sciences in 1933, designed by Ferguson and Peebles, and Calrow, Browne and FitzGibbon, Architects, and later renamed The Chrysler Museum of Art.

Developed in less than twenty years, Ghent possesses a unique image of consistent, well-designed architecture set within an attractively landscaped environment that was the hallmark of high-end, well-planned streetcar suburbs that developed between 1890 and 1930. The buildings in Ghent reflect stylistic influences rather than pure styles in and of themselves. It is not uncommon to find an individual building design composed of forms and details from several traditional architectural styles. Georgian, Federal, Colonial, Gothic, Greek, Romanesque, Medieval, Dutch Colonial and Tudor-Jacobean revivals of original architectural styles are easily identified in buildings throughout the area. But these buildings defy strict classification in the traditional sense. Rather, they represent mixes and adaptations of several styles. Stylistically there is a wide variety of late nineteenth-century architectural types, dominated by Dutch Queen Anne, Colonial Revival and shingle styles, but also including interpretations of Georgian Revival to Federal to Queen Anne and Colonial Revival. Gambrel roofs hinting at Dutch Colonial influences are occasionally seen in the Ghent area as well. Other styles randomly found in Ghent include English Tudor, English Half Timber, Italianate Townhouse and Beaux Arts. Buildings generally conform to a uniform scale of two-and-a-half—though some are clearly three—stories and are of brick construction with occasional stone façades or brick with shingled upper stories. Residences range from builder townhouses to large, detached architect-designed homes. Since architects were few in number during this period, many of Ghent's homes were built by contractors whose names were forgotten long ago, but two are particularly significant. George T. Banks and Elbert Tatterson were responsible for the construction of many Ghent homes, built to their own or architects' specifications.

"Ghent's heart, as it has always been, is in its people."

Established Norfolk architects with Ghent structures to their credit were John Kevan Peebles, Finley Forbes Ferguson, Charles M. Cassell, James Calloway Teague, G.B. Williams, George C. Moser, Charles J. Calrow, Arnold Eberhard and James W. Lee. Finley Ferguson designed the home in which he lived at 816 Westover Avenue.

Specific buildings displaying noteworthy designs, some of which have already been mentioned, include the homes of Fergus Reid, William H. White and Richard B. Tunstall, but also Frank S. Royster home, 303 Colonial Avenue, begun in 1900 and finished in 1902; the Robert M. and Robert W. Hughes residence, 418 Colonial Avenue, built circa 1895; and the William L. Tait residence, whose early address was listed only as "Mowbray Arch near Colonial Avenue" and who was in business with his brothers, James C. and Robert, in George Tait and Sons, seedsmen, located at 55 Commercial Place. Brother James C. Tait, in 1899, lived on Warren Crescent and the corner of Pembroke Avenue. Pre-1913 directories indicate Sarah Rebecca P. Tait, widow of George, lived at 422 Mowbray Arch; William L. Tait at 416 Mowbray Arch (post-1913 number 436); and James C. Tait lived up Colonial Avenue at what was then numbered 129 Beechwood Place—all of these homes remain architecturally significant. George Tait had opened his seed business at 10 Market Square in 1869, thus the Taits, with English roots, had been in Norfolk for a quarter-century by 1894. That one of the brothers, William L., would eventually move back to England has long played into the lore of 436 Mowbray Arch. Additionally, a large Colonial Revival house, originally built by L. Frederick Bruce in the 1930s is located at 535 Fairfax Avenue. But there are many others, including the early Italian Renaissance-style house at 524 Warren Crescent, exuding graceful Brunelleschian arches and color scheme of yellow brick accentuated by light colored stone, that merit the respect so rarely accorded Victorian buildings as works of art. The home touts distinctive features, from its Italian Renaissance influence to the Dutch-inspired roof and French windows.

Following a period of decline after World War II, Ghent began to stabilize during the early 1970s. The city declared Ghent a code enforcement area in 1962. Two years later the Norfolk City Council recommended that the Norfolk Redevelopment and Housing Authority (NRHA) declare Ghent a conservation area.

"Ghent has a vibrant character enhanced by its active business and neighborhood associations..."

The Ghent Neighborhood League and NRHA worked jointly for many years rehabilitating many of the historic district's once stately homes, saving many from the ravages of time and neglect. During this rehabilitation, unfortunately, numerous porches and façade details were removed from houses. The Frank S. Royster home on Colonial Avenue is but one example of porch removal; there are several others, many of which are noticeable today by the scar pattern left in the façade brick of the homes that had removals performed; many of these homes had magnificent wraparound porches. On a positive note, however, several houses divided into apartments during the mid-twentieth century, many converted to rooming houses for soldiers, sailors and defense workers during World War II, were returned to single-family dwellings. Landscape improvements that started in the 1970s included planting of new trees along residential streets and new flower gardens fronting individual houses. During this period, houses along Olney Road were razed as part of the redevelopment project and the land they once occupied was then grassed to provide recreational space for the community; another section was converted to a park.

"Ghent today provides intimate in-town living within walking distance of Norfolk's commercial heart."

Ghent's heart, as it has always been, is in its people. Ghent has a vibrant character enhanced by its active business and neighborhood associations, including the Ghent Neighborhood League and the Ghent Business Association. Community spirit is further exemplified by the Ghent Ministerial Association, a grouping of neighborhood churches of all denominations that work with the needy, and Ghent's deep ecumenical spirit, embodied in the Baptist, Episcopal, Presbyterian, Unitarian, Roman Catholic and United Methodist churches, as well as the Ohef Sholom Temple and Congregation Beth El, which have long graced Ghent by their presence. Ghent school-age children attend Walter Herron Taylor Elementary, James Blair Middle and Matthew Fontaine Maury High schools, but also Ghent School, an advanced curriculum kindergarten through eighth grade public school program on Shirley Avenue. West Ghent School, Ghent Montessori School and the Williams School offer private education within the intimate confines of Ghent's tree-lined streets.

Every spring and fall, always on the third weekends in May and October, Ghent hosts the Stockley Gardens Arts Festival. Begun in 1984, proceeds from the festival benefit the Hope House, a nonprofit organization providing support services for those with developmental disabilities. Artists in all mediums

and from across the country come to Stockley Gardens to show their work.

Ghent today provides intimate in-town living within walking distance of Norfolk's commercial heart. Gone are the spectacular trees planted by William H. White; the silver maples and magnolias that originally graced Ghent's streets have long vanished from the landscape, replaced by large oaks. The Trinidad asphaltum blocks have been paved over with asphalt, and the historic, steel-riveted bridge replaced in 1976 and since refurbished to enhance its pedestrian features. Despite changing times and tastes, Ghent's period architecture, tree-lined streets and attractive waterfront location combine to provide its residents with Norfolk's most exclusive address. Ghent Historic District, roughly bounded by Olney Road, Virginia Beach Boulevard, Smith's Creek (The Hague) and Brambleton Avenue, was added to the Virginia Register of Historic Places on June 19, 1979, and the National Register of Historic Places on July 4, 1980. But there are other sections of Ghent—North, West and East—that also play an important part in the fabric of the greater Ghent story. North Ghent was added to the National Register of Historic Places in 2001. Bounded by key transportation corridors West Princess Anne Road, Olney Road, Colonial Avenue, Colley Avenue and Hampton Boulevard, North Ghent is growing and changing as the area begins to take on more residents. Here, buildings designed and built by John R. Graham Jr. and John Kevan Peebles—and many more—are found nestled among churches, schools, parks and businesses. As a whole, Ghent reflects the great vision of the Norfolk Company's founders and the dream of John R. Graham Jr., all long gone but remembered still for their contribution to the city of Norfolk.

"Ghent reflects the great vision of the Norfolk Company's founders and the dream of John R. Graham Jr. ..."

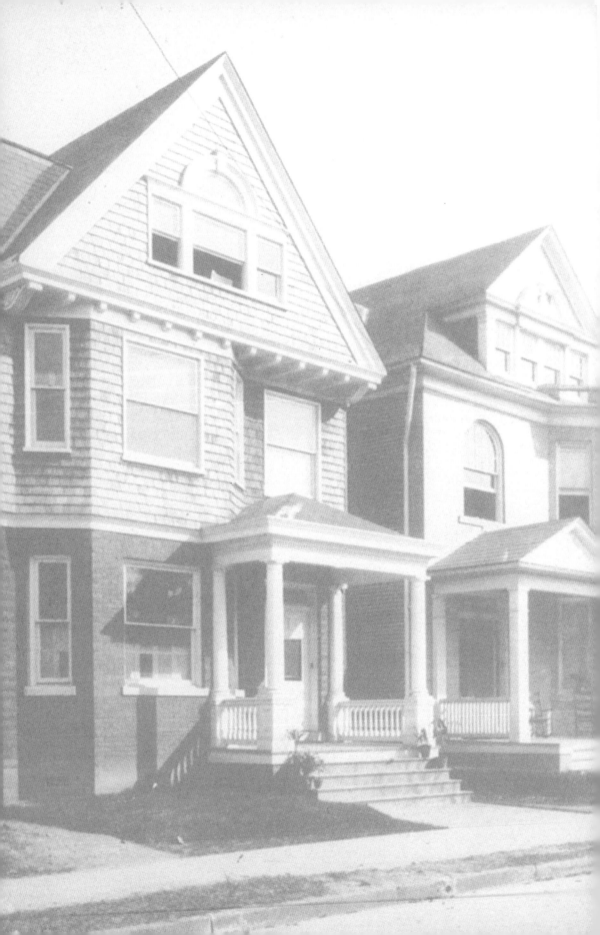

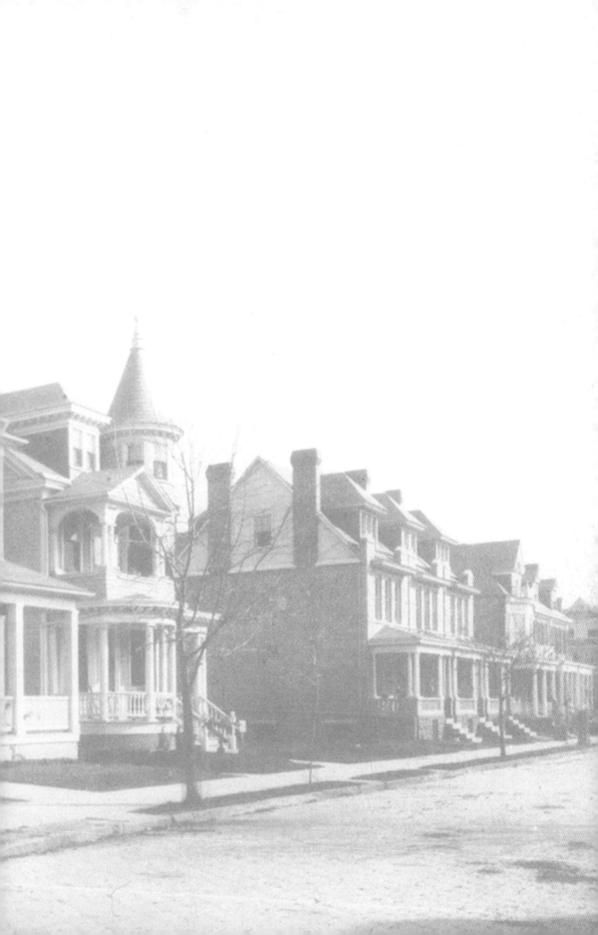

Chapter One

BEYOND THE WOODEN FOOTBRIDGE

> **"The historical importance of Ghent seems to be a collective entity, rather than the product of individual actions or events."**

Norfolk had already begun spreading northward prior to the footbridge being extended over Smith's Creek, a portion of which was later dubbed The Hague, to Ghent Farm. There was a wide and substantial bridge from Smith's Point to the property of John P. Colley connecting Fort Norfolk with the borough. This bridge was badly damaged during a severe gale in 1821 and was not in use for the next twenty-five years. H.B. Forrest stated in his 1851 directory, "A bill was recently passed in the House of Delegates authorizing James Gordon Jr. and Aaron Milhado to construct a bridge across Smith's Creek from the western terminus of York Street to the lands of John P. Colley on the opposite side of the county."

Ghent was the first suburb to be developed out of the farms that surrounded the city of Norfolk over the creeks to the north of downtown proper. A footbridge across Smith's Creek to the north of town led to Commodore Richard Drummond's farm and the DeBree property. Early recollections of Ghent invariably include going over that footbridge to "de breezes," a place where, in the minds of some children, gentle and variable winds blew. It was not until years later that two of those children, Julia Johnson Davis and her sister, realized that their nurse was saying "DeBreeses," for the new development just over the bridge, laid out on Commodore John DeBree's property. "My mother said," wrote Davis, "that in her girlhood a wooden footbridge had connected 'DeBreeses' and Norfolk proper," which explained why, in her own childhood, the bridge over Smith's Creek, later The Hague, was always referred to as "the new bridge." Davis did not come to know the name Ghent until moving out of her grandparents' house on College Place and into a new home in "DeBreeses." "I vividly remember

the excitement of moving," she recalled later, "and how we loved the open fields and plum thickets, and particularly the smooth concrete sidewalks for skating." Julia Johnson Davis would grow up and take her place as a noteworthy community leader and poet, but one who as a child lived in a prestigious Beechwood Place mansion when horse hooves crunched the white oyster shell road called Mowbray Arch. A snapshot of Mowbray Arch residents in 1902, the first year the Norfolk city directory provided a listing of those who lived there, revealed a lively mix of politicians, businessmen, doctors, bankers, teachers and widows.

The historical importance of Ghent seems to be a collective entity, rather than the product of individual actions or events. Even the antecedents of Ghent are plural. At least three colonial plantations covered all or part of the area that became Norfolk's first planned suburb. Ghent, Jasper Moran's plantation after which the development was named, was known previously as Brishie Neck, Brushy Neck and Pleasant Point before Moran acquired and renamed it. Part of it had at least one more name, Lilliput, after Moran died. Along with the succession of names went a succession of owners, the last being the collective entities of the Norfolk and Ghent Companies. The name Ghent became synonymous with the high lifestyle that the plantations connoted and after which the new suburb strove. But for seventy-five years Ghent was one house, a large frame homestead surrounded by spacious lawns and flanked by acres of farmland owned by Drummond, which was situated across Smith's Creek from Botetourt Street, just outside of the corporate limits of the city of Norfolk. A narrow footbridge, which J.P. Andre Mottu of the Norfolk and Ghent Companies eventually replaced with another at the same location as today's Botetourt Street or Ghent Bridge in the 1890s, gave an approach to the house from the northern end of Botetourt Street. The site of the house was approximately at the corner of what is today Warren Crescent and Drummond Place.

Norfolk historian Thomas J. Wertenbaker, in his 1931 work *Norfolk Historic Southern Port*, related that Commodore Richard Drummond, because of the fact that he brought home a copy of the Treaty of Ghent in his ship *Rob Roy*, gave the name Ghent to his home across the creek from Botetourt Street, and that the new suburb was named for that residence. Dr. William H.T. Squires and another

Construction was ongoing at 507 Pembroke Avenue—Fergus Reid's home—in 1892. This home is very similar to the E.C. Stedman House, Newcastle Island, Portsmouth Harbor, Maine, built by E.M. Wheelwright in 1882, and may have been drawn from the plan and elevation of that home. The major exterior differences are in the materials (the Stedman residence has rough boulders instead of marble) and the gable over the entrance—the Stedman house has a clipped gable instead of the Palladian window as in the Reid home. The plan of the house, being executed by its builders and craftsmen in this photograph, is asymmetrical and more modern than the other homes in Ghent. *Courtesy of the Sargeant Memorial Room, Norfolk Public Library.*

35

Fergus Reid's house on Pembroke Avenue at Beechwood Place, with its famous beech tree in the front yard, is left in this picture; John Graham's residence is on the right. The photograph, taken about 1902, also shows some of Beechwood Place Park. John Graham's home was the first built in Ghent, facing Pembroke Avenue at Colonial Avenue, in about 1892. *Courtesy of the Sargeant Memorial Room, Norfolk Public Library.*

early Norfolk historian, Henry Boswell Bagnall, shared the opinion, however, that the naming of the Ghent plantation was authored not by Drummond but by a previous owner of the plantation, Jasper Moran, the nephew of William Plume, a prominent Norfolk resident in the eighteenth century for whom Plume Street is named. Moran acquired the estate, still named Pleasant Point, in 1812 from the estate of Dr. William Martin. A notice of the sale, recorded on December 18, 1811, and published in the *Norfolk Gazette and Public Ledger* also on that date, may serve to resolve who first named the Pleasant Point property Ghent—or at least eliminate the tradition of Drummond's having done so. "On Friday the tenth day of January next," read the advertisement, "the subscriber will sell at auction, for ready money, the tenement and parcel of land, in the county of Norfolk, called Pleasant Point, containing by estimation, about five acres." The advertisement went on to provide the boundary, describing Pleasant Point as bordering Colley Creek, which separated it from the borough of Norfolk. The sale was being executed according to the deed of trust from Dr. William Martin to the subscriber, bearing the date of December 17, 1810, and duly proved and recorded in the Court of Norfolk

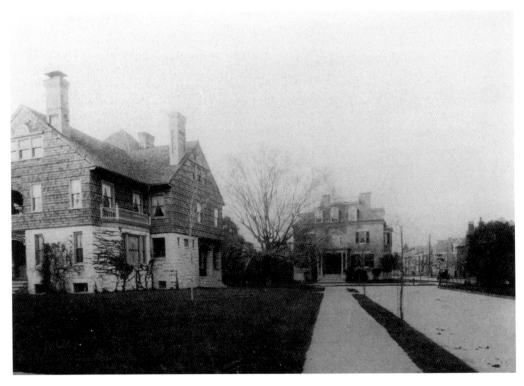

County. The subscriber advertisement was signed Merit M. Robinson, trustee. When the Treaty of Ghent, which ended the War of 1812, was ratified by President James Madison on February 17, 1815, Moran—according to the Squires-Bagnall version—changed the name of his house to Ghent. In deeds executed by Moran in 1821, he referred to his plantation by this designation. Moran was also remembered later by the naming of an avenue in Ghent in his honor. The Ghent plantation was not purchased by Drummond until 1830.

Through the next seventy years, the Ghent area was home to a series of small suburban farms. In her *Historic Recollections and Anecdotes of Old Norfolk*, published about 1937, Emma Blow Freeman Cooke wrote that "a favorite stroll for lovers and children led by their mammies was over Drummond Bridge and beyond to the beautiful grounds of Lilliput, the estate of Commodore John DeBree of Confederate navy fame." Lilliput, noted for its roses and greenhouses filled with orchids and other rare plants, stood at the present site of the Fergus Reid house at Beechwood Place, so named because of the many beech trees that grew there, one of which was particularly large at the time the Reid house was constructed.

The interior of Fergus Reid's home, showing the living room, provides a rare glimpse of the furnishings of one of Ghent's earliest residences, preserved for decades by his descendants. The picture was taken in 1982 as part of an effort to record the appearance of the home in Reid family ownership. *Courtesy of the Sargeant Memorial Room, Norfolk Public Library.*

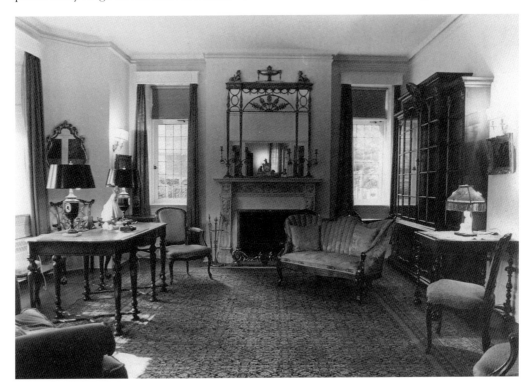

Looking north on Colonial Avenue from Olney Road, an unknown photographer took this picture of the 600 block (foreground) and the 700 block. Boissevain Avenue is the first cross street, dividing the 600 and 700 blocks. The picture, circa 1900, is part of *Art Work: Norfolk, Virginia, and Vicinity.* The Charles Wesley Fentress residence, 621 Colonial Avenue at Boissevain Avenue, is foreground left. *Courtesy of the author.*

"One of the landmarks of the section," remembered Julia Johnson Davis, "was the magnificent beech tree on the Fergus Reid property."

Where the Sarah Leigh Hospital would eventually stand along The Hague's shorter stretch, Cooke wrote, had once been the site of the Ribble farm, which could be reached only by boat. The present site of The Chrysler Museum of Art was entirely under water. At the old Ghent manor house, "boats anchored and children crabbed and shunned a lonely vault, the burial place, veiled in the mystery of a land quarrel and duel."

Wertenbaker observed that the development of Ghent in the 1890s was viewed with apprehension by some of the city's elderly residents. For generations the old West End, which began at the other extremity of the Ghent Bridge, had been the aristocratic section of Norfolk. "While the wealthy and the distinguished were moving over the creek to Ghent," wrote Wertenbaker, "the older residential sections gradually assumed an appearance of neglect and decay." Although many of the older families remained in the houses handed down to them by their forefathers, some followed the trolley to the newly created city "across the bridge," he pointed out.

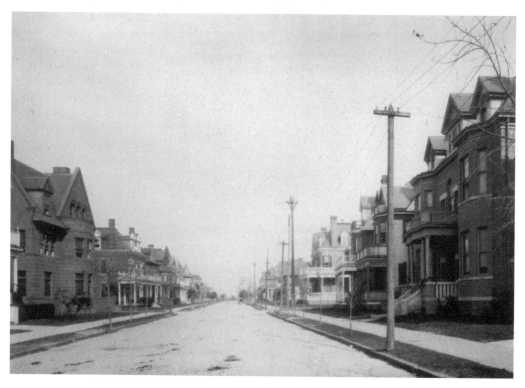

The transformation of farmland into an urban neighborhood certainly employed new methods. The detailed planning and staged execution of Ghent was Norfolk's first. Urbanization previously had been an individual, house-by-house occurrence with only the overall plat guiding the development. The Norfolk Company and, later, Ghent Company, went beyond this to include the installation of utilities, sidewalks, streets and landscaping of swards and public areas, as well as a coordinated advertising campaign to sell Norfolk citizens on the desirability of the area. The physical development of the area was a collective effort, losing the individual magnificence of various buildings within each stage of development. That there was individuality cannot be doubted. This was the eclectic period in architecture, which prevailed from 1893 through 1917, reflecting the laissez-faire individuality of the philosophies of the era. Buildings were composed of stylistic elements selected from various architectural periods of the past. Prior to this period, only one architectural style was used at a time; however, an increase in the number of architects graduating from American schools and the Beaux Arts movement in Europe during the last two decades of the nineteenth century resulted in the use of almost every architectural style that had been developed up to that point in time. The variety of Ghent is one of its strong points; however, except for identifying features of a particular architect, the individuality of purpose of some of the institutions of the area and the distinction afforded the first and last houses in one section or another, this individuality

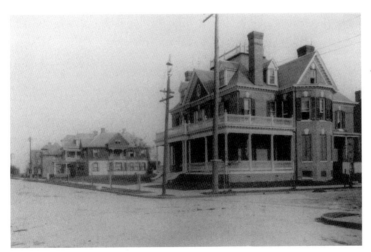

Located on the northeast corner of Colonial and Boissevain Avenues, the James E. and Fannie Etheridge home at 704 Colonial Avenue is as recognizable today for its Flemish-bond brick work as it was in about 1895, when this picture was taken. Note that 710 Colonial Avenue, the home of Walter F. Dusch of Walter J. Simmons and Company, was not yet built nor was it under construction. The next street on the right is Raleigh Avenue. The two homes nearest Raleigh and sharing the block with the Etheridge house and, eventually, the Dusch residence are no longer standing, having been replaced with new housing. The Etheridge family was in the lumber and building material business as James E. Etheridge and Company, established in 1877 in Norfolk's West Brambleton section. Dusch was Walter J. Simmons's partner in the hats, caps and furs business bearing Simmons's name. Simmons lived at 1207 Colonial Avenue. Prior to 1913, 704 and 710 Colonial Avenue were numbered 501 and 509, respectively. The Etheridge residence at 704 Colonial Avenue was fully renovated in 2002 and is denoted as a property of national historical and cultural significance. *Courtesy of the author.*

Smith's Creek—The Hague, as it hugged the shoreline of Ghent—is shown here on a snowy day in 1904, shortly after Second Presbyterian Church (center) was built. The bridge upper left was the footbridge connecting Yarmouth Street with Fairfax Avenue, and the long structure (center) is a streetcar trestle for cars that ran from Boush Street to Tazewell and Dunmore Streets and over the trestle to Mowbray Arch, where the streetcar turned right and went north. The tracks in the snow (foreground) led to the Botetourt Street (or Ghent) Bridge. *Courtesy of the author.*

played second fiddle to the whole—the integrated entity that was a direct product of the plans of the Norfolk and Ghent Companies. This coalescence varies with the area of Ghent, the time of development and the purpose of development, but does not seem to suffer greatly from this variety due to the overall planning that holds the urban fabric together in the neighborhood.

For the most part, with one or two exceptions, the notability of Ghent residents lay not in individual accomplishments, but rather in the collective importance of its citizens. Certainly, the neighborhood has seen many people of importance and many events of importance. What is relevant, of course, is the everyday nature of these people and events in Ghent. The assignment of specific values to the deeds and people charting the city's course is difficult without the perspective of history. Over a hundred years later, Norfolkians are just beginning to fully understand and appreciate the crucial role many of these persons played in the emergence of the city as a national presence. One can single out a few important individuals, such as Ghent's promoters; prominent architects of the day; Confederate personages such as J.E.B. Stuart's widow and General Robert E. Lee's adjutant general, Walter Herron Taylor; and the father of the modern supermarket, David Pender, owner of a chain of groceries that would eventually become the Colonial Stores. These people and their lawyer,

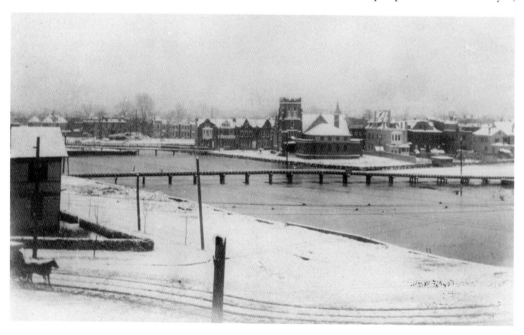

judge and doctor neighbors all lived together in a small area of Norfolk representing the best that Norfolk had to offer and the forces that helped mold her and guide her through the opening years of the twentieth century. The people who populated Ghent during its early years generally rebuilt the city of Norfolk after the American Civil War, rebuilt the trade on which much of the city's power and influence rested—and still does—and were instrumental in transforming Norfolk from a regional to a national city during the prosperous years between the Civil War and the end of World War I. This was a great accomplishment requiring a concerted team effort. The team lived in Ghent.

As for two of the aforementioned residents, Flora Cooke Stuart, wife and widow of Confederate Major General John Ewell Brown "J.E.B." Stuart and daughter of United States Army Brigadier General Philip Saint George Cooke, lived at 551 Warren Crescent in the Robert Page Waller residence. From the time of her husband's death in May 1864 for the remaining forty-nine years of her life Flora Stuart wore the black of mourning. David Pender, a native of Tarboro, North Carolina, came to Norfolk in the 1900s. He lived at 536 Redgate Avenue. Soon after his arrival, Pender founded his grocery story enterprise, D. Pender Grocery Company. His first store was one of the finest and most complete in the South. In 1919 Pender's had grown so popular that its

While out of view in the previous photograph, the Botetourt Street Bridge looking south toward downtown Norfolk was a winter wonderland when this picture was taken in 1904. The bridge is popularly called the Ghent Bridge by residents, but in fact, there were many bridges once traversing Smith's Creek, thus the properly applied street names to distinguish them. *Courtesy of the author.*

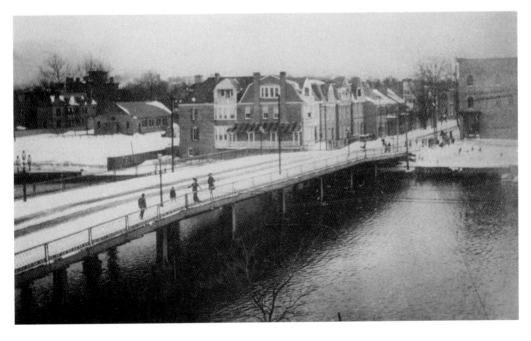

Colonial Avenue at Warren Crescent in 1902 reveals a Ghent suburb that has begun to fill in. The Frank S. Royster home at 303 Colonial Avenue, completed between 1900 and 1902, is on the left. The view is looking straight north to Beechwood Place. *Courtesy of the Sargeant Memorial Room, Norfolk Public Library.*

proprietor began opening branch stores. His chain grew to more than 400 stores, 120 meat markets and 2 bakeries in Virginia and North Carolina by the 1930s. While he held the option on land in Ghent to operate the suburb's first grocery store, opposition to commercial encroachment on the neighborhood led him to withdraw from the project and sell the land. Pender owned two lots at the corner of Raleigh Avenue and Manteo Street, which Pender sold to the Phillips Company for $4,500 on February 22, 1907, with the intention of Phillips building grocery and drug stores following plans originally drawn by Pender.

Those who opted to take a chance on living in Ghent, particularly before trolley service, had to get there by other means. "Our fathers always walked to their offices," Julia Johnson Davis recalled, "though of course those in the cotton

business merely had to cross 'the new bridge' and then the one to Atlantic City at that time—a toll bridge. My sister says that to her as a child being 'in cotton' was synonymous with money, leisure, and a white linen suit." As a small child, Davis remembered the horse cars, which did not go, as she observed, to Ghent. There was a turntable on York Street, "just this side of the Atlantic City Bridge," she opined. The horse cars stopped anywhere in that block, and she could remember well the subsequent indignation of adults when they heard that the new electric cars would stop only at the corner. There were also no direct routes at that time from Ghent to Cedar Grove and Elmwood Cemeteries. "My most frequent recollection of the cars," wrote Davis was boarding one with a basket of flowers to go to the cemetery with her grandmother. The car left Ghent, went to Bute Street and then Granby and

"Ghent was a small, green, quiet, unhurried world that its first residents left and returned to..."

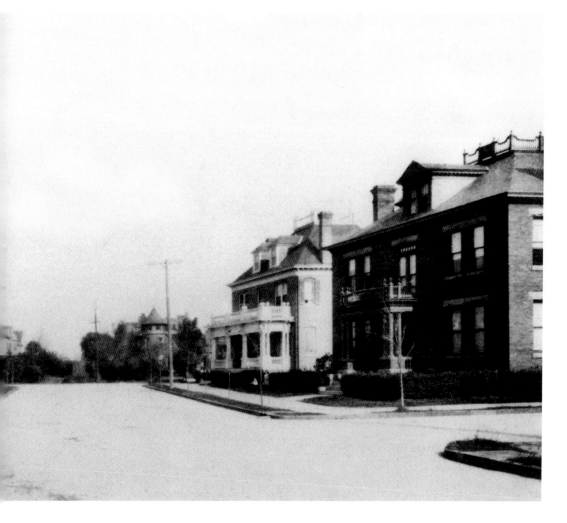

Main Streets before putting Davis and her grandmother off at a cross street that led directly to a gate in the brick wall of Elmwood.

Ghent was a small, green, quiet, unhurried world that its first residents left and returned to, comprising, in those early years, Beechwood Place, Warren Crescent, Pembroke Avenue, the white oyster shell road called Mowbray Arch and Colonial Avenue, and up as far as Fairfax Avenue, first named Mary Street. There was little traffic and few passersby, yet the life of the streets was varied and colorful, and as Julia Johnson Davis would recollect, "completely a part of our own." But the concept of Ghent as a quality residential area, even with early inconveniences, was developed from the very first plans. Sometimes realization of a concept can be a problem—such was not the case with Ghent. The first residents, mostly principals in the Norfolk and Ghent Companies, set the style and standards that were to subsequently attract other "quality" residents, both from long-standing Norfolk families and from newly arrived entrepreneurs from the North and other parts of the South. Among the first families, Graham, Tunstall, White and Reid were active participants in the Norfolk Company. They represented the engineering, law and trading professions. Graham was a newcomer from the North; the rest were native Norfolkians.

This circa 1900 view of the 400 block of Fairfax Avenue was taken by an unknown photographer standing on Colonial Avenue and looking east, revealing some of the section's loveliest residences. Note important exterior details original to these homes, particularly the porches. The image was published in *Art Work: Norfolk, Virginia, and Vicinity. Courtesy of the author.*

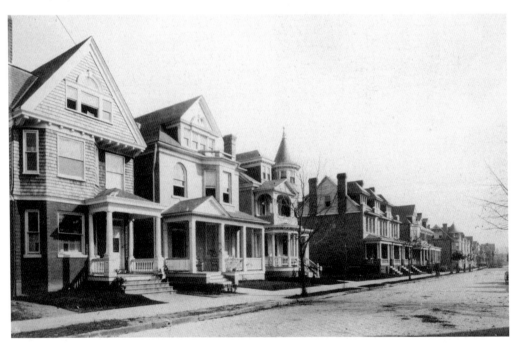

No matter from whence they came, the suburb's residents could agree on one description that was true—Ghent was in a world of its own. Each morning, right after breakfast, a grocery wagon came around, not to deliver but to take orders. Telephones were not common then, and even when residents in Ghent eventually got them, the grocery store had not considered a telephone necessary to do business. The horse, recalled Julia Davis, stood quiet, while the driver went to the kitchen with a little book, in which the mistress of the house wrote the order for the day, to be delivered later. Soon after him the milk wagon appeared, very different in style, low slung, with an opening on each side, through which one could see enormous, shiny milk cans. The milkman always drove standing up, half in, half out, with one foot resting on the side step, ready to drop the reins and spring to the ground. The milk was ladled into smaller cans, according to the amount the customer wanted, and the horse, by most accounts, could have made the rounds completely unaided, he had done it so many times. These two drivers—the grocer and the milkman—were

The residence of H. Caldwell Hardy, situated at the corner of Boissevain Avenue and Stockley Gardens, is pictured here in 1905. The home was designed by Ferguson and Calrow Architects. The Hardy home later became the guild house for Christ and Saint Luke's Episcopal Church. *Courtesy of the author.*

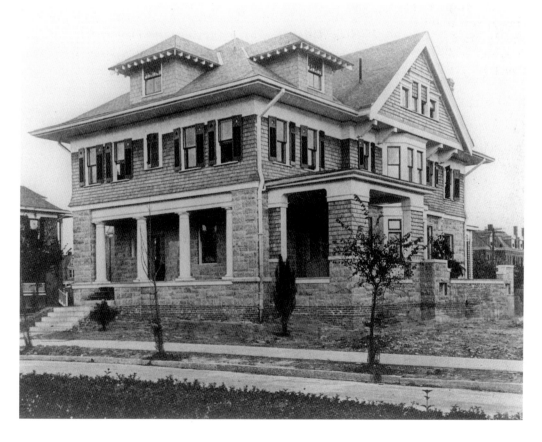

the ones who most frequently gave Ghent children tows on their sleds in winter, when Norfolk got considerably more snow than it does today.

But the grocer and milkman were not the only delivery drivers who made their way into Ghent. The lumbering, dripping ice wagon, with its two stout horses, was a daily sight in summer, according to Davis—and a great favorite. Children gathered around the iceman's wagon, begging for ice and always getting it. "I do not know why a piece of ice, fresh from the wagon and wrapped in newspaper," observed Davis, "tasted so much better than a piece from our own ice box, but I suspect it was because we were discouraged from opening the refrigerator." Another wagon the children watched for daily carried long logs used in piling for construction. The children dubbed them pole wagons. It always passed the children empty, headed for parts unfamiliar to them to get a fresh load of poles. As the wagon passed empty, its solitary, long pole running the centerline of the wagon became an imaginary horse for them to climb aboard and ride for a block or so before climbing off, fearful of ending up too far from home.

"In those halcyon days of early Ghent there were other personalities who stand out in memory, those whose lives were inextricably tied to the upbringing of 'the team.'"

An amusing touch was added to the wagons' horses in the summer when their drivers dressed them in straw hats, their ears poking out of two round holes, giving the effect of a very long-nosed old lady in a bonnet. "Why some prankster did not add strings," wrote Davis, "I do not know. The horses of the carriages and traps that drove over in the afternoon often had a sort of fringed net, with tassels, thrown over them to keep off flies, but these dray horses simply swished their tails and wrinkled their skin and let it go at that." But at least they had their hats, which no fashionable horse of their day would have dreamt of wearing.

Not all of the traffic coming and going in Ghent was horse-drawn, as there was an Italian "banana" man pushing his wheelbarrow, crying out his wares, remembered Davis. He would call out, "'Ice banana, ten centa dozen! 'Ice banana, ten centa dozen!" Residents usually kept a whole bunch of bananas hanging in cool cellars, but if out, the banana man would gladly break the bunch and sell a banana for a penny to the children following him along. Fast on the banana man's heels would often be black men with covered baskets brimming with blue crabs. They would call out that they had the crabs and raise the cover for children to see

what they could already hear, the scuffling of blue crabs that had just been caught. The same routine would be repeated with black men selling "hook 'n line spots," these being considered superior to fish trapped in a seine. And in the spring, there were always strawberries being sold up and down the street—and cantaloupes—all fresh from nearby farmers' fields.

At regular intervals there came the scissors grinder, pushing along a framework cart that held his whetstone. With his foot-operated treadle whose belt whirled the stone, the scissor grinder skillfully pressed a blade against it, sparks flying, sharpening whatever blades in the house needed sharpening. Occasionally, the junk man would come by crying out, "Old bottles! Old iron!" and the "bad boys" sold him whatever they had collected. Then, of course, there was what Ghent children called the Hokey Pokey man, with his little cart and crying out his ice cream, "Hokey Pokey, five cents cake!"

There were two figures the children watched for above all the others, and while they, too, were Italian, they earned a following among Ghent children not for ice, bananas or

The Saint George's School for Boys and Girls of primary, secondary and college preparatory classes, located at 413 Boissevain Avenue near Colonial Avenue, was a private school founded in 1900. The school, headed by Evelyn Henry Southall, was open October 1 through May 31 each year. Fergus Reid, W.W. Robertson and W.W. Starke served as the school's board of trustees. The picture shown here is from a school informational booklet dated 1923–1924. *Courtesy of the author.*

Atlantic City School Number 2, renamed Robert E. Lee School in November 1912, was photographed by Harry C. Mann about 1908. The building, constructed in 1901 and located at the corner of Graydon and Moran Avenues, was in Norfolk's Atlantic City section. The principal was George L. Fentress when this picture was taken. Atlantic City, annexed by the city of Norfolk in 1890, covered a broad swath, including both sides of Colley Avenue southwest of Olney Road and extending from the Norfolk and Western Railroad terminal at Lambert's Point to the railroad tracks at Twenty-third Street all the way to Elmwood Cemetery. The area was so large that three new public schools were built there after 1899: Atlantic City School Number 1, renamed the Patrick Henry School; also Atlantic City School Number 3, renamed John Marshall School and located on Omohundro Avenue, and the school building shown here. *Courtesy of the author.*

treats, but for their music. Both Italians played street organs; "the big organ grinder and the little organ grinder" was the distinction made by children who saw them coming. The "big" and "little" descriptions applied not to the men but their instruments. The little organ grinder, which one of the men carried on his back until ready to play it, was only half the attraction—and certainly not the most popular. The "little organ grinder" brought with him a small monkey attired in a red suit and a feather-trimmed fez hat, who, tethered by a long chain, danced and grimaced, holding out a tin cup for pennies. "To tell the truth," wrote Julia Davis, "we were always afraid of the monkey, and were always relieved to see him jump on his master's shoulder when the little concert was concluded." The children held out much adoration, however, for the "big organ grinder." His instrument was a huge, ungainly affair the size of a small piano, and was pushed along very much like a wheelbarrow, with two handles at one end and two small wheels at the other. Some of the big organ grinder's selections included "Il Trovatore," and another, inspired by the Spanish-American War, "The Blue and the Gray."

But there were personages—other than the monkey—who frightened the children, one of whom the children in those early days dubbed "Dick, Dick Dead Eye," a poor, half-witted man who wandered Ghent. He had lost an eye, hence the nickname, and the "bad boys" of Ghent threw sticks at him,

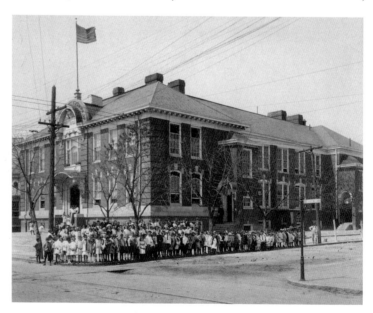

shouting his name and goading him to anger. Most of the children were more afraid than malicious when "Dick" came around. Even decades later, in recounting the story, Julia Davis hoped not to offend by mentioning him in her stories of old Ghent, but he was an integral part of growing up there and she felt compelled to tell of him. The "bad boys" of Ghent, who have been mentioned more than once, were a longtime problem and also a source of fear for many of the section's residents, including Davis. Articles were written in the newspapers with large type headlines, "Ghent bad boys before bar of commission."

The "bad boys" were the sons of Ghent's most prominent families, but they were guilty of the worst kinds of violence, vandalism and theft. To lend perspective, the bad boys had started causing mischief rather young. By the time they became headline news in the early 1900s, the boys had years of experience and their "mischief" had morphed into serious crime. They were, in effect, a street gang that finally committed so many hateful crimes that they were hauled

Norfolk public schools first allotted money for the construction of Atlantic City School Number 1 in 1899. The school, located on Colley Avenue at Pembroke Avenue, was completed a year later and subsequently renamed Patrick Henry School. Harry C. Mann also took this picture, circa 1910. *Courtesy of the author.*

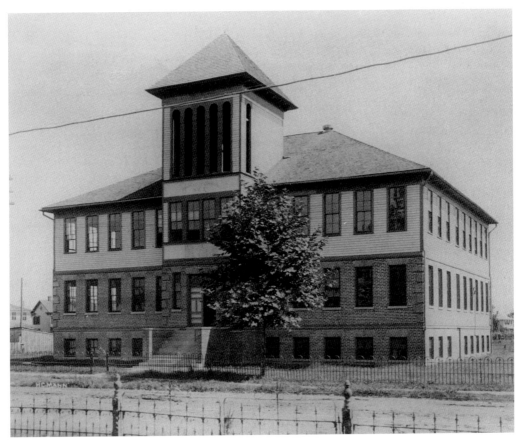

The 500 block of Pembroke Avenue was the subject of this circa 1895 view, first published as part of the turn-of-the-century photographic essay Art Work: Norfolk, Virginia, and Vicinity. The homes (left to right, starting foreground) are 530, 524, 518 and 502 Pembroke Avenue, the John R. Graham Jr. house anchoring the corner of Pembroke and Colonial Avenues at the head of Beechwood Place. Courtesy of the author.

before the citizens' commission in late December 1906. Robert Tait, chairman of the beautification committee of the commission, laid bare the situation once and for all when he told his colleagues, "What's the use of our beautifying anything when the chances are, ten to one, that those bad boys will destroy everything that we do." Among the bad boys' crimes was the case of a cook, an old black woman, on whom the boys took particular delight in siccing their dogs whenever she started for her home in the evening. On another occasion they beat the woman badly. Some neighbors had regular run-ins with the bad boys, and many were afraid of the gang, which exacted retribution swiftly when challenged. Tait himself lost four gallons of ice cream one evening after leaving it on a back porch on a winter's night, which seemed relatively minor by comparison, but it was theft all the same. The chief of police had already told Tait and others he was powerless to punish the bad boys, as their fathers were too influential, leaving no one with significant influence and power to prosecute them for their wrongdoings. The only end to their shenanigans came as

adulthood responsibilities loomed and parents sent many abroad "on tour" in Europe and other far-flung places and colleges and universities to learn a profession before bringing them into family-run businesses, professional practices, politics or a substantive trade.

In those halcyon days of early Ghent there were other personalities who would stand out in memory, those whose lives were inextricably tied to the upbringing of "the team." Julia Davis and Emma Cooke both recalled sweetly the most majestic figures on their quiet streets as the black nurses who cradled infants and clutched the hands of small children in their care. The infants, dressed in long white dresses with multitudes of fine tucks and Valenciennes lace descending in a cascade of white muslin almost to the ground, revealed only tiny faces covered by a blue chiffon veil that was usually attached to the nurse's shoulder. "There was never a figure of greater dignity," wrote Davis later, "than one of these old nurses, and it was an ill-starred infant indeed who did not first meet the world under a blue veil."

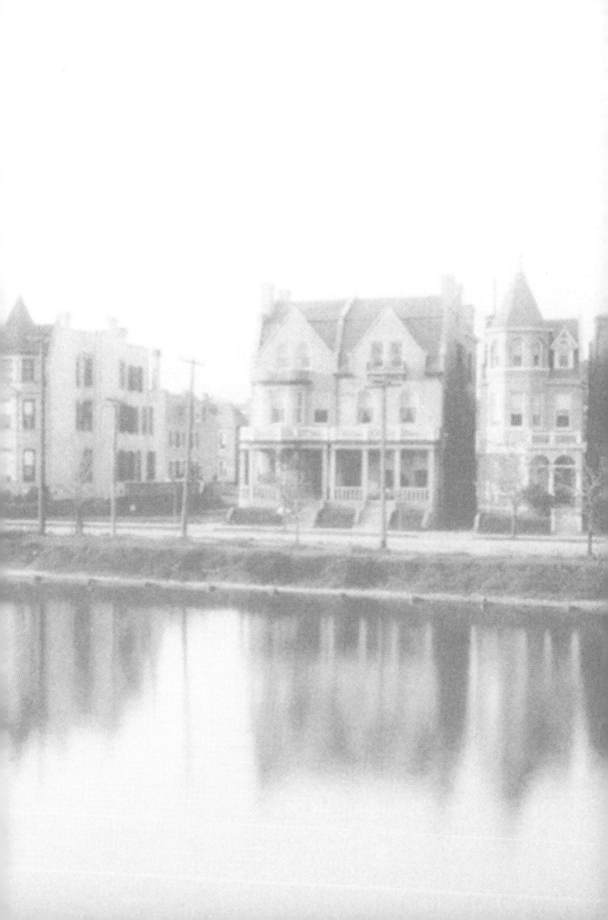

Chapter Two

PLANNING A NEW COMMUNITY

Early Norfolk historians wrote that the development of new suburbs bounding the city's downtown followed closely the spreading of the streetcar system as tracks were first laid here in 1869. "Hard upon the laying down of streetcar tracks came the development of new suburbs. The most important of these, located across Smith's Creek near Atlantic City, was called Ghent," wrote Thomas J. Wertenbaker in his history of the city, *Norfolk Historic Southern Port*, in 1931.

This expanse of farmland was taken over by the Norfolk Company in 1890, plotted off into streets and avenues and, again, according to Wertenbaker, "in a remarkably short period converted into one of the most exclusive sections of Norfolk...The west branch of the creek, which had extended back across Princess Anne Road, and the lower part, lined with a stone buttress, was rechristened The Hague." Paved streets, granolithic sidewalks, sewerage pipes, water mains and gas lines were provided for the new community. Several public squares were laid off on reclaimed tracts, and hundreds of silver maples and magnolia trees were planted along the thoroughfares. "In 1893 only a score of houses, 'all of handsome and modern design' (from *Industrial Advantages of Norfolk*), had been erected, or were in the course of construction. A decade later the entire suburb was built up," Wertenbaker wrote. He described the success of the Ghent undertaking as "phenomenal"—and it was.

Perhaps the annexation of the area in 1890 encouraged development through assuring future residents of all the advantages of the nearby city center, but it was the electrification and extension of the trolley lines by 1894 that drove Ghent's continued development. Commuting was made possible—and

easier. Much of Ghent's success can be attributed at this point to Adolph Boissevain's personal representative in the area, J.P. Andre Mottu.

Adolph Boissevain of Amsterdam, The Netherlands, founded the old banking house of Adolph Boissevain and Company after the Civil War for the primary purpose of developing American enterprises, principally railroads. At that time, the credit of the United States was at a low point and the public was somewhat loath to invest in American securities. Boissevain, who was related to Eugene Jan Boissevain, husband of the late Pulitzer Prize poet Edna Saint Vincent Millay, then organized the London firm of Blake, Boissevain and Company, with the cooperation of the New York and Boston firms of Blake Brothers and Company.

Among the railroads financed principally by these businesses under the leadership of Boissevain was the Norfolk and Western. The active president of the railroad then was Frederick J. Kimball of Philadelphia, where its headquarters was then located. Kimball, a great supporter of Virginia, interested

John R. Graham Jr.'s house at 502 Pembroke Avenue at Colonial Avenue was the first home constructed in Ghent. *Courtesy of the Sargeant Memorial Room, Norfolk Public Library.*

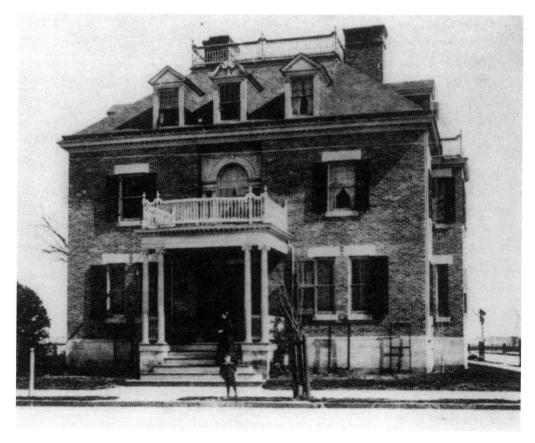

Fergus Reid's residence on Pembroke Avenue at Beechwood Place is pictured about 1895. *Courtesy of the Sargeant Memorial Room, Norfolk Public Library.*

Campbell of Norfolk took this photograph of Mary Reid, wife of Fergus Reid, with daughter Helen about 1900. Mary Wilson Chamberlaine married Fergus Reid, a cotton merchant, in 1898. The couple resided at 507 Pembroke Avenue at Beechwood Place, and from this home, the couple entertained and contributed to the social life of the city. The couple had three children, but one, Janet, died in infancy. Two others, Fergus Jr. and Helen, prospered in adulthood. *Courtesy of the Sargeant Memorial Room, Norfolk Public Library.*

Boissevain in the rich resources of the commonwealth, which resulted in the formation abroad of three syndicates. They were the Virginia Land Company, the Virginia Investment Association and the Consolidated Coal, Iron and Land Company, all with several millions of dollars in capital at their disposal. The purpose of their organization was to develop land and industrial subcorporations, strung out from Norfolk, Virginia, to Columbus, Ohio. The local subcorporations would include the Norfolk and Ghent Companies and the Portsmouth Company.

Some of the first building lots in Ghent were bought by Boissevain, whose contribution to its development also was remembered in the naming of Boissevain Avenue. Dr. William H.T. Squires once wrote: "Ghent was laid out with elaborate geometrical lines, arcs and parks, along Samuel Smith's Creek (The Hague). In 1895 a few scattered houses gave promise of thousands who were to move over Ghent Bridge." The publication, *Industrial Advantages of Norfolk*, mentions that Ghent property was being sold in 1890 at $1,400 per acre.

But Boissevain was rarely in Virginia, and the Philadelphia members of the company, though thoroughly interested and

vested in the Ghent venture, were not on scene to run it. For a number of years, Boissevain came to Virginia only once a year from his European headquarters. But to represent him in his Virginia investments, Boissevain sent J.P. Andre Mottu, with whom he had been associated in Amsterdam. Mottu was Boissevain's general sales agent. Included in Boissevain's other interests were the Seaboard Fire Insurance Company, the Real Estate Insurance Company, the Real Estate Exchange and the Chamber of Commerce. Thus, Mottu was in a position to coordinate many aspects of the sale of property in the area.

Mottu, born in Amsterdam on July 5, 1866, had studied at the business college there and at Geneva, Switzerland, after which he was employed by a South African bank in Amsterdam and, later, the American banking firm of Blake, Boissevain and Company of London, England, and Amsterdam. In 1890 Mottu came to the United States and, after spending about a year visiting various parts of Virginia, located in Norfolk as the field agent for his future operations. Mottu became prominent in the cultural and business life of the city from the moment of his introduction to the society of Norfolk's west side. He formed Mottu and Company, bankers and

"The first homes were built in the Mowbray Arch area by some of the promoters of the Norfolk Company. Sometime in early May 1891 work began on the foundation of Ghent's first house."

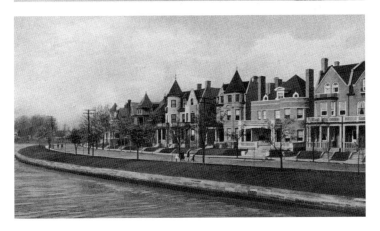

Mowbray Arch from the Botetourt Street Bridge (foreground) was photographed by an unknown photographer about 1900. There was no bulkheading along the water's edge at that time, but by the time the Hugh C. Leighton Company postcard, printed in Germany, was published circa 1910, stones had been laid to create an attractive bulkhead. Notice also the addition of the large residence (second from the right) at 418 Mowbray Arch and the porches originally built on many of these homes. *Courtesy of the author.*

The John W. and Anastasia D. Burrow residence at 419 Colonial Avenue was built in 1894 and remained in the John W. Burrow family until 1933, when it was occupied by the Garrison-Williams School, now the Williams School, one of Norfolk's premier kindergarten to grade eight private schools. The photograph is believed to have been taken in April 1899, and was provided by Dr. Frederic R. Walker, former Williams School headmaster. John Burrow was a wholesale and retail druggist with a store at 142 Main Street at the head of Market Square in 1890 and 1891. His shop eventually became Burrow, Martin and Company, Inc. *Courtesy of Dr. Frederic R. Walker.*

passenger agents for the Holland-America Line, and served as general agent of the Norfolk Company, president of the Norfolk and Ghent Companies and as general superintendent of the Holland Realty Corporation and of the Portsmouth Company. He also acted as Belgian and Dutch consul in Norfolk, as vice-president and treasurer of the Norfolk Silk Company and for a number of years was treasurer of the Norfolk Symphony Orchestra. He bought the old Colley farm in Ghent, on Pembroke Avenue on the Atlantic City side of The Hague. Until his death in 1934, he lived there in a large red brick house that stood for decades on the west side of The Hague—its rural setting defying the city's urban sprawl. Mottu is largely considered the founder of Ghent.

To the people involved in the Norfolk Company, the development of Ghent was a very personal undertaking. Not only were they intimately involved in it, but many subsequently made Ghent their home. The names of the streets reflect this involvement. Boissevain Avenue was named for Adolph Boissevain, the financial backer of the company. Other name connections are not so obvious. Pembroke, a name frequently associated with Hampton Roads history, in this case refers not to local lore, but rather to Alfred P. Thom's middle name. Thom also had a hand in naming Stockley Gardens, which refers to his birthplace in Northampton County, Virginia. Other participants in the development of Ghent were also honored. Fairfax Avenue was originally

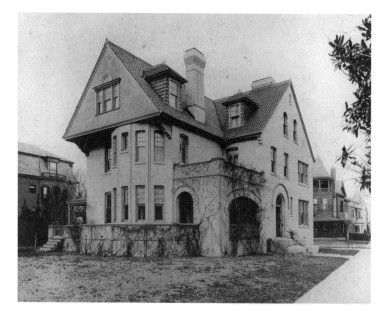

Mary Street, after a sister of John Graham. Richard Olney, attorney general and secretary of state in President Grover Cleveland's second administration, was the inspiration for Olney Road. Olney, who exerted powerful influence over domestic and international affairs, is famous for declaring the United States as "practically sovereign on this continent, and its fiat is law upon the subjects to which it confines its interposition," in an 1895 negotiation with the British over a Venezuelan border dispute. Theodore Roosevelt later made this principle a corollary of the Monroe Doctrine. Beechwood Place was named, according to Robert Baylor Tunstall, by Fergus Reid because of a very beautiful beech tree on the front side of Reid's property overlooking the little park, but there is somewhat of a controversy as to whether this is entirely true, or whether the numerous beech trees formerly part of Commodore Richard DeBree's Lilliput plantation contributed to its naming. The short street leading from the Ghent Bridge was originally—and prosaically—named Bridge Street, but this was appropriately changed to Drummond Place.

Strong evidence exists that the venture had not only detailed plans for development, but also plans for specific implementation. Given the nature of the business interests involved and the timing of development, speculation was probably one of the prime motivations. The nature of speculation assumes a relatively small initial investment that is expected to grow appreciably in a reasonably short

An unknown photographer standing approximately at 317 Colonial Avenue took this sweeping image of Beechwood Place looking toward Pembroke Avenue, circa 1895. This picture was included in *Art Work: Norfolk, Virginia, and Vicinity*. *Courtesy of the author*.

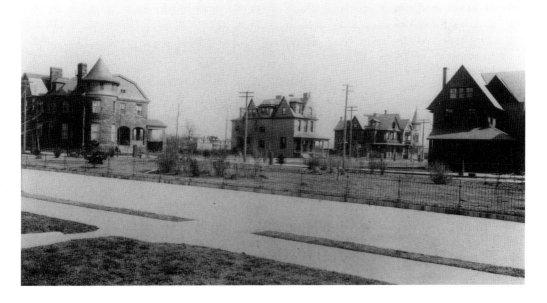

The 8,100-square-foot Frank S. Royster residence, an imposing twenty-odd room Georgian Revival home at the corner of Colonial Avenue at Warren Crescent, is shown here, center, as it appeared about 1911. The home was completed between 1900 and 1902. Frank S. Royster was the son of a North Carolina planter. His business success came from the special fertilizers he developed for tobacco and cotton growers, but Royster had his hand in other businesses, such as banks, railroads and a steamship company. As busy as he was as a captain of industry, Royster set aside a considerable amount of his time for community service, which he held as important as any effort achieved in the boardroom. Royster and his wife, Mary Rice Royster, had eight children, four of whom lived to adulthood. He died in 1928, but the family continued to live in the house until after World War II, when the house was sold. *Courtesy of the Sargeant Memorial Room, Norfolk Public Library.*

period of time. Until realization of some of this gain, cash availability is expected to be tight. To minimize the amount of capital needed at the outset, only enough capital to buy the land to initiate development in a small area was raised among investors. The profits realized from Ghent's first stage of development were used to finance improvements in the second stage and until the Ghent area was complete. While common practice today, this technique was evolving at the time Ghent was developed. Rather than building model homes for home purchasers to choose, as is done today, Ghent's developers instead established an initial floor for investment, ensuring that no house costing less than $7,500 could be constructed in the area, though this figure was eventually lowered to encourage further development in the face of economically challenging times to come. Land costs were halved for builders who constructed homes in the higher dollar ranges. While literature of the period indicates houses were completely built and landscaped before being placed on the market, this was done by others, not the Norfolk Company or, later, the Ghent Company. Land was developed by individuals, for personal use among Ghent's investors and promoters, but also for sale or rent in the majority of cases. City directories, land ownership maps and other resources indicate that the developers of Ghent were relatively few, buying land, building, selling or renting and buying more land. Some persons dealt largely in land in a speculative manner by buying land, holding it a few years and then selling it. Many of these developers became prominent in the real estate business in Norfolk and Virginia Beach, and their

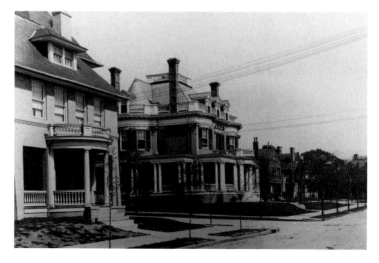

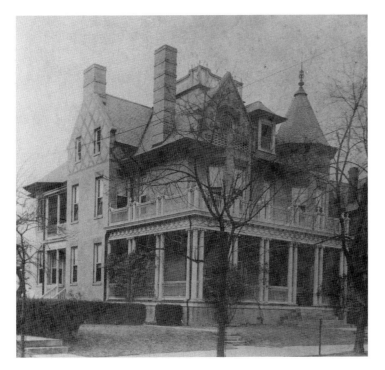

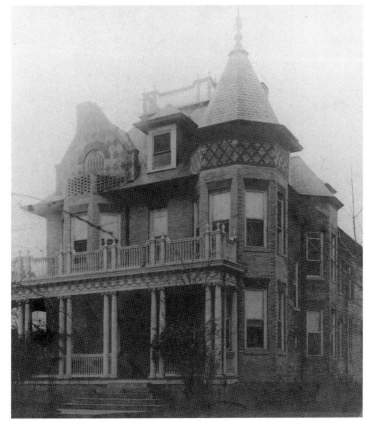

The residence of Leonard P. Roberts, shown in these images circa 1910, was originally numbered 18 Warren Crescent pre-1913, after which the address became 539 Warren Crescent. The house was constructed in 1898. The contractor was George T. Banks and the subcontractor Thomas Thomas and Company for the roofing work. *Courtesy of the Sargeant Memorial Room, Norfolk Public Library.*

names are still recognizable among realty organizations in Hampton Roads today.

In the context of phased development, the first stage took place primarily on the old Willis Langley plantation portion of the Norfolk Company's land holdings. The Willis Langley plantation was an area best described as bounded by Armistead Bridge Road (now West Princess Anne Road), Moran Avenue, Olney Road, the Ribble tract and Paradise and Colley Creeks. This was logical since it was adjacent to existing development to the east. The first Ribble to appear in Norfolk directories was a butcher named J.E. Ribble who lived in Norfolk County, but ran his meat shop at the old city market. His descendant, Frederick Ribble, a tinner, was listed in the directories for 1892 and 1893, but did not reside on the tract, which by that time had become part of Norfolk city with the section's annexation two years earlier. Municipal improvements began almost immediately. One of the first improvements was the Botetourt Street Bridge, otherwise known as the Ghent Bridge, which extended from the end of Botetourt Street to the new

The library of the Leonard P. Roberts residence is shown here about 1900. At the time this photograph was taken, Roberts was Norfolk's leading grocer, having been in the grocery business since 1875. His store was on Commercial Place. *Courtesy of the Sargeant Memorial Room, Norfolk Public Library.*

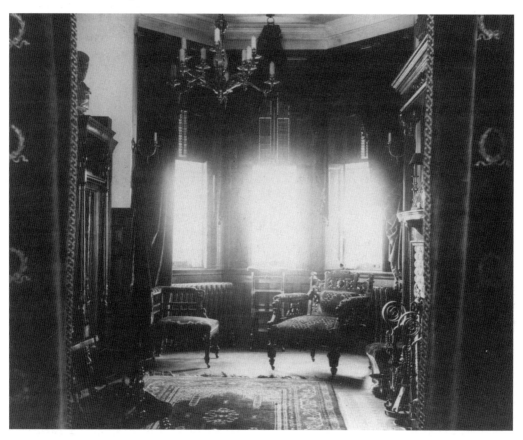

suburb. Built in 1891, the new bridge replaced an old wooden footbridge that had linked the city with the plantations across the creek for nearly two hundred years.

The first homes were built in the Mowbray Arch area by some of the promoters of the company. Sometime in early May 1891 work began on the foundation of Ghent's first house. The Norfolk Company had contracted with the firm of J.A. and W.T. Wilson of Baltimore, Maryland, to design and build several houses. John Appleton Wilson specialized in residential architecture and had an established relationship with principals of the Norfolk Company. He actually drew plans, in fact, for a twin townhouse that was never built, and for four residences, including those of John R. Graham Jr., engineer and general superintendent of the company, his wife, Florence, and their sons, John III and Joseph, who built Ghent's first house at 502 Pembroke Avenue; Fergus Reid, a Norfolk Company director and cotton merchant, and his wife, Mary Chamberlaine, at 507 Pembroke Avenue at Beechwood Place; Richard B. Tunstall, another company director, and his wife, Elizabeth, and their son, Robert Baylor, at 530 Pembroke Avenue; and Horace Hardy, Norfolk manager of Price, Reid and Company, and his wife, Jessie, and their son, two-year-old Horace Jr., at 442 Mowbray Arch. The residences of Hardy, Tunstall and

Colonial Avenue remained the most important—and prestigious—street address in Ghent in those early years. Colonial Avenue at Raleigh Avenue, north of Olney Road, had also begun to be developed when this picture of a couple in their car was taken in 1902. *Courtesy of the Sargeant Memorial Room, Norfolk Public Library.*

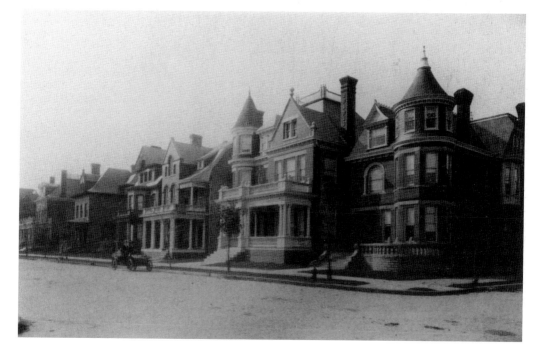

The Walter H. Doyle residence at 518 Pembroke Avenue was first listed in Norfolk city directories as "Pembroke Avenue near Colonial Avenue," but as point of reference, he was John Graham's next-door neighbor at the time this picture was taken by an unknown photographer. Graham's home was out of this image to the right and sat imposingly at 502 Pembroke Avenue at Colonial Avenue facing Beechwood Place with a water view. This image was part of *Art Work: Norfolk, Virginia, and Vicinity*. Walter H. Doyle's home appeared, as shown here, in the 1895 edition, section one. *Courtesy of the author.*

Reid, in addition to the William H. White (later also known as the Henry Kirn) residence at 434 Pembroke Avenue on the northeast corner of Pembroke and Colonial Avenues, were all completed and occupied by the end of 1892. Wilson had drawn up plans in March of that year for the massive North Carolina brownstone residence that would become the home of William White, a prominent Norfolk attorney. But there were other out-of-state designers whose work is still standing in Ghent. Helen Reid, Fergus's sister, employed the Louisville, Kentucky, architectural firm of Maury and Dodd to design her residence at 317 Colonial Avenue, next door to brother Fergus facing Beechwood Place. But Helen Reid never saw the house completed. She had gone to Cincinnati, Ohio, in the hopes of reviving her failing health, but died, instead, in the home of her brother-in-law in April 1893. When finished, this home would be occupied by William M. Whaley, a railroader.

By 1893 a score of homes were finished or under construction. Land during this first early phase of development was selling for a minimum of $1,400 per acre, but Ghent was still too suburban for some, who described traversing the bridge from home to work in Norfolk's bustling downtown city center and back again an exhausting experience. Graham's dream of a model suburb was taking shape, even if Norfolk's old establishment was not wholly sold on the project. Once Graham had the company's property

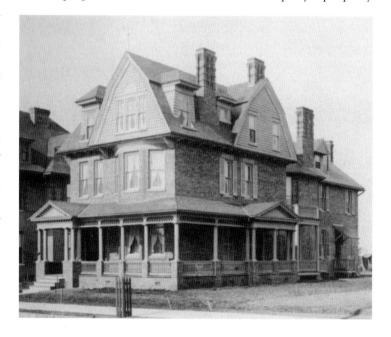

laid out and improvements well underway, lots were sold for development. By this time the price for a lot was $2,500 for a twenty-five-foot by one-hundred-foot lot. In June 1893 the *Norfolk Landmark* reported the public's perception that the Norfolk Company required that houses could not be built on their lots costing less than $7,500, but a newspaper query to the company revealed that this was a mistaken impression. There were restrictions, including that no house cost less than $4,000, which was still a considerable amount of money to construct a residence, then and for many years to come. But more than mistaken impression, lowering the price may have had more to do with economic reality.

While the Norfolk Company had made appreciable progress by the end of 1893, only a small part of its land holdings had been developed, and Beechwood Place, described as a "small but tastefully laid out park" in earlier accounts of the neighborhood, was the centerpiece—or heart—of Ghent. The *Virginian* in January 1893 declared, "The showing for 1893 is bright for Norfolk and the *Virginian* sees no clouds on the horizon." But the newspaper did not count on a stock market collapse and multiple bankruptcies to cast a pallor over Norfolk's otherwise bright future. The panic of 1893 followed several successive steps that predictably precede such crashes. On February 20, 1893, the Philadelphia and Reading Railway Company, with capital of $40 million and a debt in excess of $125 million, plummeted into bankruptcy, and on May 5, after paying out its regular dividends, the National Cordage Company, with $20 million in capital and $10 million in liability, followed. The management of the Philadelphia and Reading Railway Company and the National Cordage Company had engaged in a rash of speculation. National Cordage Company kept up its speculative road to ruin up to the moment it went under. In the opening week of May the stock market collapsed. Before year's end, the Erie, Northern Pacific, Union and Atchison Railroads had gone the way of the Philadelphia and Reading. A total of five hundred banks and sixteen thousand businesses declared bankruptcy. Banks began calling their loans and credit started to dry up quickly. During the worst months of 1894 unemployment figures reached as high as 20 percent, and it was not until four years later, in 1898, that the economy went back to its 1892 level. A depression swept the country.

"Beechwood Place, described as a 'small but tastefully laid out park' in earlier accounts of the neighborhood, was the centerpiece—or heart—of Ghent."

"Ghent was laid out by thirty-six-year-old John R. Graham Jr., a civil engineer who hailed from Philadelphia, Pennsylvania, and was well noted for his railroad and municipal work."

Not surprisingly, by the spring of 1893 only thirteen homes had been built in Ghent, and coinciding with multiple bankruptcies nationwide, that May the Norfolk Company advertised money for homes, offering to lend up to two-thirds of the combined values of the house and lot. Applications were to be addressed to John H. Dingee in Philadelphia or John Graham at 47 Granby Street. Graham proved his versatility in the business world in the toughest of times. He had already surveyed and laid out the Norfolk Company's property, designed a state-of-the-art steel-riveted bridge over Smith's Creek, supervised the construction of the company's first homes and had now gone into the money lending business to keep the company's investment in Ghent afloat. Due to his—and others'—perseverance in the face of a national depression, Ghent survived—and so did the Norfolk Company.

John Graham's Dream Comes to Life—and Grows

"The plans produced by Graham were detailed and complete. Graham intended that Colonial Avenue become a grand boulevard with mansions on either side, a boulevard every bit as beautiful as those of Baron Haussmann's Paris..."

The Norfolk Company had begun in the fall of 1890 to execute its development of the original tract of some 220 acres. Ghent was laid out by thirty-six-year-old John R. Graham Jr., a civil engineer who hailed from Philadelphia, Pennsylvania, and was well noted for his railroad and municipal work. He was brought into the Ghent project to transform the land into the most modern, innovative suburb of its day. Graham moved to Norfolk permanently, building the first house in Norfolk's newest suburb at the northwest corner of Pembroke and Colonial Avenues in 1892. But he was not just a chance participant in the Ghent venture. As the son of a prominent Philadelphia industrialist, Graham had obtained experience on various projects sponsored by his father. One of these projects was as chief engineer in Virginia in 1879 for the New River Railroad and Manufacturing Company, which had been founded by his father. This railroad was merged with the Norfolk and Western and subsequently involved in opening up the Pocahontas Coal Region in West Virginia to the Norfolk trade. Graham personally directed the first shipment of coal from the Pocahontas fields to Norfolk. He worked for Norfolk and Western until 1884, when he moved to Philadelphia as manager of the Camden Iron Works. In 1890, Frederick J. Kimball, president of the Norfolk and Western as well as charter member of the Norfolk Company, persuaded Graham to become engineer and general superintendent of the Norfolk Company.

Within a month of his hire, in early June 1890, Graham had pulled together a staff of his own and was prepared to make a preliminary survey of the land, knowing that a previous plan for the land's development had been dismissed by the syndicate

as "unimaginative." The plans produced by Graham were detailed and complete. Graham intended, as one example, that Colonial Avenue become a grand boulevard with mansions on either side, a boulevard every bit as beautiful as those of Baron Haussmann's Paris; thus homes built along Colonial Avenue remain among the most important. Beechwood Place was to be Ghent's heart, the centerpiece of the suburb and the focal point from which Graham wrought his designs. While Norfolk had experienced significant growth in the past, the detailed planning that accompanied Ghent's development made it Norfolk's first forerunner of the modern suburb, as is indicated by an extensive report taken from a period description of the Ghent undertaking, published in 1897:

> *The design, including all the municipal requirements and conveniences were elaborated in the smallest details and adopted before the work was begun, and the execution was complete in each detail before the property was placed upon the market. Sewer mains, water and gas mains, were laid down and connected with each lot. The streets were paved with asphalt blocks, granite curb and granolithic footways. The shrubs in the park and the trees along the streets were planted. Nothing was left undone. The advantage of a complete system like this to residents can be easily understood. There can be no trouble and expense incurred by reason of inefficient arrangements or make-shift appliances.*

John Graham also saw the need to replace the wooden footbridge connecting Ghent to the city, which had washed away during a storm over a year before, in 1889. He designed an impressive steel-riveted bridge to span the creek, thus connecting Mowbray Arch with Botetourt Street. By September 1890 a contract in the amount of approximately $38,000 was let to build the bridge. Later that month, the company also began sheetpiling the waterfront that followed the line of its southern boundary. This sheetpiling was the beginning of a seawall along Mowbray Arch. The bridge was completed in March 1891. The March 6 *Norfolk Landmark* reported that a gentleman had stopped to notice the bridge and reported that its ten lamps would have three gaslight jets each. The bridge, according to this passerby, would be "very unpopular with couples" for its many lights.

"S.L. Foster was paving Ghent's streets with Trinidad asphaltum blocks by November 1891. Within two years, more than eight hundred thousand of these twenty-pound blocks would be laid in Ghent."

"Graham's plan for Ghent went beyond providing the suburb with city utility services and paved thoroughfares. His vision extended to the suburb's original landscape plan, which was executed by some two hundred men and twenty teams of horses and wagons employed by the Norfolk Company to plant magnolia and silver maple trees…"

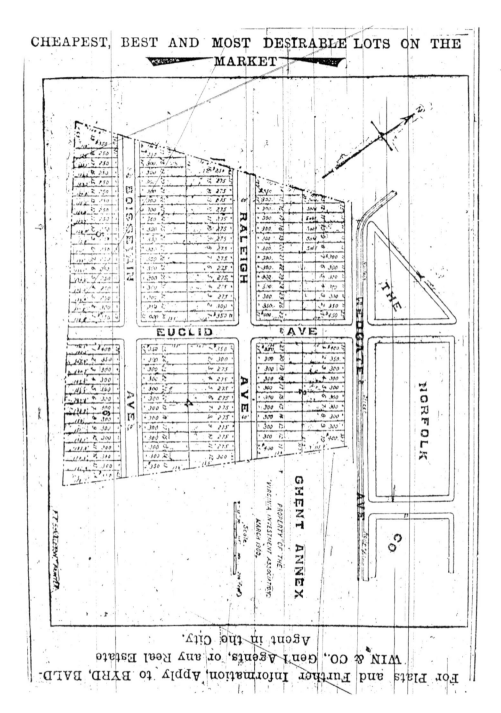

This plat was published in the May 27, 1900 *Virginian-Pilot* newspaper. Labeled "Ghent Annex" and the property of the Virginia Investment Association, the illustration shows Ghent's development as it spread north of Olney Road. Land belonging to the Norfolk Company is still indicated above Redgate Avenue, and the trolley tracks are running down the street's center. *Courtesy of the author.*

T. Marshall Bellamy, one of Ghent's developers, a principal party to the Norfolk Company and one-time resident of 712 Westover Avenue, reflected many years later that the public had the idea that the homes should be worth at least $7,000 in 1900. In fact, Ghent property was selling for $1,400 per acre in 1890—a figure that would increase exponentially as more homes were built. Norfolk's late historian, Henry Boswell Bagnall, recorded in 1900, when the government census for Norfolk listed 46,624 persons, that Ghent contained "beautifully laid off streets, well paved and adorned with shade trees, green grass plots and shrubbery…Several hundred elegant homes, which cost from $4,000 to $75,000, and a large number of apartment houses, churches, schoolhouses and clubs add a million dollars to the city's real estate values." Lots sold at half price, of course, if the buyer agreed to erect a home in this price range.

Street improvements added immeasurably to Ghent's overall appeal. S.L. Foster was paving streets with Trinidad asphaltum blocks by November 1891. Within two years, more than eight hundred thousand of these twenty-pound blocks would be laid in Ghent. In December 1891, in the process of making street improvements, the Moran family burial vault

Mowbray Arch (foreground) was originally paved in oyster shells, seen here in this photograph, circa 1895, from *Art Work: Norfolk, Virginia, and Vicinity*. The picture also shows the Botetourt Street (also called Ghent) Bridge, designed by John R. Graham Jr. and completed to his specifications. *Courtesy of the author.*

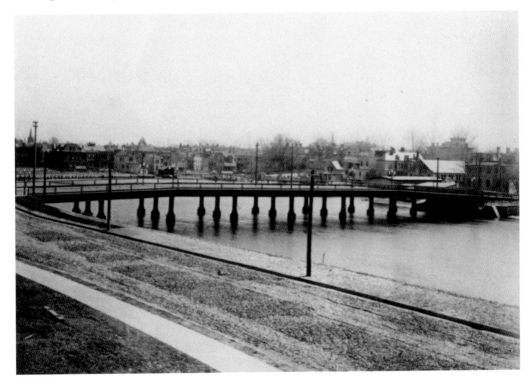

was opened and the single body inside removed and reburied. Graham was moving forward at clipper speed to get Ghent juxtaposed as Norfolk's premier address.

Graham had not stopped with his bridge, street and seawall projects. In February 1891 Graham and Alfred P. Thom submitted a plan to introduce city water, sewerage, gas and electricity into the Atlantic City ward. The Norfolk Company would undertake these improvements if the ward bonded itself in the amount of $100,000. The company appropriated $152,000 for laying water and sewer pipes, and paving and lighting at least a few of Ghent's streets. A few months later, in June, Thom asked the city of Norfolk to extend water mains to Ghent, using the new bridge to bring the lines over. The following month Ghent residents found their steel-riveted bridge the object of interest for North Carolina excursionists who wanted to see firsthand what they had read so much about in the newspapers.

Sarah Leigh Hospital, founded by Norfolk surgeon Dr. Southgate Leigh, was under construction when this photograph was taken in 1902. Note also ongoing construction to shore up the banks of Smith's Creek and the rudimentary bridge (right) spanning the waterway. *Courtesy of the author.*

The Norfolk Company rapidly changed the landscape—literally and figuratively. Graham's plan, too, went beyond providing Ghent with its city utility services and paved thoroughfares. His vision extended to the suburb's original landscape plan, which was executed by some two hundred men and twenty teams of horses and wagons employed by the company to plant magnolia and silver maple trees, excavate the sewers and lay water pipes. These were backbreaking tasks performed as quickly as anyone then living in Norfolk had ever seen. The newspapers and business journals covered stories, sometimes teetering on the sensational, of their work as it made headway. "In making excavations for sewers on the property of the Norfolk Company," reported the *Norfolk Journal of Commerce*, "several hundred skeletons have been found. The coffins in which these bodies were buried were put together with wrought nails, which indicate that the interments were made many years ago." Slightly sensational,

"The first electric streetcar went through Ghent on October 23, 1894. With the arrival of the streetcar, Ghent became far more desirable to those who had resisted moving 'to the suburbs' for its inconveniences."

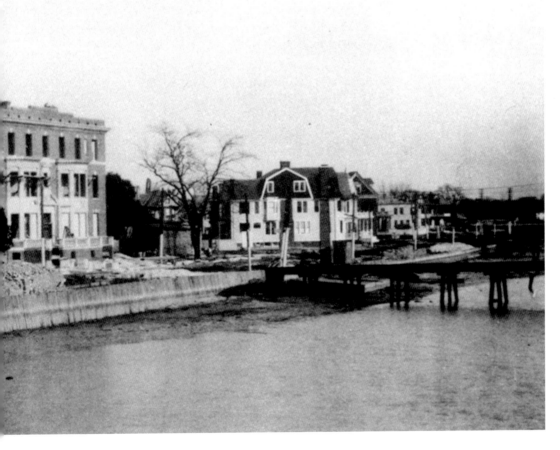

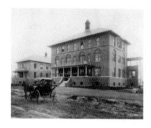

Norfolk Protestant Hospital was under construction when this picture was taken in 1902. The hospital opened on March 26, 1903, on land officially bounded by Colley, Raleigh and Boissevain Avenues. The new hospital had twenty-three private rooms and accommodations for fifty ward patients. *Courtesy of the author.*

yes, but the newspaper later corrected its story, informing the readership that only three or four skeletons had actually been disinterred.

Duly noted by past Norfolk historians was the winter of 1892, which spilled over into the early months of 1893, before the stock market crash that spring. In less than one month, spanning December 21, 1892, to January 19, 1893, the mean temperature in Norfolk was twenty-four degrees, and during this time, an incredible thirty-one inches of snow blanketed the city and no less than a dozen ships were locked in ice off Ocean View. During this period, Norfolk's citizens could walk or skate across expansive bodies of water—it was *that* cold. Also observed in the newspapers was the significant number of horses pulling streetcars that had taken spills on Norfolk's icy streets. The Society for the Prevention of Cruelty to Animals (SPCA) went to court to have Norfolk's streetcar horses pulled from duty until they were roughshod properly to prevent falls, many of them having already been seriously injured. "Drivers should be more careful turning the southeast corner of Warren Crescent and Pembroke Avenue in Ghent as the snow hides the curbing," cautioned the *Norfolk Landmark.* Many sleighs had also been damaged by the curbing, including a sleigh occupied by a prominent city official. The *Landmark* also remarked that sleighing in Ghent was particularly good on the broad expanse of Colonial Avenue.

By February 1893 Thom, already a powerful Norfolk politician, requested that streetcar service be routed to Ghent. The Norfolk Company was prepared to furnish its own streetcar service if the existing streetcar company failed to

This Harry C. Mann hand-colored postcard, from his original photograph, is pre-1910 and shows Sarah Leigh Hospital facing Smith's Creek—The Hague. Note the early bulkheading, and also the footbridge far right. *Courtesy of the author.*

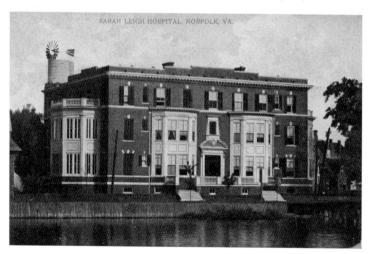

do so. The company was ready to operate its own streetcars, having earlier acquired a charter to establish streetcar service in Norfolk. To reinforce its desire to put electrical streetcars into Ghent to replace horse-drawn streetcars, the Norfolk Company solicited the signatures of two hundred prominent businessmen stating their support of this initiative. The list was presented to Norfolk's Common Council, but it was not until October 23, 1894, that the first electric streetcar went through Ghent. With the arrival of the streetcar, however, Ghent became far more desirable to those who had resisted moving "to the suburbs" for its inconveniences.

The year 1893 also saw the last two residences built by the Norfolk Company go up that spring. Not counting the price of the land beneath them, these were the brick and shingle home built for Helen Reid, which cost $5,500, and William H. White's massive stone residence that cost $13,700—these were the smallest and largest, respectively, built by the company in Ghent. White paid top dollar, in his day, for materials and services to complete his home: $486 for a slate roof; $640 for painting the house, and $777.60 for plastering the interior. Today a combination of these materials and services would cost tens of thousands of dollars. White planted large trees in his yard to complete the picture. He wanted his home as inviting and graciously appointed as possible, as he also

Dr. Southgate Leigh (far right) is pictured giving an operation demonstration about 1895. Dr. Leigh was born on May 21, 1864, in Lynchburg, Virginia, the son of John Purviance Leigh Jr. and Fannie P. Cowery. An alumnus of Columbia University, Dr. Leigh began practicing medicine in Norfolk in 1893. While he was the founder and visiting surgeon of Sarah Leigh Hospital, Dr. Leigh was also consulting surgeon to the Norfolk and Western, Pennsylvania, Chesapeake and Ohio and Atlantic Coast Line Railroads. Dr. Leigh was involved in community affairs as well, serving as president of Norfolk's Common Council, bank director and director of the Norfolk-Portsmouth Chamber of Commerce. He was also founder of the American College of Surgeons and former president of the Medical Society of Virginia. Dr. Leigh married Alice

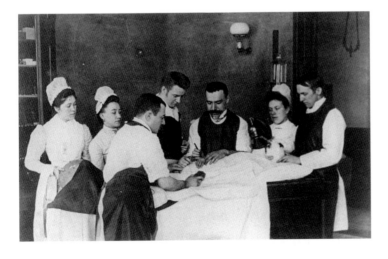

Creekmore, and they had four children, including Dr. Southgate Leigh Jr., Alice Leigh, Sarah Leigh and Benjamin Watkins Leigh, three of whom lived into the 1990s. When Dr. Leigh died on March 6, 1936, at the age of seventy-one, he was attending a commerce association meeting. *Courtesy of the author.*

Walter H. Doyle, a principal figure in Ghent's development, was president of the Citizens' Bank of Norfolk when this picture was taken for publication about 1900. Doyle was born in Norfolk in 1845 and received all of his early education in the city school system, but pursued his advanced education at Calvert College, Maryland. Walter Doyle married Virginia Camp, daughter of George W. Camp, and the couple had four children, Bessie A., Edward Fitzgerald, Walter H. Jr. and John F. The Doyle family resided at 518 Pembroke Avenue. *Courtesy of the author.*

enjoyed entertaining guests, eventually gaining a reputation for the many lavish parties given in his Ghent home. The *Virginian* newspaper in January 1894 wrote of a party given by White at which delightful music was furnished by the Borjes Orchestra, "stationed on the landing above the great stairway in the second hall. The attractiveness of this lovely home," observed the newspaper, "is greatly enhanced by the number of its unexpected niches and cozy corners, and on this occasion one would frequently see an interesting couple comfortably seated in some romantic nook, half ensconced behind a palm or portiere, safely conversing, while the strains of sweet music gently floated from above."

Success was indicated in Ghent as early as 1896, despite the national depression, when the Norfolk Company formed the subsidiary Ghent Company with the same objectives, same interests, same plans and designs and virtually the same directors. John H. Dingee was the new Ghent Company president. Alfred P. Thom was vice-president and general counsel. The secretary was J.M. Wirgman of Philadelphia, and the treasurer was William H. Triol, also of Philadelphia. The engineer and superintendent was Graham, noted to be not from Philadelphia, but from Norfolk, having adopted the city as his hometown. Mottu was listed as general sales agent in Norfolk. The eleven-man board of directors again included Dingee, Campbell and West from Philadelphia, with the additions of Wirgman and Logan M. Bullitt. The six Norfolk directors remained the same with the exception being Ramsey and Osborne, who were replaced by Walter H. Doyle and William H. White. Dingee and Wirgman were also president and secretary, respectively, of the Pulaski, Virginia, Land and Improvement Company during this same period of time, formed much along the same lines as the Norfolk and Ghent Companies. Bullitt had already lent his name to prestigious Bullitt Park in Franklin County, Ohio, in 1889. By the 1890s, several large homes took root across Alum Creek in the Bullitt Park area, whose borders include mansions and a park as well as the campus of the Columbus School for Girls, an exclusive private school. Camp Bushnell was overlaid for several months on the unsold lots of Bullitt Park in 1898, centered at Drexel Circle, bringing new utilities to the area, and subsequently, more home building. By 1909, Bullitt Park and the Lutheran community of Pleasant Ridge, south of Main Street, decided to merge neighborhoods and incorporate as the village of

Bexley. Later, with growth, the village of Bexley became the city of Bexley. Bullitt's development experience in Ohio was strikingly similar to what took place in Norfolk, and to which he was also a significant participant.

The assets turned over to the Ghent Company by the Norfolk Company consisted primarily of the greater portion of undeveloped Ghent. From maps available at that time this was probably just that portion east of Colley Creek. The reasons for forming the separate company are not entirely clear. The most obvious explanation is the charter limits of the capitalization of the Norfolk Company and the limitation of landholding ability to five hundred acres. It is known that the Norfolk Company was active in other areas of the country. Other companies may have been formed in those areas, and other companies were definitely formed in the Ghent area around 1900, per the Guarantee Title Corporation Index. The Mowbray Arch to Olney Road section of Ghent had only twenty-two additional homes added to existing housing stock by the spring of 1896, and it was not until April 1899 that the Norfolk Company announced its intentions to make improvements to another large portion of its land holdings. The area that the company intended to develop was an "extension" of Ghent streets north of Olney Road to and including Redgate Avenue and west of Colonial Avenue to Colley Avenue, including Stockley Gardens. Due to the depression of the 1890s, Ghent was not an overnight

This large house at 621 Colonial Avenue, pre-1913 numbered 424, was designed by Carpenter and Peebles, a Norfolk architectural team responsible for a number Ghent's most significant homes. It was built for Charles Wesley Fentress, a prominent Norfolk businessman. Fentress was a director of the City National Bank of Norfolk and owner of C.W. Fentress and Company, wholesale dealers in butter, eggs and cheese. Born in Princess Anne County, Virginia, in 1856, a son of James and Annie Dawley Fentress, C. Wesley Fentress launched his business career at the age of sixteen, opening a retail grocery store on the corner of Church and Freemason Streets in Norfolk. He stayed at that location until 1889. This was also the year he organized his wholesale business. Fentress was so successful that Norfolk Refrigerating and Cold Storage Company was established; he was one of its founders. *Courtesy of the author.*

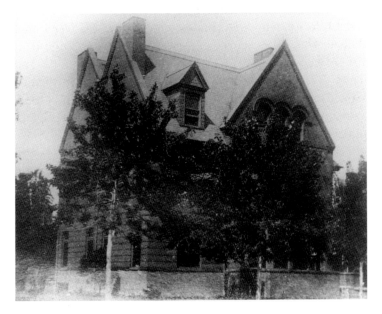

success; it would take years to achieve the success envisioned by its founders.

Development continued to center around Beechwood Place through 1896 and 1897, with only a few homes located to the north, mostly on Colonial Avenue. Several of these large homes constructed between 1896 and 1897 were the work of a locally prominent architectural firm, Carpenter and Peebles, established in 1893. J. Edwin Carpenter, who was originally from Columbia, Tennessee, received his architectural degree from Massachusetts Institute of Technology. John Kevan Peebles, the more prominent member of the firm, hailed from Petersburg, Virginia, and earned his degree from the University of Virginia. By 1896 eleven prominent residences in Ghent were attributed to Carpenter and Peebles, including the George L. Arps residence, a Georgian Revival built of red brick laid in Flemish bond at 401 Warren Crescent; the Charles J. Colonna residence at 801 Colonial Avenue (pre-1913 numbered 600 Colonial Avenue); the George P. Hudson residence at 709 Colonial Avenue; the Charles O. Wrenn home at 703 Colonial Avenue (pre-1913 this had been numbered 502 Colonial Avenue); the Charles Wesley Fentress residence at 621 Colonial Avenue (pre-1913 numbered 424); the Charles E. Verdier residence at the corner of Boissevain and Moran Avenues; the Littleton Waller Tazewell (L.W.T.) Waller residence at 524 Pembroke Avenue; the Robert Page Waller home at 551 Warren Crescent; the Samuel W. Bowman residence at 502 Fairfax Avenue; and the L. Henry Hornthal and Louis Hornthal residences at 416 and 418 Pembroke

Charles Wesley Fentress and his family were departing their home on Colonial Avenue at the corner of Boissevain Avenue for the seven-mile trip to the Jamestown Exposition grounds when this picture was taken by an unknown photographer. The car is a four-cylinder Mitchell, likely a 1906 or 1907 model. The headlights were acetylene, and the sidelights carbide lamps. His first wife, Sue Bayton, daughter of Reverend T.J. Bayton, of Portsmouth, Virginia, died at twenty-four years of age, leaving an infant child, who died soon after his mother. Fentress married again to Effie Eley, a daughter of Captain Hubert Eley, of Berkley, and they became the parents of four children, J. Hubert, Ethel Ann, Charles W. and Thomas J. Wife Effie and two of their children are shown in the car headed to the exposition. *Courtesy of the author.*

Avenue, respectively. All of these, except for the Verdier residence, are still standing. Arnold Eberhard drew the plans for the residence of McDonald L. Wrenn, president of the Citizens' Bank of Norfolk and vice-president of A. Wrenn and Sons, and Charles's brother. McDonald Wrenn resided at 517 Pembroke Avenue (pre-1913 this was numbered 233). Still other homes of this era of equal importance include the homes of S. Harry and Martha Herman at 300 Boissevain Avenue, Albert B. Schwarzkopf at 707 Stockley Gardens and Robert M. and Robert W. Hughes at 418 Colonial Avenue.

The residents of the aforementioned Carpenter and Peebles and Eberhard homes, as well as the others, were a representative cross-section of Norfolk society. Bowman, a twenty-seven-year-old lithographer, was one of the first to purchase and build on a lot in Ghent. But the young lithographer also branched into other businesses, becoming vice-president of the Quratol Company, a patent medicine manufacturer. Schwarzkopf, a self-made man, was the cashier of the Norfolk National Bank before becoming its vice-president, but importantly, he was also named president of the South Ghent Land Company. L. Henry Hornthal, president of the Columbian Peanut Company, and his wife, Louise, commissioned 416 Pembroke Avenue as their residence, and after its completion, had the residence at 418 Pembroke Avenue built for their son, Louis, secretary-treasurer of the peanut company, and his wife, Carrie. Charles O. Wrenn was president of A. Wrenn and Sons; his brother, McDonald L., was his partner. The firm of A. Wrenn and Sons, established by their father, Aurelius Wrenn, in 1852, manufactured various styles of vehicles and a full line of Wrenn's light buggies; over ten thousand of them were shipped out during the years prior to 1902. The manufacture of horse-drawn wagons, buggies, surreys

"This is where I go to school," wrote a young woman named Gladys to her friend in Providence, Rhode Island, in 1904. The divided back, hand-colored postcard was published by Louis Kaufman and Sons of Baltimore, Maryland, as series number A23360. The school was the Leache-Wood Seminary, which had moved from its location at 138 Granby Street (with a large addition fronting Freemason Street) to 407 Fairfax Avenue at Mowbray Arch in September 1900. The Leache-Wood Seminary remained at this site until it closed for good in 1917. The school, founded in 1871 by two remarkable women, Irene Leache and Annie Cogswell Wood, was sold to Agnes Douglas West in 1898, two years before the move to Ghent. *Courtesy of the author.*

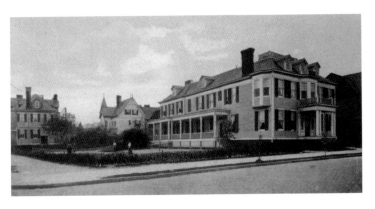

81

T. Marshall Bellamy is shown in his office in 1904. *Courtesy of the Sargeant Memorial Room, Norfolk Public Library.*

and the like was continued until 1922, when the automobile supplanted the horse. But Wrenn adapted, manufacturing automobile truck bodies, repairing and painting vehicles, while jobbing Baker Trailers, B.K. Brake Equipment and other automobile equipment. Littleton Waller Tazewell Waller was a major in the United States Marine Corps when he lived at the house on Pembroke Avenue. Born on September 26, 1856, L.W.T. Waller was appointed a second lieutenant in the corps on June 24, 1880, with initial successive tours of duty at Marine Barracks Norfolk, and Washington, D.C. He also had later shore duty in Norfolk. During the Spanish-American War Waller was aboard the battleship USS *Indiana* at the battle of Santiago, and he played a significant role in America's colonial expansion into the early twentieth century, including the Boxer Rebellion and President Theodore Roosevelt's campaign in the Philippines. Lionized for his role in crushing the Philippine Moros, he advanced to major general; he died in Philadelphia on July 13, 1926. Members of the Waller and Tazewell families have lived in this house for most of its history. The Charles E. Verdier home, while no longer standing, was largely occupied by Verdier's wife, Sadie M., as he died shortly after moving into the house in 1897, the year it was completed; his provisioning company was run by Edmund R. Elliott and Samuel T. Dickinson Jr. from 1898 until the company's name was changed. Dickinson, too, lived in Ghent.

With the creation of the Ghent Company in 1896, the pace of development quickened, though it still remained largely east of Colley Creek until after 1900, when the creek bed was filled and Stockley Gardens was developed. One

Miss Caperton Preston's dancing class of smiling little girls took their lessons at Saint George's School, located at 413 Boissevain Avenue, which prior to 1913 was numbered 311–313. The picture was taken in 1909. About ten years later Miss Caperton had opened Preston School of Dancing at 1111 Colley Avenue, where she also lived. *Courtesy of the author.*

of the more prominent homes, that of Frank S. Royster at 303 Colonial Avenue, was built during this phase in 1900, according to plans drawn by Peebles and filed with the city of Norfolk as building permit number 1369, dated March 12 of that year. Adding to the activity of the Ghent Company at this time was construction to the east on what was formerly known as the Ribble farm. The property had been tied up in an inheritance suit until 1896. Development took place immediately by a gentleman named J.W. Keeling. Most of the construction that took place on the Ribble parcel was the work of W.W. Webster. The development of this tract was in keeping with the development in Ghent, but also with the less grand development to the east and north. Structures built in what was called East Ghent were smaller and almost all were row-type houses. Most of this area was built over a period of five years.

By 1905 the Ghent Company had become the surviving company in the Ghent area. This was about the time of the development of the last part of the original 1890 plat. The Norfolk Company, thus, after 1896, probably acted largely as a landholding and speculation corporation, while its subsidiary or subsidiaries undertook the actual development if land was not sold to someone else.

The cornerstone of Christ Church (later Christ and Saint Luke's Episcopal Church) was laid on October 28, 1909, with religious ceremonies led by the Right Reverend Alfred M. Randolph, bishop of the Diocese of Southern Virginia, with secular rights conducted by Norfolk Masonic Lodge Number 1. The first service in the new Christ Church took place on Christmas Day, 1910. This was the third church building occupied by this Episcopalian congregation. The first Christ Church was built in 1800 on Church Street, now Saint Paul's Boulevard, across the street from the 1739 Borough Church. When the church burned to the ground in 1827, a new church was erected at the corner of Freemason and Cumberland Streets, and it was the building from which the congregation moved when the third Christ Church, located at the corner of Olney Road and Stockley Gardens, was completed in 1910. The designation of Christ and Saint Luke's Church came in 1935, when the congregation of Saint Luke's Episcopal Church, located in Ghent, joined with Christ Church. P.M. Taylor was the photographer. *Courtesy of the Sargeant Memorial Room, Norfolk Public Library.*

This pre-1910 view of Lee Park shows the three bridges to Ghent in the background, including the Botetourt Street Bridge, a streetcar trestle and a footbridge that connected Yarmouth Street with Fairfax Avenue. *Courtesy of the author.*

Despite the march of time, Beechwood Place remained the benchmark of exclusivity. As Colonial Avenue travels south from Olney Road, it bisects two arcs, Warren Crescent and Mowbray Arch, terminating at The Hague. The center point from which the semicircles were derived is Beechwood Place's garden square. In the early years of Ghent's establishment and for many years to come, it was not unusual to find little boys in their knickers and girls in play dresses chasing hoops and playing ball around this square. But Beechwood Place also served another purpose. The homes along Colonial Avenue were the oldest and the most exclusive in the neighborhood, but not all were of equal value. Homes decreased in value as their distance from Beechwood Place—the heart of Ghent—increased.

By 1904 architect Arnold Eberhard, who had drawn the plans for the McDonald L. Wrenn home on Pembroke Avenue, suggested the construction of a seawall along Mowbray Arch, which up to that time had been little more than a rugged shoreline of marshes extending inland on both ends. In making his recommendation, however, Eberhard further warned the public about the dangers of lowering building standards. He strongly argued a return to buildings erected at a respectable cost, thus preserving what he called the qualities of comfort, utility and artistic conception that the first builders intended. His words were not heeded. In later years, large portions of North and East Ghent had deteriorated so badly that affected sections were razed as slums, the structural integrity of the homes of far less quality than Ghent's earliest buildings.

Of Ghent's architects, many of whom were renowned for their work nationally, the most famous among them was

The Borough Club at the foot of the Botetourt Street (or Ghent) Bridge was a stylish place for residents of Ghent to socialize. Opened in 1913 at 630 Botetourt, the Borough Club was managed by Matthew D. Morley, who had been a steward at the Virginia Club. This postcard was published about the year the club opened. *Courtesy of the author.*

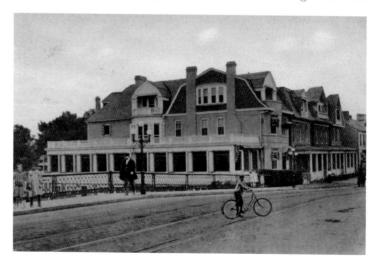

Peebles, who became senior partner in the firm of Ferguson and Peebles, located at 150 Duke Street. Peebles began practicing architecture in Norfolk in 1892, continuing until his death in 1934. While he practiced throughout Virginia and in many Southern states, serving on the restoration committee for the Virginia State Capitol in Richmond from 1902 to 1903 and as chairman of the architectural review board responsible for designing buildings at the Jamestown Exposition of 1907, he left a wide swath of buildings to his credit in Norfolk. Ohef Sholom Temple, the Ghent United Methodist Church and the Frank S. Royster residence are just a few examples of his work in Ghent.

Finley Forbes Ferguson, Peebles's one-time partner, studied architecture at the Massachusetts Institute of Technology and had designed the old Phi Beta Kappa Hall in Williamsburg, Virginia. In 1902 Ferguson assisted Peebles in the building of the Ghent United Methodist Church and, in 1917, joined Peebles's firm.

Nearly all of the homes abutting Beechwood Place were built between 1892 and 1900. Each is placed at a different angle to catch the light at different times of the day. The exteriors of these suburban homes were never white nor were they to flaunt brightly painted red brick. The homes were to be uniformly "mellow softened shades of color, in exquisite keeping with the surrounding objects," according to James Early in his *Romanticism and American Architecture*, published in 1965. Early also wrote that in 1842 Andrew Jackson Downing had said, "the practical rule should be to avoid all those colors which nature avoids." Building materials most favored at the time Ghent was being built utilized nature's pallet—the warm tones of granite, brownstone, slate, oak and straw were employed for better shadows. As a result, the materials used in Ghent used yellow brick, stones of several varieties and cedar shake.

Graham's home was no exception to the coloration and material rules pervasive in Ghent. The position of his house gave Graham a good view down the street that he had laid out only two years before, in 1890, which led directly to the water. This yellow brick Colonial-style home has a very simple exterior and follows basic hall-parlor-passage plans of that period. With three stories and a basement, Graham's home, like most in Ghent, is set on a base of stone that is repeated in the lintels and sills of the windows. The French mansard

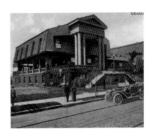

The Borough Club was not the only establishment in Ghent. The Ghent Club, at 600 Olney Road across Smith's Creek from Mowbray Arch, was on the trolley line but also remained accessible to the city's first automobiles. When the Ohef Sholom Temple was destroyed by fire on February 12, 1916, all churches graciously offered facilities, but services were conducted at the Ghent Club. This Louis Kaufmann and Sons postcard was mailed on March 12, 1913. *Courtesy of the author.*

roof, over time, lost its balustrade. The mansard roof, chosen because it permits more headroom on the top floor, came over as a revival of the Second Empire style but was losing its popularity after the 1870s.

The William H. White residence (also known as the Henry Kirn residence) on the adjacent corner—434 Pembroke Avenue—contrasted with Graham's in its massiveness. Built of reddish stone, the White house is typically Victorian in its eclecticism, but is clearly Romanesque with a tower and arched entranceway. There was also Dutch influence in its gambrel roofs of original red shingles. The red shingles were carried over to the top of the tower.

Across from John Graham's home stands Fergus Reid's residence at 507 Pembroke Avenue on Beechwood Place, which stayed in Reid's family for a number of years, including the ownership by his daughter, Baroness Helen de Lustrac, wife of Baron Jean de Lustrac, a French army officer at the time of their marriage on November 24, 1925. The Reids and de Lustracs had given Norfolk a taste of European aristocracy in the familiar face of a bride most had known since childhood and who would continue to captivate Norfolkians' attention for decades to come. The de Lustracs held two religious ceremonies, one Roman Catholic in accordance with the baron's faith and the other an Episcopalian service to satisfy Helen's religious upbringing; both ceremonies garnered much attention in the local press. The de Lustracs lived overseas most of their married life, though they came back to Norfolk frequently to visit Helen's parents, each visit covered with some fanfare by the Norfolk newspapers. The de Lustracs had a daughter, Princess Anne de Lustrac of Bavaria, born on September 27, 1927. Princess Anne was

The second building used as Norfolk High School, located on Omohundro Avenue, returned to serving as an elementary school when Matthew Fontaine Maury High School opened in March 1911. This pre-1910 image of the Omohundro School shows it in use as a high school. In April 1912 Supervisor J. Paul Spence suggested the naming of Norfolk public schools for notable persons, and that November the school board ordered elementary buildings named according to Spence's recommendations. Omohundro School became the John Marshall School, for the nation's first chief justice of the Supreme Court. *Courtesy of the author.*

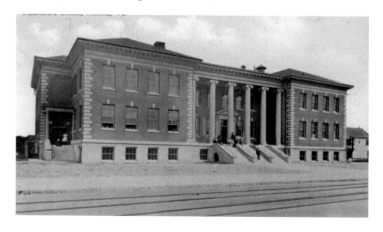

killed in car accident in Milan, Italy, on August 16, 1999. The princess had been a widow for over forty years at the time of her death. Her husband, Prince Heinrich, was killed a year after their marriage, ironically in a 1958 car crash in Argentina. Despite living among Europe's royalty, Princess de Lustrac never forgot her mother's roots in Norfolk—and her grandparents' home on Beechwood Place. The Reid house, built of rough-hewn marble and brown shingles characteristic of the work of great American architect Henry Hobson Richardson, also recalled Richardson's style in its use of round arches, squat columns, tower and overall sense of solidity and simplicity.

The Dutch Colonial house next door, also belonging to the Reids and which was originally built for Fergus's sister, exemplifies the shingle-style homes of the 1870s and 1880s. The home was built with stained red shingles over red brick with crème-colored trim. Sitting imposingly next door to the Dutch Colonial at 317 Colonial Avenue, Frank S. Royster commissioned his home, the work of John Kevan Peebles, in 1900. This yellow-brick palatial mansion is French style of the Second Empire. Continuing to the end of Colonial Avenue to Mowbray Arch, at number 442, is the aforementioned Horace Hardy residence (and sometimes the Hardy-Twohy home), finished in 1892. The yellow brick and stone home has lost the cupola, but retains many of its finer qualities, including thirteen-inch-thick walls. Next to the Horace Hardy residence is 436 Mowbray Arch, a picturesque English Tudor

This white border Louis Kaufmann and Sons postcard of Graydon Park, mailed on October 31, 1917, shows the expansive park-like median dividing traffic along the street. *Courtesy of the author.*

The home of C. Moran Barry, located at 542 Mowbray Arch at the corner of Mill Street, is pictured about 1915 in this Harry C. Mann photograph. Barry was president of O'Neill-Barry Company; Barry, Parks and Roper, Inc.; vice-president of Mutual Savings and Loan Company, Inc.; and treasurer of Universal Savings Corporation. Barry, Parks and Roper, successors to Commonwealth Insurance and Realty Company, were involved in real estate, rental property, insurance loans and investments, with offices in the Bank of Commerce Building at 300 East Main Street. *Courtesy of the Sargeant Memorial Room, Norfolk Public Library.*

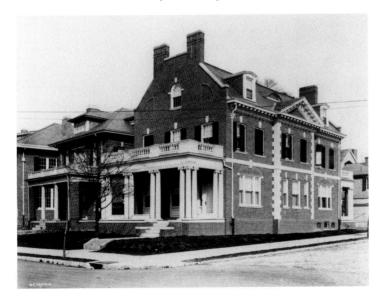

The Gothic-style First Presbyterian Church of Norfolk on Colonial Avenue at Redgate Avenue is shown as it appeared about 1920. Originally Ghent Presbyterian Church, the *Norfolk Ledger* reported that the edifice seen in this photograph was formally dedicated on February 18, 1911, with the Reverend Stuart Nye Hutchinson, pastor, overseeing the services. Ghent Presbyterian Church had been the outcome of a movement set in motion in 1901 by the Brotherhood Bible Class at First Presbyterian Church, then under the leadership of Joseph Brown, who founded the class in 1899. Members of this class selected the site upon which the church now stands and raised the first money toward purchase of the lots. The first building on this site was determined to be too small with

with a romantic origin that only adds to its overall charm and whimsical design. The Tait family, part of who were then living up on Colonial Avenue, purportedly had a daughter who was sent to boarding school in England. While there, she met a young architect who fell in love with her and wanted desperately to marry her. The Tait girl, alas, had other plans. Returning to Norfolk she married an old beau, but as a wedding gift, the rejected architect sent the blueprints of the house that would become number 436 Mowbray Arch, which he had designed. He thus facetiously, as it were, offered his

the growth of the Ghent section, and thus it was necessary to build a larger edifice. At a congregational meeting held May 1, 1910, $50,000 was raised for new construction, half of it from Frank S. Royster. Ground was broken that December and the cornerstone laid by Mrs. George Dodd Armstrong on March 15, 1911. First and Ghent Presbyterian Churches voted to come together on March 17, 1912, with Reverend Hutchinson chosen pastor for the enjoined congregations; the first service of the united congregations was held that April 7.
Courtesy of the Sargeant Memorial Room, Norfolk Public Library.

heartfelt feelings for her by designing a wonderful house in which all aspects of it are mismatched and asymmetrical.

The house at 436 Mowbray Arch was finished in 1900 for William L. Tait exactly according to the blueprints rendered by the unknown English architect. Unfortunately, those plans were lost, reportedly when William L. Tait moved his family back to England. Looking at the exterior of 436 Mowbray Arch, every window is different and arranged in folk tradition without concern for symmetry. Another Tudor feature of the house is the alternating pattern of plan and fish-scale shingles over the side porch. As further example of this house's purposeful lack of symmetry, within the home, every wall of the library is a different width, the Italian marble tile and wood fireplace is not centered in its room and the bookcases as well as their panes all vary in size. On the glass over the bookcases, as part of the original design, there were painted the crests of Oxford and Cambridge, additional reminders of the architect. Behind the library he had designed a living room separated by heavy sliding doors—cherry on one side and maple on the other. The windows of the living room originally overlooked a garden of azaleas, the first ones brought to Norfolk. The architect put great detail into his plan for the house, using maple paneling below the chair rail in the dining room and lighted by Louis Comfort Tiffany shaded sconces. All five upstairs bedrooms had French parquet floors installed. By 1913 this wonderfully eclectic home was occupied by William B. Rodman, general

Firemen of Fire Station Number 3, then located in Norfolk's Atlantic City section on West Fairfax Avenue near Colley Avenue, pulled out their equipment for photographer Harry C. Mann to take their picture in 1912. The steam engine to the far left is engraved with Thomas Kevill's name. The fire department was incorporated as part of city government in 1871, making it possible for firemen to be compensated for their valuable services. The department's first fire chief after incorporation was Thomas Kevill, a personage already famous in Norfolk and vicinity as a volunteer gunner aboard the Confederate ironclad CSS *Virginia* when she engaged the Union fleet in Hampton Roads on March 8–9, 1862, and specifically, the Federal ironclad USS *Monitor* on the second day of the battle. Kevill, a member of the United Fire Company at the start of the Civil War, was joined by several firemen from his unit, each of whom served alongside Kevill manning the guns of the *Virginia*. Courtesy of the author.

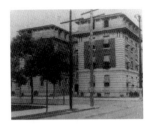

The Vendome Apartments were located at 411 Olney Road at the corner of Colonial Avenue. This picture, by an unknown photographer, was taken about 1914. The Vendome was torn down for new development. *Courtesy of the Sargeant Memorial Room, Norfolk Public Library.*

solicitor of the Norfolk Southern Railroad Company and John L. Roper Lumber Company.

But not all of Ghent's development during this period was its palatial homes. Two hospitals and the arrival of Leache-Wood Seminary were also important additions to the neighborhood, the seminary in particular because of what its progenitors, alumnae and friends would do to breathe life into the city's art community. Sarah Leigh Hospital was built in the Beaux Arts style in 1902 on Mowbray Arch; it opened the following year. The construction of the thirty-five-bed private hospital, Dr. Southgate Leigh's tribute to his aunt, was a sign of Ghent's importance—and its prosperity—that such a facility would be built within its boundaries. A fourth story and two wings were eventually added to the building. When built, the hospital was considered innovative with one operating room, a state-of-the-art design, including rounded corners for easy cleaning, a basement-based air-cooling system, fire protection and sound control features. When Dr. Leigh died in 1936, the hospital was reorganized as a nonprofit and renamed Leigh Memorial Hospital; thirty-six years later, Norfolk General Hospital and Leigh Memorial Hospital merged to form Medical Center Hospitals. By combining resources, the two facilities were able to broaden the scope of health care services provided to the Hampton Roads community.

The Norfolk Retreat for the Sick, established on May 6, 1888, and originally located between Holt, Reilly, Mariner and Walke Streets, opened with John L. Roper as its first president. The

Pembroke Avenue once extended further east. The homes in the immediate foreground of this picture were razed long ago but were among some of Norfolk's largest and most elegant residences. The photograph, depicting the corner of Pembroke Avenue and Mowbray Arch, was taken in 1915. *Courtesy of the author.*

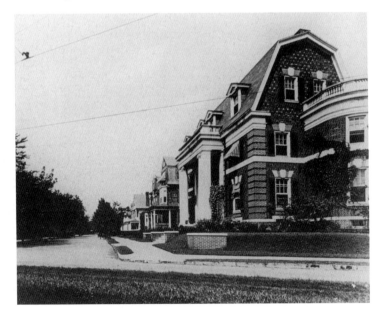

hospital's annual report dated May 8, 1894, indicated that the facility had served 317 patients. From this time, steady growth was evidenced with each year to follow. By 1896 the Holt Street hospital had proved inadequate and it was felt inadvisable to rebuild at that location. The property, originally purchased for $8,500, was sold for $23,500 and new property was obtained along The Hague, land owned by J.P. Andre Mottu, for which the hospital board paid $13,500 and set its remaining funds aside for construction. In the years that followed the land buy, the hospital's lady managers carried out the hard work of getting a new health care facility operational. In 1898 the name changed to Norfolk Protestant Hospital, and two years later, in 1900, Roper resigned as president of the board and George L. Arps was elected in his place.

By 1900 the hospital's board and lady managers realized new buildings would have to be built for the growing number of patients, but this required an additional $10,000 to fill in the land to provide space for the erection of necessary buildings. An offer to exchange that property for a more suitable site was made, with the additional sum of $3,500 proffered for the land that became the home of the more familiar Norfolk Protestant Hospital, the footprint of which became the anchor

Pembroke Avenue, looking west from The Hague, about 1915, provides greater perspective of the breadth of the street. Sarah Leigh Hospital is on the far left. *Courtesy of the author.*

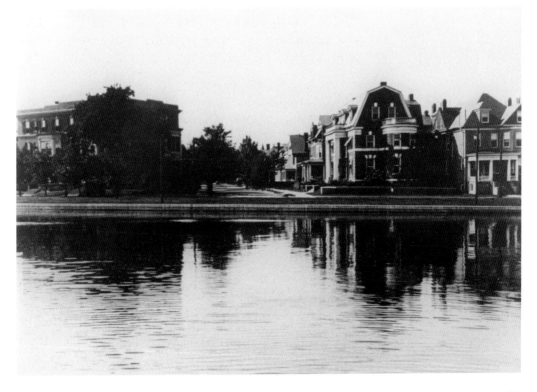

The interior of 518 Pembroke Avenue, formerly the home of Walter H. Doyle, had become the residence of Cecil E. Billups, of C. Billups Son and Company, by the time Harry C. Mann took this picture about 1915. C. Billups Son and Company, originally Cealy and Cecil E. Billups, was a purveyor of agricultural implements. *Courtesy of the Sargeant Memorial Room, Norfolk Public Library.*

of the present-day Sentara Norfolk General Hospital and Children's Hospital of the King's Daughters. The property now encompassing these latter hospitals—Norfolk General and King's Daughters—was originally forty-two lots, nineteen of which were high ground—good land—and in better shape for development. The cornerstone of the Norfolk Protestant Hospital was not laid until November 26, 1902, as it had been determined by the facility's board of directors that building would not begin until $40,000 was banked. The money was raised among approximately five hundred people, though among them were one or two very large contributors—Ghent residents Fergus Reid and George L. Arps. For Arps his contribution to the new, then-state-of-the-art health care facility was personal. Arps's wife, Annie Vaughn, had died in 1880 at thirty-three years of age, leaving him to raise the couple's only child and son, Frederick.

Norfolk Protestant Hospital opened on March 26, 1903, on land officially bounded by Colley, Raleigh and Boissevain Avenues. The new hospital had twenty-three private rooms

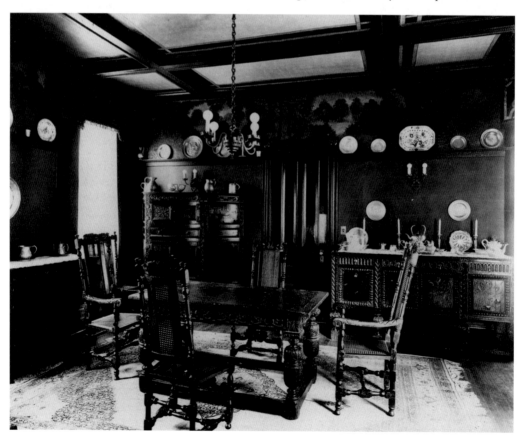

and accommodations for fifty ward patients. Management of the hospital was taken over by the board of directors and an executive committee, which consisted of seven ladies, elected to assist the director with purchasing, supplies and supervision of the internal management of the hospital. A medical advisory board was also formed, made up of three doctors, elected to advise the directors in medical matters. The first organizations to form in support of Norfolk's newest and most advanced hospital were the Hospital Aid Society, Ladies' Auxiliary and Juvenile Aid Society, described years later as "little girls who had grown to be young women and who furnished the children's ward." Due largely to his failing health, George Arps resigned as president of the board in 1904. He was succeeded by John B. Jenkins, who served one year, until 1905. For the next few years, hospital business was controlled by the hospital's vice-president, Samuel T. Dickinson Jr.,

Henry Kirn (pictured here about 1900) was one of Norfolk's best-known citizens and businessmen, and while associated with various businesses and financial institutions, Kirn had his greatest success in truck farming. He was born in Württemberg, Germany, on December 1, 1844, where he was educated and served an apprenticeship of three years in the blacksmith trade. At the age of seventeen Henry Kirn came to the United States, landing in New York City and eventually Philadelphia. Kirn met Richard Cox, from Norfolk County, Virginia, from whom he learned the truck farming trade. Kirn became one of the largest farmers in Virginia, running Southern Produce Company, but was also a director of the Norfolk National Bank, the Norfolk Bank for Savings and Trust, Norfolk Marine Bank and the Merchants' and Farmers' Bank of Portsmouth. *Courtesy of the author.*

whose father was one of Virginia's most prominent physicians and surgeons in Caroline County, Virginia, where young Dickinson was born. Raised with an abiding respect for such a hospital and its potential impact on the health and well-being of the community, Dickinson moved Norfolk Protestant Hospital forward to meet the challenges of Norfolk's growing population. During that time, in 1905, the ladies' executive committee sponsored its first Spielgartenfest—an event put on by a large number of Norfolk's young people to raise money for the hospital.

While the Leache-Wood Seminary at 407 Fairfax Avenue had moved to Ghent to continue the education of young women in 1900, by 1917 its doors had closed to that purpose. But in its wake came important advances to an endeavor that had been—at least in large measure—the vision of the school's founders, Irene Leache and Annie Cogswell Wood, to bring an art museum to Norfolk. That endeavor had been taken up originally under the name Irene Leache Alumnae Association in 1905, which changed its name in 1917 to the Irene Leache Art Association, eventually becoming simply the Irene Leache Memorial and the Norfolk Society of Arts,

In 1915 Henry Kirn resided at this home, situated at 434 Pembroke Avenue, also known as the William H. White residence. Kirn was the president of Southern Produce Company and treasurer of American Fertilizing Company. Kirn had married in 1856 in Philadelphia to Elizabeth Smith, who was born in Nuremburg, Bavaria, on May 8, 1838. They had Anna, who married M.W. Armistead; Henry Jr.; Rufus; Clara; Bessie; and two boys, both named Charles, who died. Prior to 1913, the home was numbered 304 Pembroke Avenue. *Courtesy of the Sargeant Memorial Room, Norfolk Public Library.*

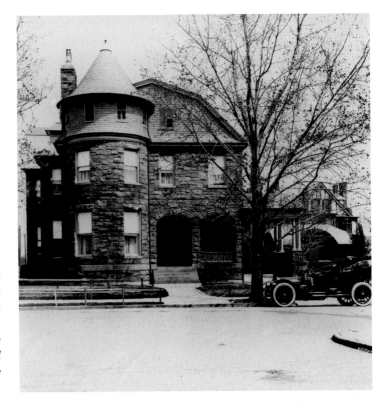

the latter permitting members other than the women of the Leache-Wood Alumnae Association to join, thus increasing the Society's financial and political influence. Under any name, the purpose of the erstwhile women who formed this effort remained the same, their drive to provide culture to the city unwavering. Enter Florence Knapp Sloane, wife of knitting mill magnate William Sloane, who had come to Norfolk with her husband to make their home in 1895, and who saw for the city not only a place to hang paintings and display sculpture, but also a first-class art museum.

Until the spring of 1917, the association's art was being kept in the Van Wyck Library, hardly the preferable— or safest—location for the group's increasingly valuable collections, and in private homes. The Norfolk Society of Arts formed a committee that lobbied Norfolk community leaders for a permanent home for the collection, formally maintained under the auspices of the Irene Leache Library. Florence Sloane offered the society a parcel of land she and William Sloane owned on Mowbray Arch at Fairfax Avenue that March as temporary quarters and it was accepted. Florence Sloane financed the construction of

Down the block from Kirn's residence was the home of Edward R. Baird, shown here, at 544 Pembroke Avenue. Baird, a prominent attorney, was a principal of Baird, Swink and Moreland. His partners were Gilbert Swink and W. Haywood Moreland. The picture was taken by Harry C. Mann. *Courtesy of the Sargeant Memorial Room, Norfolk Public Library.*

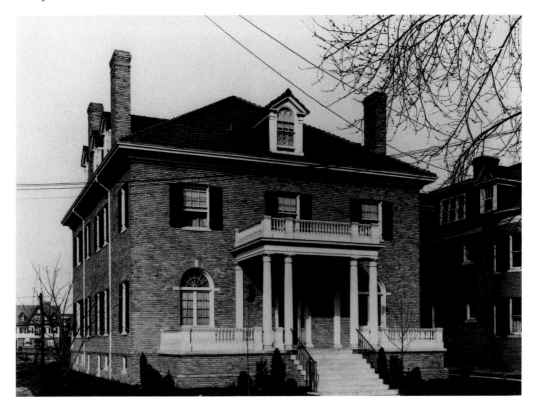

The home of Richard D. Cooke, located at 517 Warren Crescent, is pictured here about 1915 in this Harry C. Mann photograph. Richard Cooke was a partner in the law firm of Willcox, Cooke and Willcox, which also included Westmore J. Willcox and Thomas H. Willcox Jr. Westmore Willcox was Cooke's neighbor at 516 Warren Crescent. *Courtesy of the Sargeant Memorial Room, Norfolk Public Library.*

the building herself, with two stipulations, one being that it be used during World War I to entertain servicemen with dances, teas and open house every night, members of the society acting as hostesses, and the second that the arrangement was for six years. In 1919, the war over, the building reverted from the United Service Club to a gallery for the Norfolk Society of Arts, gaining a new identity—the Society of Arts Building.

The Norfolk Common Council had agreed on October 2, 1917, to set aside reclaimed land in the vicinity of Lee Park and west of Duke Street for the future Norfolk Museum of Arts and Sciences. Completion of the museum would not happen quickly. In October 1918, World War I winding to a close, the Norfolk Society of Arts conducted its first meeting in the building Florence Sloane had built for them, and where much of Norfolk's cultural life would continue to be nurtured with exhibits and lectures and poetry readings reminiscent of those held a century earlier to the heart-pounding rhythm of a spine-tingling poem by Edgar Allan Poe or the joyful experiment of language in Walt Whitman's

verse. Two years after the war, the Norfolk Society of Arts appointed a music committee, which sponsored many concerts, some given by artists from Norfolk while others came from New York, Washington, D.C., Baltimore and throughout the South. The society also promulgated a dramatic club that in 1927, after presenting a number of plays with great success, developed into the Little Theater of Norfolk.

Thomas J. Wertenbaker wrote in 1931 that while the Norfolk Society of Arts had made significant strides in expanding art offerings in the city, it had in the meantime renewed efforts to find a permanent home to replace the temporary quarters on Mowbray Arch. To move the situation along, Florence Sloane made pointed inquiries with the Norfolk City Council, reminding the council of the ordinance of 1917 authorizing the museum in Lee Park. The council affirmed this grant and fixed on a particularly desirable location facing The Hague. With affirmation from the city council, the society began a building fund. In July 1924 the city agreed to appropriate $12,500 a year for the

"The Norfolk Museum of Arts and Sciences opened to the public on March 5, 1933, amid the financial turmoil of the Great Depression and Adolph Hitler's rise to power in Germany."

J. Iredell Jenkins, whose home at 528 Warren Crescent is shown in this circa 1915 Harry C. Mann photograph, was president and treasurer of Jenkins Paint and Oil Company. *Courtesy of the Sargeant Memorial Room, Norfolk Public Library.*

Samuel T. Dickinson Jr., who lived at 714 Boissevain Avenue and is shown here about 1900, founded S.T. Dickinson and Company, provision brokers, located at number 170 Water Street, on Norfolk's expansive commercial waterfront, in 1897. His company succeeded C.E. Verdier and Company. As a young man, Dickinson spent six years in the railroad business, working first for the Pennsylvania Railroad and later on the Louisville and Nashville Railroad, going to work for the latter in order to accept a better position with the Panama Railroad Company in South America. He became an officer of the Panama Railroad, but returned home to Virginia, establishing his provisioning business. He married Ruth Owens, daughter of B.H. and Missouri Owens, on October 25, 1897. B.H. Owens was a very prominent businessman in Portsmouth, Virginia. Dickinson, vice-president of the Norfolk Protestant Hospital, largely ran the facility for several years at the beginning of the twentieth century. *Courtesy of the author.*

maintenance and operation of the yet unnamed museum if the society provided a building costing not less than $125,000. The title of the building was to be vested in the city, but custody would remain with the society.

By 1926, the society's board of trustees appointed Florence Sloane head of the committee to raise money for the museum, which had been and would remain a slow, iterative process. Florence Sloane remained undaunted. Wertenbaker reported that some months later, when it became known that twenty-three persons, largely couples, had subscribed $104,500, her faith in people wanting an art museum in their community badly enough to fund it had come true. The large donors' names would ring familiar—Fergus Reid; William and Florence Sloane; the three Grandy brothers, Cyrus Wiley Grandy III, William Boswell Selden Grandy, Dr. Charles Rollin Grandy; and Caroline Selden Grandy, daughter of Cyrus Wiley Grandy III, who subsequently married Stockton Heth Tyler. Subscriptions in hand, in June 1926 the Society of Arts officially named the new museum the Norfolk Museum of Arts and Sciences. With almost all of the money needed to go to construction on the museum raised by May 1928, Florence Sloane sold the Society of Arts Building, but it would be another five years before the Norfolk Museum would come into existence. The most serious setback came with the stock market crash in 1929, which made it difficult, and in some cases impossible,

The foundation of the Norfolk Museum of Arts and Sciences (later renamed The Chrysler Museum of Art) was being laid when this photograph was taken on August 16, 1930. *Courtesy of the Sargeant Memorial Room, Norfolk Public Library.*

Raleigh Avenue, north of Olney Road, is shown here as it appeared about 1915 on this white border Louis Kaufmann and Sons postcard. *Courtesy of the author.*

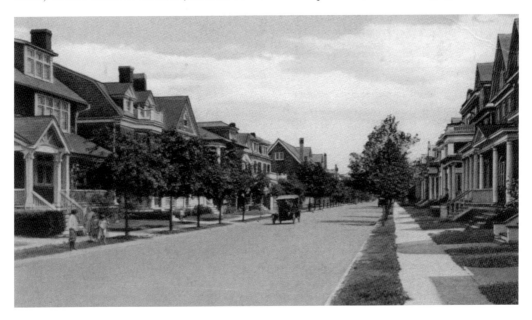

The Norfolk Museum of Arts and Sciences is shown here, in this Charles S. Borjes photograph, on June 30, 1939; the museum had been open just a little over seven years and already attendance was in the tens of thousands per year. Admission was free—a stipulation of the Norfolk Society of Arts when it opened in 1933. *Courtesy of the Sargeant Memorial Room, Norfolk Public Library.*

for subscribers to fulfill their pledges. Construction halted occasionally when cash ran out, and Florence Sloane had to get out and solicit additional money to continue the society's work in progress.

The Norfolk Museum of Arts and Sciences opened to the public on March 5, 1933, amid the financial turmoil of the Great Depression and Adolph Hitler's rise to power in Germany. The original plans for the museum called for a multi-wing structure in the Florentine Renaissance style, of tooled stone, concrete and steel, but funding constraints had limited the building to a single display area. Despite its initial size—and this museum would decades later grow into its founders' vision as a world-class facility—the Norfolk Museum of Arts and Sciences drew annual attendance of over forty thousand. To complete the building to its original plan, the society proposed that the city apply to the federal Public Works Administration (PWA) for a grant, to be matched by city funds, but this initially met with strong political opposition. Thomas Wertenbaker wrote, "After

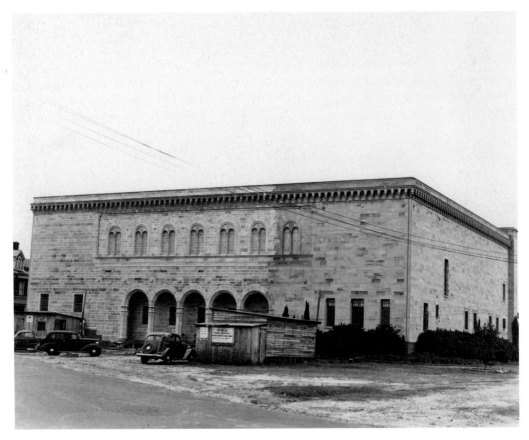

three years of uncertainty and the election of a new council, the friends of the museum won." The federal grant was accepted and matched by a loan, and work proceeded on the museum's second wing in 1938 to accommodate the requirements of the Irene Leache Memorial. The new wing opened on October 1, 1939, with fifteen galleries, a library, auditorium and statuary hall, and the Irene Leache Memorial moved into its new home. The museum board further elicited unemployed men with funds granted by yet another New Deal program, the Reconstruction Finance Corporation (RFC), to landscape the grounds. Completion of the museum's second wing fulfilled the original promise of the Irene Leache Library nearly four decades earlier to find a permanent place to display the collection that had continued to grow significantly from the first pieces bought by Irene Leache and Annie Wood.

H.D. Vollmer photographed an art class at the Norfolk Museum of Arts and Sciences on July 20, 1937. *Courtesy of the Sargeant Memorial Room, Norfolk Public Library.*

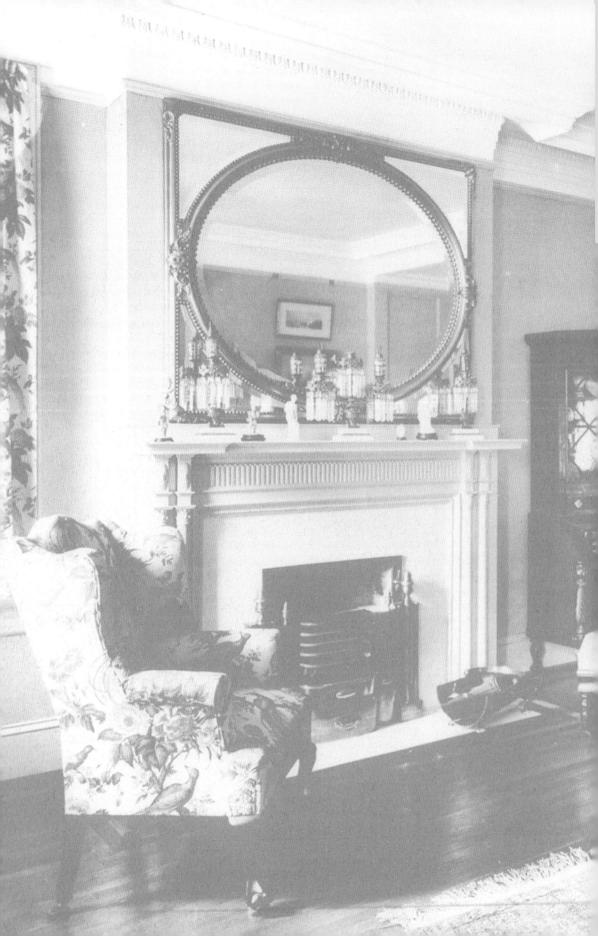

Chapter Four

GOING NORTH OF OLNEY ROAD

The 600 block of Stockley Gardens, shown here circa 1905, was part of the turn-of-the-century photographic essay _Art Work: Norfolk, Virginia, and Vicinity._ Confederate General Robert E. Lee's former adjutant, Colonel Walter Herron Taylor, constructed homes for himself and his family on this block, juxtaposed between Olney Road and Boissevain Avenue along the west side of the gardens. The gardens, also designed by Walter Herron Taylor, were newly planted when this picture was taken. _Courtesy of the author._

North Ghent was historically part of the original 220-acre tract of land subdivided by the Norfolk Company and developed as Norfolk's first planned suburb. Development of North Ghent occurred during the area's second phase of growth, which actually began in 1899 and continued well into the 1920s. Subsequent development occurred in the western section of the suburb, now known as West Ghent, primarily after 1920, but with some homes of earlier vintage.

While the first phase of development, from 1892 to 1900, took place largely in the highly desirable Mowbray Arch and southern section of Ghent, plans for encouraging the development of those areas outside of Mowbray Arch were formally underway. Following the economic panic of 1893 the Norfolk Company officially announced that it would begin construction of another large section of the Ghent subdivision in 1899. In April of that year, the company wrote: "The area now being improved is an extension of the Ghent

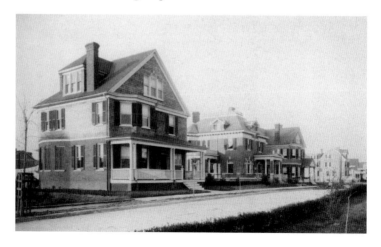

streets north of Olney Road to and including Redgate Avenue and west of Colonial Avenue to Colley Avenue, including Stockley Gardens." These boundaries directly followed the lines of what would later become the Ghent Historic District on three of its four sides. The northern boundary of West Princess Anne Road was in the original boundaries of the subdivision.

Once laid out, Stockley Gardens was complemented on either side by residences and religious structures. Several of the townhouses on the west side of Stockley Gardens were designed and built by Stockley Gardens architect Walter Herron Taylor for his family. The east side of Stockley Gardens includes some residential buildings, but more notably, its impressive religious structures. The Ghent United Methodist Church, located on Stockley Gardens at Raleigh Avenue, was built in 1902. The

The number of apartment buildings in the North Ghent area is best appreciated in some of the early postcard images promulgated to promote them to potential renters. Louis Kaufmann and Sons printed the postcard shown here, also about 1915, of Westover Avenue looking west. *Courtesy of the author.*

Ghent apartment houses such as those on Colonial Avenue looking from Westover Avenue were all the rage in the 1910s and 1920s. This Louis Kaufmann and Sons postcard was published about 1915. *Courtesy of the author.*

church is patterned after Sir Christopher Wren's Saint Martin's-in-the-Fields and was designed by Norfolk architect John Kevan Peebles. The large Gothic Revival church at Olney Road and Stockley Gardens, Christ and Saint Luke's Episcopal, was built in 1909 to the designs of the Philadelphia architectural firm of Watson and Hickol and assisted by the Norfolk firm of Ferguson and Calrow. The Ohef Sholom Temple, also on Stockley Gardens and designed by Peebles, was built somewhat later, in 1917.

Almost the entire area between Colonial Avenue and Colley Avenue north of Olney Road and including Stockley Gardens was built upon by 1910. According to a 1910 Sanborn map, few lots remained undeveloped on the streets south of Redgate Avenue, while north of it was described as increasingly sparse. Redgate Avenue was almost fully development while Westover Avenue, one street north, consisted of half-built and half-vacant lots, and Graydon Avenue, one street over from Westover, included scattered residential development. No development was located on West Princess Anne Road, then called Armistead Bridge Road, which formed the northern edge of the second phase of Ghent development.

When a fire gutted the first Norfolk High School, also called the Hemenway School, at the corner of Lovitt and Park Avenues in Brambleton, on September 14, 1908, classes were

Greenway Court was lined with attractive apartment houses at the time this Louis Kaufman and Sons postcard was published about 1915. *Courtesy of the author.*

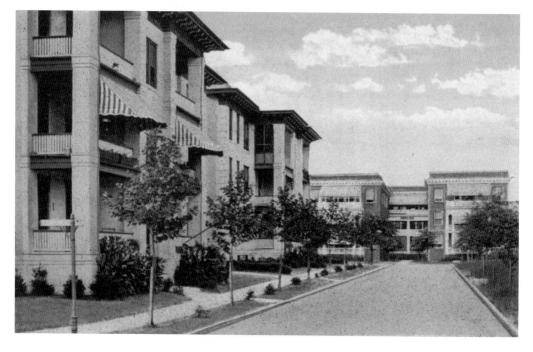

The Maury High School sophomore class posed in 1912 for this picture, taken on the school's massive front steps. Opened in March 1911, Maury's first principal was George McKendree Bain. Enrollment was 750 students in that opening year. In those days, Principal Bain made only $2,250 a year. Female assistant principals were paid considerably less, $1,100. *Courtesy of the author.*

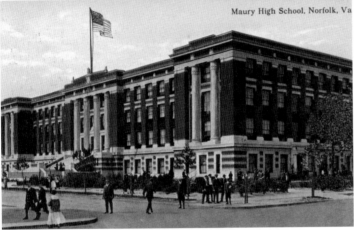

Maury High School, Norfolk, Va

Maury High School, shown here on this Louis Kaufmann and Sons postcard circa 1915, was named in honor of Matthew Fontaine Maury, the Pathfinder of the Seas and commodore of the Confederate States Navy, and except for General Douglas MacArthur, perhaps the most decorated American in history. The school name was suggested by the second wife of Dr. Frank Anthony Walke, Belle W. Tunstall. Dr. Walke entered the United States Navy as an assistant surgeon after graduating from the Universities of Virginia and Pennsylvania in 1851. Stationed at the United States Naval Hospital at Portsmouth, he went through the yellow fever epidemic there in 1855. He left naval service in 1857, opening a drug store in Norfolk while also practicing medicine. Walke was Maury's contemporary, and both joined the Confederacy within days of Virginia's secession from the Union in April 1861—Walke as a surgeon, Maury as a commander in the navy. Belle Walke's suggestion of Maury as a name was readily accepted. *Courtesy of the author.*

Norfolk Fire Station Number 4, located on East Olney Road, is pictured here circa 1908. When the station was established in 1893, Irish-born Martin J. Ryan was chief of the Norfolk Fire Department. Harry C. Mann, one of the most prolific photographers to ever chronicle Hampton Roads, took this and several additional photographs contained in this volume between the years 1906 and 1922. The early fire engines were horse-drawn water pumping machines manned by black men until about 1849, when whites began taking over positions on the engines. The very first fire company in Norfolk was established in 1797 by Robert Archer and was called the Union Fire Company of Fire Company Number 1. The firemen were completely volunteer before the city incorporated the fire department in 1871. Only the fire wardens were paid prior to incorporation. *Courtesy of the author.*

scheduled to start the next day. Students temporarily moved to the newly built John Marshall School on Omohundro Avenue. In November 1908 several Norfolk High School trustees visited other cities to get ideas for a new high school in the city. Two months later, in January 1909, Norfolk Select and Common Councils appropriated $26,025 to purchase the land for a new building, located at Fifteenth Street and Moran Avenue. The purchase of this site created some opposition, and various groups of citizens, with the best of intentions, delayed a decision to build there by proposals that included rebuilding the old Hemenway School to a size that would accommodate the city's growing high school-age population, building two high schools—one east, one west—in the city and the last, convert city park and build the new high school there.

After school board members were thoroughly confused by the number of proposals, motions, amendments to motions, none of which succeeded, Fifteenth Street and Moran Avenue was chosen as the site on which the new school would be built. Norfolk councils then appropriated a quarter-million dollars to build Norfolk's new high school building. Within three years, in March 1911, Matthew Fontaine Maury High School was complete and all Norfolk high school students transferred there. The construction of Maury High School was a tremendous boon to the west side of Norfolk, but

particularly the Ghent and North Ghent sections, which had exhibited steady, expansive growth between the Elizabeth and Lafayette Rivers.

Between 1910 and 1928 the entire North Ghent area was fully developed. Much of that development consisted of three- and four-story apartment buildings on the few remaining lots along Redgate and along undeveloped lots north of that street. Graydon Avenue, fronting an expansive grassy median, is a particularly good example of the clustering of single-family residences and apartment buildings. West Princess Anne Road, which had no buildings on it in 1910, was almost filled in by 1928 with only a few remaining vacant lots scattered between built ones. This northern edge was similarly filled with homes and apartment buildings.

During the five years following 1902 Ghent construction occurred in areas generally south of Westover and Redgate Avenues and east of Colley Avenue. For the most part, these houses were less pretentious than those originally constructed around Beechwood Place, Pembroke Avenue and Colonial Avenue. They were still, without doubt, very roomy homes. Many were rowhouses constructed for rental markets. Others

Pelham Place Apartments, juxtaposed on Olney Road, is pictured as it appeared in 1910. Harry C. Mann, one of the era's most famous photographers, took the picture. Mann photographed extensively in Hampton Roads from 1906 through 1922. *Courtesy of the author.*

Maury High School's fledgling baseball team was touted in the Norfolk Landmark newspaper on March 29, 1911, as a "crack" team. The record of the 1911 team was impressive. Because there were few high schools to play, Maury's baseball squad squared off against teams from the College of William and Mary, Old Point College and a team from the United States Navy's USS *Franklin*, in addition to Portsmouth High School, Norfolk Academy and Newport News High School. Of the ten games played that season, Maury won eight, including wins against Old Point and the *Franklin*'s sailors. *Courtesy of the author.*

Colonial Avenue United Methodist Church at 1420 Colonial Avenue is pictured here on this Louis Kaufmann and Sons, of Baltimore, Maryland, postcard, about 1913, two years after it was built. While Gothic or Romanesque Revival churches were dominant at the turn of the twentieth century, the early 1900s also proffered an assortment of unique styles that are still standing today. Built in 1911, the Colonial Avenue United Methodist Church has polygonal form with an unusual two-level dome of clerestory windows. *Courtesy of the author.*

The residence of Frederick M. Killam, president of F.M. Killam Company, Inc., at 820 Graydon Avenue was one of the most magnificent in North Ghent, but still part of the original Ghent development. Killam is posed on the porch of his home with his children, circa 1915. Killam was also the treasurer of the Highland Park Syndicate and Lambert's Point

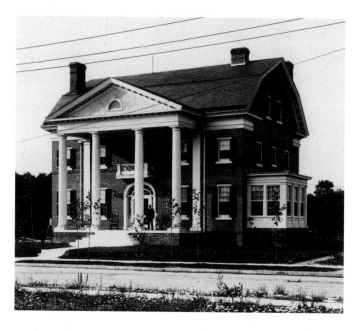

Investment Company. Norfolk's Killam Avenue was named in his honor. *Courtesy of the Sargeant Memorial Room, Norfolk Public Library.*

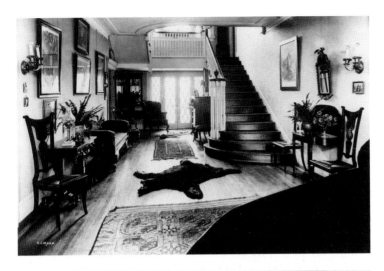

Interior photographs of Ghent's earliest homes are not commonplace. The three interior photographs of the Frederick M. Killam house at 820 Graydon Avenue provide a glimpse of the decorative arts of the period. Depicted are the entry hall, living room and a bedroom of the residence. Harry C. Mann took each of these photographs. *Courtesy of the Sargeant Memorial Room, Norfolk Public Library.*

First Baptist Church, located at the corner of Westover and Moran Avenues, is shown as it appeared about 1915 on this Louis Kaufmann and Sons postcard. The church had moved to this location five years earlier, in 1910, but this belies the rich history that preceded the move. This was Norfolk's first Baptist church, organized in 1805 with assistance from a Baptist congregation in Portsmouth—and its congregation was initially interracial. The church eventually split, its black congregants forming the First Baptist Church on Bute Street and the whites building a church on Cumberland and Market Streets called the Cumberland Street Baptist Church. Part of the Cumberland Street congregation formed the Freemason Street Baptist Church in 1848; the city then had three Baptist congregations. In 1886 Cumberland Street Baptist Church became the First Baptist Church of Norfolk. The First Baptist building at Westover and Moran

were freestanding, though closely grouped, townhouses built for one's own family or for sale on the single-family home market.

In the decade between 1902 and 1912, the seawall around Mowbray Arch was started in various phases. It was first suggested in 1904 by Arnold Eberhard, a local architect who designed some of the most prominent homes in Ghent. In 1909 the Norfolk City Council took advantage of leftover stone from a job at the Norfolk Navy Yard in Portsmouth, Virginia, to continue the seawall to Olney Road, thus indicating its actual start sometime between 1904 and 1909. In 1922 the Yarmouth Street circle was added.

During the run up to and including the 1907 Jamestown Exposition held in Norfolk, building in the city was geared toward construction of housing for those expected to attend the event. Consequently, much of the housing increase from this period took the form of apartment buildings, at a time when most of the building had been single-family residences. Pelham Place Apartments, the Holland Apartments, Raleigh Square and others were built specifically with Jamestown Exposition visitors in mind, those who might spend weeks, if not months, in the city attending exposition events. Many of these apartment structures, however, such as The Severn, The Redgate, The Vendome, The Stratford and a few others, have been demolished.

After filling in Colley Creek to create Stockley Gardens, and the creation of The Hague in 1900, development quickly

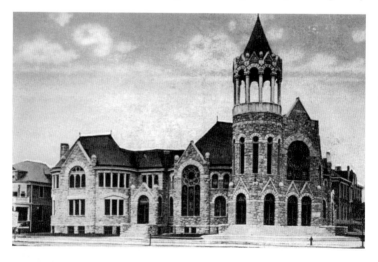

was ravaged by fire on October 2, 1970, and the congregation moved away from Ghent for a new location on Kempsville Road. *Courtesy of the author.*

spread to the west. One of the first groups of housing to be constructed in the area was by Walter Herron Taylor for his family facing Stockley Gardens between Olney Road and Boissevain Avenue; these homes were numbered 609, 613 and 617–619. The Protestant Hospital, soon to become Norfolk General Hospital and formerly located on the site of the Colley Farm, constructed a new building in 1901 on Raleigh Avenue west of Colley that was the beginning of the present medical center. Also at this time, between 1901 and 1902, Sarah Leigh Hospital was being built along Mowbray Arch just east of the Ghent Bridge. Homes in the same block, built prior to the construction of the hospital, would be razed over time to make way for additions to the hospital. Sarah Leigh Hospital, which was eventually acquired by Norfolk General, moved from its location on The Hague and the building itself was torn down after a devastating fire in June 1987.

By 1902 much of the original portion of Ghent had been established. The primary section was fast filling with houses, except for those areas on land filled to create the semicircle of Mowbray Arch. In the first section, running alongside the streets were sidewalks or footways, winding around the arcs, and fledgling trees and plantings were beginning to fill out in parks and swards. As had become the practice in subdivision development—and Ghent was no exception—the land was almost totally cleared before construction took place. Early photographs of Beechwood Place show a grassy common with small tufts of trees. Fergus Reid's beechwood tree is the only substantive growth among a forest of saplings

Aerial photographs were taken of Ghent in the mid-1920s that illustrate more clearly the density north of Olney Road—the thoroughfare bisecting the photograph left just above Stone Park. Maury High School is north, top center in the photograph, to lend perspective. *Courtesy of the author.*

The intersection of Colonial Avenue at Twenty-first Street was bustling with activity in the 1920s. Charles S. Borjes took this picture of Master's Auto Service in 1924. *Courtesy of the Sargeant Memorial Room, Norfolk Public Library.*

lining Ghent's streets. Colley Creek had been filled in, but Stockley Gardens had not yet taken on its eventual manicured appearance. Other sections of Ghent, where most new construction took place after 1902, were in the process of receiving streets and utilities and lacked the polish of the older portion of the development. The mere fact, however, that Ghent was assuming a finished appearance just ten years after the beginning of construction attests to the success of the developers' planning and forethought—and most particularly, to John Graham's level of design detail.

The period between 1907 and 1912 saw much of the construction activity to the north and west of Stockley Gardens. The primary physical improvements that had taken place during this second phase of Ghent development were distinguished by the laying out of Stockley Gardens in 1911 and the construction of houses on the lots of land fronting the north-south and east-west streets making up this northern section of Ghent. The three rectangular blocks of land located just north of The Hague and called Stockley Gardens were laid out in 1900 by Walter Herron Taylor, prominent Norfolk citizen, engineer and architect. Today, of course, a wide walk runs down the center of the long, open, grassy squares and culminates at a circular planting bed with benches. Maturing shade trees and low plants have replaced the original rosebush-planting scheme. Neglect eventually took hold and severe damage from the hurricane of late August 1933 put the gardens on the renewal list.

The Woman's Club of Norfolk at 524 Fairfax Avenue, photographed on November 30, 1925, by Charles S. Borjes, was originally built by Alvah H. Martin as his primary residence between 1890 and 1891. The mansion has been home to the Woman's Club of Norfolk since 1925, when the women bought it from the Virginia Club for $45,000, half what the men had paid for the residence in 1919. The three-story, twenty-one room mansion had been the vision of Martin, Norfolk County clerk for thirty-three years and a powerful figure in Republican politics. *Courtesy of the Sargeant Memorial Room, Norfolk Public Library.*

During this key five-year period starting in 1907, some construction did take place in what was to become West Ghent and North Ghent. Much, but not all, of the construction was in apartment buildings. During this period other building activity east and south of Stockley Gardens occurred on filled land that was just barely ready for construction. The east side of Stockley Gardens took on its institutional air with the addition of Christ Church (later renamed Christ and Saint Luke's) in 1909. Ghent United Methodist Church had been designed and built earlier—in 1902—by John Kevan Peebles and Finley Forbes Ferguson. The latter attended Hampden-Sydney College and received his bachelor of science in architecture from Massachusetts Institute of Technology in 1889. The First Presbyterian Church was built just a block away on Colonial Avenue at Redgate Avenue, according to a 1911 design rendered by Finley Ferguson.

Ghent United Methodist Church had been the vision of John W. Grandy, first president of the Ghent Methodist Church Society of Norfolk, president of Dodson, Fearing, Millar and the Grandy Jobbing Company. His home was on Colonial Avenue near Redgate Avenue. Grandy held an organizational meeting in his Colonial Avenue residence in June 1902 to discuss plans for a Methodist house of worship for Ghent residents. Charter members of the church eventually included Grandy; Willis W. Vicar, cashier of the Norfolk Bank for Savings and Trust who had served on Norfolk's Select Council, and who lived at 513 Fairfax Avenue; William H. Newell, associated with the Norfolk and

Norfolk's Twenty-first Street was known as "Auto Row" at the time this picture was taken by Acme Photo Company founder Henry W. Gillen in 1925. The Dixie Motor Car Company is the second building on the left, located closest to the street's intersection with Manteo Street. Overland Buick occupies the two large buildings on the right. The view in this photograph is looking toward Colley Avenue down Twenty-first Street. Gillen is remembered today as an important figure in the commercial photography business. He had come to Norfolk with a national reputation as a pioneer motion picture camera operator and had also worked for the largest pictorial news syndicates in New York and Chicago before coming to Norfolk in 1912 as the first cameraman for the Pathe Company, and later Paramount and Artcraft and other studios around the city. Gillen started his own studio, Acme, in 1918. *Courtesy of the author.*

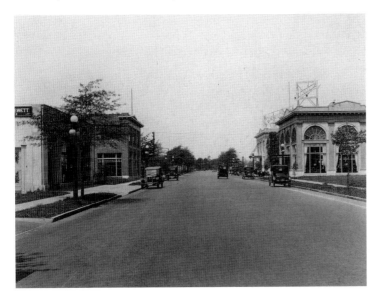

The Firestone Service Center on Olney Road at Boush Street, shown here circa 1930 in this Charles S. Borjes photograph, is still there today, though dramatically renovated to include second-story offices above retail. *Courtesy of the Sargeant Memorial Room, Norfolk Public Library.*

Carolina Railroad Company; Frank Harrison, an agent with Smith-Courtney Company who lived at 94 Duncan Avenue in Ghent; Elbert Tatterson, a well known and respected Norfolk contractor and builder; Timothy W. Worsham, in the peanut business; T.H. Stiff; P.H. Malbon; Dr. Christopher F. Newbill, a physician and Atlantic City resident; Charles N. Whitehurst of CNW and Brother, grocers, who lived at 620 Colonial Avenue; William J. Woodward, director of Nottingham and Wrenn, who lived at 365 Hamilton Avenue; and William D. Roberts, a manufacturing agent with offices on Roanoke Avenue who eventually lived at 903 Fairfax Avenue. Five months later, in November 1902, a temporary church was built and Reverend J.B. Winn was named the church's first minister. In its first year of operation, Ghent United Methodist Church, also called Ghent Tabernacle, had 132 members. Among the unique items once in the

Saint Andrew's Episcopal Church, located at 1004 Graydon Avenue at Leigh Street in West Ghent, was photographed by Charles S. Borjes on December 16, 1934. *Courtesy of the Sargeant Memorial Room, Norfolk Public Library.*

The cast of a Patrick Henry School play posed for photographer H.D. Vollmer in 1928. The cast included Jacqueline Holly (flapper, far left), Clara J. Vollmer (butterfly, second from left), Bloundon Harris (clown, top center), Jessie Saunders (baby, fourth from left), Thomas Hardy (black cat, bottom right), Eloise Winder (later Davidson) (Chinese flower girl, directly behind the girl with the wand), Amy Arline (baby, directly to the right behind girl with wand), Daisy Sayres (later Ryscuck) (clown, second from right) and H.D. Vollmer Jr. (wizard, far right). Unfortunately, not all of the children are identifiable. Patrick Henry School was located at the corner of Colley and Pembroke Avenues. *Courtesy of the author.*

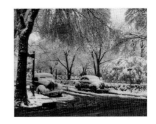

church's possession was a set of offering plates contributed by the Grandy family on their return from Jerusalem in 1903. The plates were made of olive wood inscribed with the words "The Lord loveth a cheerful giver" around their edges. The present church building was built in 1921 and was modeled after London's Saint Martin's-in-the-Field.

Also among the churches that would eventually be built north of Olney Road was Sacred Heart Roman Catholic Church. Saint Mary's of the Immaculate Conception Catholic Church was the only Roman Catholic church in Norfolk until 1894, when Sacred Heart Chapel was constructed on the northwest corner of York and Dunmore Streets on property acquired from the Ward estate for $2,300. The Bay Shore trolley car from Ocean View came across the water on Mowbray Arch in front of Sarah Leigh Hospital on a wooden trestle and down Dunmore Street, stopping at the corner of York Street. Sacred Heart's parish boundaries began at the Elizabeth River and Granby Street, ran north along Granby Street to Twenty-

Ghent residents make their way through Stockley Gardens, turned into a winter wonderland by a heavy snowfall, in February 1936. H.D. Vollmer was the photographer. *Courtesy of the author.*

Class E9-B2 of Blair Junior High School was photographed on January 21, 1929, by photographer Ernest L. Long. Standing across the back of the room, left to right: Douglas Spruill, Catherine Dugan, Elizabeth Darden, teacher Miss Baxter, Ida Carrao, Larry Powell, Jack Runn, William Dryden, Jack Rase. First row (against the wall) of seated students, left to right: Nell Harrell, Veronica Santos, Russell Williams and Lillian Gates. Second row, seated left to right: Elizabeth Falconer, Margaret West, Nellie Sharperio, Grace Walker and Nat White. Third row, left to right: Louise Hayes, Jean Berry, June Richardson, Sarah Thornton, Hurburt Harrison and Alfred Carrol. Fourth row, left to right: Frank Hoggshead, Irving Linehan, Meridith Scott, George Wichard and Victor Smith. Fifth row, left to right: John Fawcett, Frank Miles, Sigruid Bergman, Bauman Cooke and Henry Boyd. Class officers were Henry Boyd, president; Frank Miles, vice-president; Lillian Yates, secretary; and Elizabeth Falconer, treasurer. *Courtesy of the author.*

Schlain's Market was located at 700 West Olney Road when this picture was taken on June 17, 1932. *Courtesy of the Sargeant Memorial Room, Norfolk Public Library.*

The staff of Schlain's Market is pictured here on June 17, 1932. Front row, left to right: Julius Schlain, Julius's wife, Jeannette Schlain, Miss Olga I. Paul, Lawrence Smith, Iva M. Rhodes and Phillip Green. Back row, left to right: Streeter Schmus, Hyman Sandler, Walter Pitt, Avery L. Owen Jr. and David Dazinger. The Schlains' son, Julius Schlain Jr., was later president of Ghent Improvement Corporation, which acquired old buildings in Ghent in the early 1960s and rehabilitated them. His partner in several of these later ventures was Lee David Cohen, a developer who had

ninth Street, then south on Colley Avenue to the Norfolk and Western Railroad tracks to Lambert's Point Docks, then back along the river to its starting point.

The original Sacred Heart Chapel was a red pressed brick structure with a gray slate roof. The round stained-glass window of this chapel, which cast light over the original chapel's altar, was moved in later years to the stairwell of the present-day Sacred Heart rectory; there was also a large star lighted by gas over the altar, largely used at Christmas. Francis Xavier McCarthy was Sacred Heart's first priest, and it was he who oversaw construction of the chapel. Though it was intended as a temporary building to house worshippers while other arrangements for a church might be made, the chapel was the parish's home for thirty years. Sometime in 1912, Father Thomas E. Waters came to Sacred Heart. Waters renovated the little chapel, adding steam heat—a luxury in that period. He also repaired and refurbished the old rectory house, acquired from the Ward family in 1895. The rectory's lawn bordered Paradise Creek, one of the names given to an offshoot of Smith's Creek opposite Sarah Leigh Hospital. While occupied by the Ward family, the home was purportedly the place in which a terrible tragedy unfolded. As the story was told over the years, a young naval officer became enraged with his sweetheart, a beautiful woman, and stabbed her near

moved to Norfolk in 1963 with his mother, the former Bertha Glasser, a Norfolk native. *Courtesy of the Sargeant Memorial Room, Norfolk Public Library.*

the heart. The woman's screams attracted the attention of Ward family members, who went to her aid, but she died in the parlor of the Ward residence. The woman's blood stained the hardwood floor and could be seen for years to come as a reminder of the tragedy that had occurred there. The old Ward mansion and Sacred Heart's first chapel, which had been subsequently used as a gymnasium by schoolchildren, were eventually razed.

Lots for a Catholic school were purchased on March 19, 1913, located about two hundred feet west of Colonial Avenue on Armistead Bridge Road, later called West Princess Anne Road, in Ghent. By May of that year the parish bought lots along Blow Street adjoining the school site to expand the footprint of a new church. Nearly a year later, on March 21, 1914, lots on Graydon Avenue were acquired to build the rectory. An excerpt from the *Baltimore and Richmond Christian Advocate*, dated November 8, 1917, stated that four blocks north of Stockley Gardens, from the Ghent United Methodist congregation's site, "the Catholics hold a site whereon to erect a great church."

Grace Elizabeth Twohy, wife of John Twohy II, joined her German shepherd in the garden of the couple's Ghent home, 442 Mowbray Arch, on May 7, 1934. Grace, daughter of Frederick Chapman and Grace Elizabeth Merrick of Cleveland, Ohio, married John Twohy II on September 10, 1924. Upon moving to Norfolk she took a constructive role in the community. An avid gardener, Grace established the Town and Country Garden Club, and also served as president of the Garden Club of Norfolk and the Garden Club of America. Her husband, John Twohy II, was a Norfolk native born June 11, 1900, to John and Katherine Dugan Twohy. He owned and operated a number of construction firms, but was best known for his interest in the Commonwealth Sand and Gravel Corporation, which he founded and which was headquartered in Richmond. The couple was the parents of three children,

including Patricia Ann, wife of Dr. George H.B. Rector; Edward Merrick; and John Twohy IV. Charles S. Borjes is credited with having taken this lovely photograph of Grace Twohy. The house, built for Horace Hardy, is also referred to as the Hardy-Twohy residence. *Courtesy of the author.*

"Construction activity in Ghent and North Ghent after 1912 was essentially in the form of filling in vacant lots and of new structures replacing older ones."

Sacred Heart owned the lots for its school for several years before a stately and commodious red brick building known as Sacred Heart School was completed. The school opened in 1920 with 180 students of all ages. The first five graduates of Sacred Heart's school were Margaret Britt, Julia Forrest, Anita Cofer, Olive Borden, who went to Hollywood and became a movie star, and Margaret Stevenson. In October 1921 plans were promulgated for the construction of a new Sacred Heart Church—the edifice that stands today. The building, designed by Ferguson and Peebles, embodies the Florentine Renaissance style of architecture prevalent in the United States of the 1920s. The church's three altars, the altar rail and flanking statues were carved from Carrera marble by Italian craftsmen. The church's outstanding features also include its classic columns and arches and a magnificent organ. Over the choir loft is a rose window. The open woodwork in the ceiling with its scrollwork on the beams is also unique. The stained-glass windows were made by Franz Mayer of Munich, Germany, who had already crafted exquisite windows for Christ Church (now Christ and Saint Luke's Episcopal) and Saint Mary's of the Immaculate Conception. The church's Stations of the Cross were imported from Italy, and the plaques under each were made by John J. O'Keefe. The rectory, on Graydon Avenue, was occupied by parish priests two weeks before the church's dedication, on November 1, 1925, by Bishop William Haley of Raleigh, North Carolina.

Easter Sunday traffic on Colonial Avenue, looking toward Redgate Avenue and Olney Road, is shown here on April 9, 1939. Charles S. Borjes photographed Colonial on several Easter Sundays over the years, and every time the street was just as jammed with cars. *Courtesy of the Sargeant Memorial Room, Norfolk Public Library.*

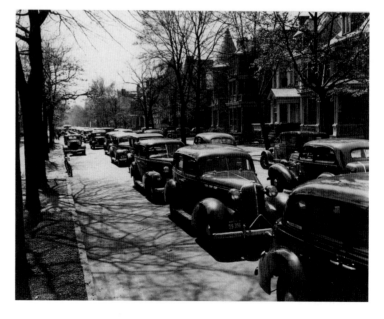

The 1910s led also to the relocation of the Ohef Sholom Temple to Ghent from its downtown location at Freemason Street and Monticello Avenue. In 1911 an advisory committee was appointed by Temple President Albert Gerst to look for a building site there. When fire destroyed the Ohef Sholom's temple on February 12, 1916, D.E. Levy went into the burning building and rescued the Sefer Torah. While all churches graciously offered facilities, Ohef Sholom's congregation chose to worship at the Ghent Club. After much deliberation, 100 feet on the northeast corner of Stockley Gardens and 195 feet on Raleigh Avenue were purchased from Alfred P. Thom. The architectural firm of Ferguson, Calrow and Wrenn was engaged to design the new temple, which was estimated to cost, as a new fireproof structure, $1.5 million. The Khedive Temple bought Ohef Sholom's former property for $37,000. The laying of the cornerstone for the new building at Stockley Gardens and Raleigh Avenue took place on April 19, 1917, conducted by the Most Worshipful Grand Master of Masons in Virginia.

The Ionic Greek architecture of Ohef Sholom Temple is punctuated by the inscription across the top of its façade: "My house shall be called a house of prayer for all peoples." Dedication exercises were held on the evening of April 22, 1918, and for the community on Sunday afternoon, April 28. The present temple would be completely remodeled and enlarged in 1968.

"...the apartment buildings that line up along Hampton Boulevard, West Princess Anne Road and throughout West Ghent recall the period in Norfolk's history when the savvy young businessman and his family lived in apartments."

Photographer Charles S. Borjes snapped a picture of these children who obligingly mugged for his camera on Easter Sunday in 1940. The picture was taken in Ghent on what appears to be Colonial Avenue north of Olney Road. *Courtesy of the author.*

Construction activity in Ghent and North Ghent after 1912 was essentially in the form of filling in vacant lots and of new structures replacing older ones. For the most part, the post-1912 construction is found in the fringe areas of the neighborhood, especially to the north and west. Building included further apartments—many now converted to condominiums—built before the automobile induced widespread flight to the suburbs. The other major structural type in the post-1912 period was institutional. The expansion of Sarah Leigh Hospital and the design and construction of Ohef Sholom Temple by Ferguson and Peebles in 1917 typify this development.

Charles S. Borjes photographed the L. Frederick Bruce residence at 535 Fairfax Avenue on November 1, 1940. Bruce was the treasurer of Vaughan and Barnes, Inc. *Courtesy of the Sargeant Memorial Room, Norfolk Public Library.*

To the west, the apartment buildings that line up along Hampton Boulevard, West Princess Anne Road and throughout West Ghent recall the period in Norfolk's history when the savvy young businessman and his family lived in apartments. Despite the speed with which suburbs beyond Ghent developed, an apartment near the downtown section was considered fashionable in a way that ceased to exist in all but the very large metropolitan centers of the country. In Norfolk this was true until the early 1990s, when the impetus to live downtown and within its immediate neighborhoods once again became highly desirable. Many of Norfolk's early

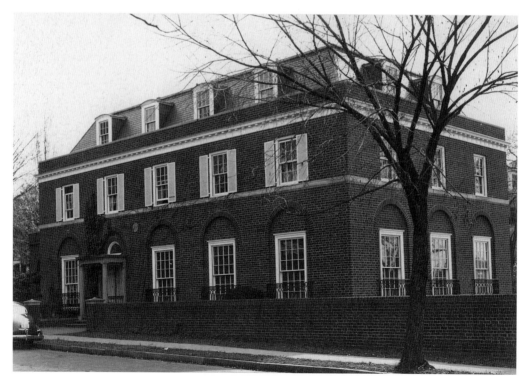

apartments were built in Ghent and its North, West and East extensions in the early 1900s, when it was believed Norfolk was on track to become "a city of apartment houses."

West Ghent development was not, however, executed on a prominent half-acre plot of former farmland, located at the corner of what is today West Princess Anne Road and Hampton Boulevard. The land, then owned by Captain Francis Tarrant, who maintained a small family burial ground on his property, became the final resting place of scores of victims of Norfolk's yellow fever epidemic of 1855, buried in a mass grave when the city's death rate exceeded the ability to build enough coffins and dig individual burial plots. Bodies draped in sickbed blankets and sheets were interred in several pits, each containing bodies laid eight abreast and four deep. The land remained privately owned for decades, and into the early twentieth century there were headstones still visible for a known number of Tarrant family members as well as a very limited number of fever victims whose families had identified the proximity of their placement in the mass grave and placed headstones to mark their family member's final resting place. It was not until April 1993 that Junior Girl Scout Troop 328 organized the

Olney Road looking east from Colley Avenue toward Christ and Saint Luke's Episcopal Church (left) was covered by the remnants of a winter snow, circa 1940. *Courtesy of the author.*

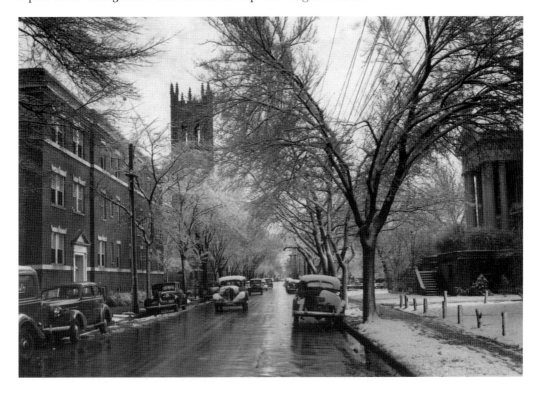

effort that led to the dedication of Yellow Fever Memorial Park and the erection of a marker to the memory of those who lost their lives to a mosquito-borne disease that killed thousands in the nineteenth century.

Norfolk's yellow fever victims are not the only ones remembered in West Ghent. The section's Memorial Oak would be dedicated in 1923 by the Garden Club of Norfolk with a marker inscribed with the words: "This tree is dedicated as a memorial to the sons of Norfolk who died for their country in the World War." The bronze plaque is located at 1400 Westover Avenue, and while the marker was meant to honor the tragic loss of life in World War I, the tree is over two hundred years old and weakened by disease. While they have not done so for more than two decades, students at Walter Herron Taylor Elementary School once paraded to Memorial Oak at the end of each May to honor those who had given their lives for their country.

By the end of 1912 upward of a million dollars had been spent over a span of several years to build up the western section of Ghent. Buildings in West Ghent first centered on Westover and Colley Avenues and the Graydon Park section, where developers erected a mix of no less than six apartment buildings with spacious residences. From about 1900 and continuing for about a decade and a half, development catered to Norfolk's increasing population. Apartment buildings, most of them built for middle- and upper-class residents, were appointed with expensive fixtures and features. Units rented quickly. One apartment building

The Second Presbyterian Church, Mowbray Arch at Yarmouth Street, is visible in this Charles Borjes picture, taken on April 22, 1940. Black workers, foreground, were putting the finishing touches on gardens outside the front entrance of the Norfolk Museum of Arts and Sciences. Courtesy of the Sargeant Memorial Room, Norfolk Public Library.

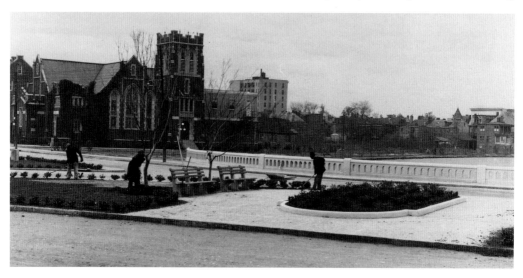

with ten flats on Redgate Avenue, finished in time for what were then dubbed "October movers," was entirely rented before the plaster was on, and three of them had been let before the foundation was laid in early 1912. In those days, hundreds of people were looking for apartments, and nearly every high-end renting property in Ghent had been taken. Observers attributed the rush to move into apartments to three issues: the high cost of living in a single-family residence or attached townhouse, the cost of fuel and the servant problem; experienced house servants were becoming increasingly difficult to find, but the practice of employing them in the city was largely going out of vogue as Norfolk emerged from World War I a different city.

In the Graydon Park section, there was The Wyandotte, in late 1912 a new apartment house development, built in proximity to The Brandon, both of which had been rented to capacity. Farther down Colley Avenue was The Adrian, a brick apartment house with flats at "reasonable" prices, and just south of this was yet another finely constructed group of apartments. On the north side of Graydon, between Blow and Manteo, was another, while on Westover Avenue and on Redgate Avenue there were several more in the course of construction that were to be finished before winter set in.

The paving of Colley Avenue north from Redgate meant more development. The movement was northward—and had been since the Jamestown Exposition of 1907. But by 1912 this northward development was even more pronounced than it had been over the preceding five years.

The Ghent neighborhood twenty years after its inception, or nearly one generation after the steel-riveted bridge and the streetcar put it within reach of the citizens of Norfolk, was completely built up except for scattered lots, many on filled land, and the extreme northern and western fringes of the neighborhood. This in itself is not particularly remarkable, except that the structures on the ground represented the realization of a plan by Ghent's developers conceived in 1890 and systematically implemented and extended in a period of twenty years. The objective of the developers was to build a quality residential area to which the best of Norfolk's citizens would be attracted. That they succeeded is readily apparent, witnessed by the imposing edifices of the larger homes and the simple good taste of the smaller, less pretentious residences, as well as the list of residents in Ghent during those early years.

"The paving of Colley Avenue north from Redgate meant more development. The movement was northward—and had been since the Jamestown Exposition of 1907."

125

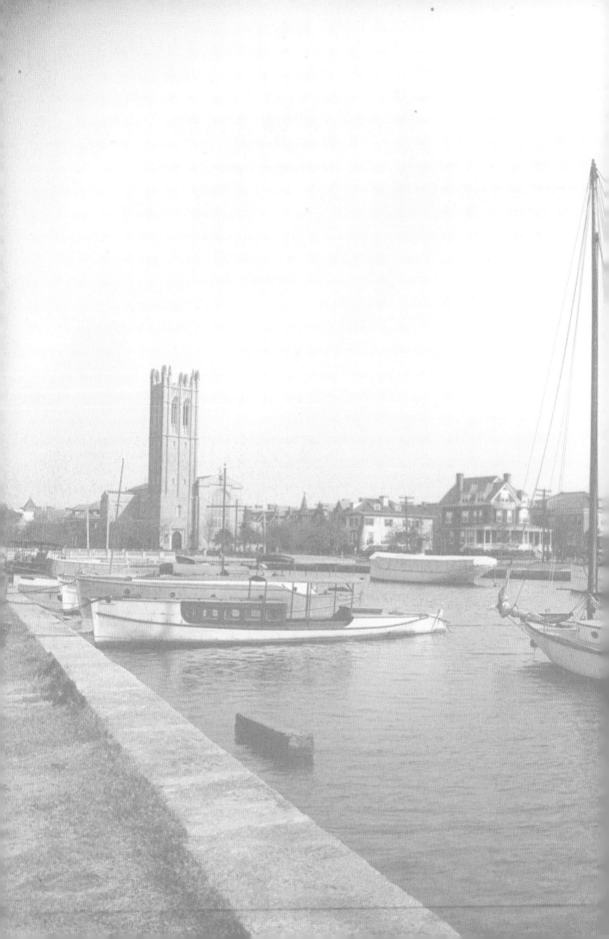

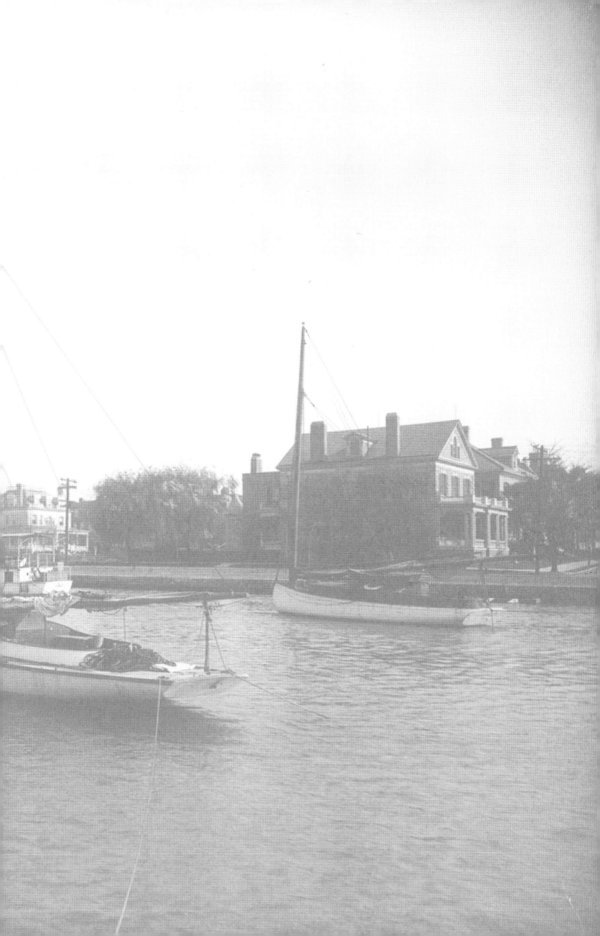

Chapter Five

Norfolk's Yacht Haven—The Hague

Smith's Creek, a portion of which was dubbed The Hague by Norfolk Company promoters, is a small tidal branch of the Eastern Branch of the Elizabeth River. Its shorter end skirts the filled in land on which the Norfolk Museum of Arts and Sciences, later renamed The Chrysler Museum of Art, was constructed in the early 1930s, while the other end, shown here about 1910, comes up to Olney Road facing Stockley Gardens at the Stone Park. The large houses on the right face Mowbray Arch. Christ Episcopal Church is center in this Harry C. Mann photograph. *Courtesy of the author.*

Samuel Smith's Creek pushed toward soggy marsh farmland, splitting so that one branch crept toward Elmwood Cemetery while the other trickled through what would eventually become Stockley Gardens. To the west was John P. Colley's farm and Brambleton, also once a farm. A wooden footbridge spanned the tidal creek water with a path running from the bridge to one lone house. Pleasant Point belonged to Dr. William Martin in 1810, and was subsequently acquired from his estate by a nephew, Jasper Moran, two years later. The wooden footbridge would be replaced with Norfolk's first steel-riveted bridge in 1891 and, in keeping with the progressive nature of the times, a pair of trolley tracks was soon laid across the bridge. For many years the tracks were still visible—long after no trolleys ran into Ghent.

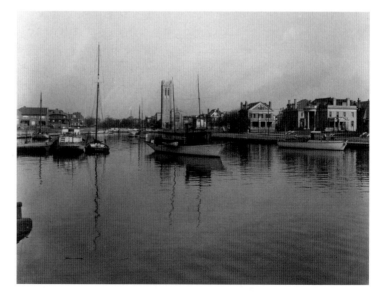

By the early 1950s Norfolk was being touted by Frederic C. Heutte, the city's superintendent of Parks and Forestry, as the "Venice of America." Heutte saw the shades of the Grand Canal in the city's most picturesque waterway—The Hague. Though The Hague is but a small Y-shaped twig of the Elizabeth River, historically it is one of the Hampton Roads area's most interesting waterways. The shortest leg of The Hague abuts today's Chrysler Museum of Art at Yarmouth Street; the other is confined at the Stone Park on Olney Road, before Christ and Saint Luke's Episcopal Church. This latter stretch is bounded by an arc of substantial residences. In days gone by the west bank was bounded not by towering apartment buildings and residences, but commercial boatyards and piers as well as anchorage and moorage space usually crowded with sleek sail and power yachts, oyster boats and fishing trawlers, knockabouts of various design and condition, tugs and barge hulks. The Hague has a surface area of roughly twenty-five acres and a shoreline about two miles long. It was indicated commonly

Harry C. Mann took this stunningly beautiful photograph of yachts and sailboats anchored in Smith's Creek, a portion of which was renamed The Hague, about 1915. Christ Episcopal Church is to the left. Fairfax and Pembroke Avenues (left to right) terminate on Mowbray Arch. *Courtesy of the author.*

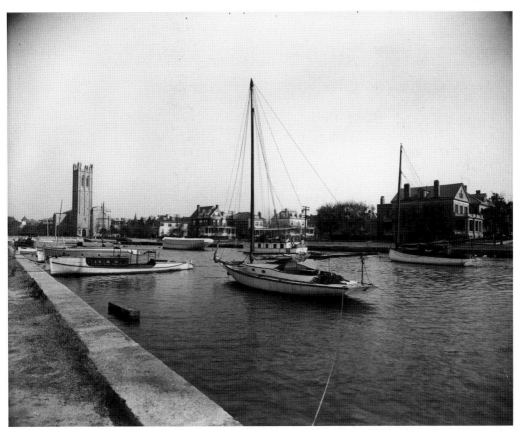

on maritime charts by the prosaic name of Smith's Creek, by early accounts, and also Paradise, Pudding and Colley Creeks, depending on a particular section of the waterway.

Beyond Heutte's comparison to Venice's Grand Canal, The Hague, as its name implies, recalls The Netherlands and Dutch banking house that sponsored the development of the Ghent community in which the waterway is situated. The first plat recorded of the area was of the Norfolk Company and its subsidiary, the Ghent Company, in 1897, designating this water as "The Hague." In selecting this name, Ghent's progenitors honored the founder of the Dutch banking house, Adolph Boissevain, and The Netherlands's seat of government, The Hague.

The *Virginian-Pilot* of July 6, 1909, reported that the Common Council had appropriated $3,000 to purchase stone for the continuation of the Mowbray Arch seawall toward Olney Road. The stone was to be brought from the Norfolk Navy Yard at Portsmouth, where it had been left by contractors who razed the government's seawall. It was noted that the stone had been offered to the city at a "fabulously low price." On either end of the seawall were parks. Lee Park was juxtapositioned where The Chrysler Museum of Art—formerly the Norfolk Museum of Arts and Sciences—was later built, and Stone Park was once

During military homecoming week in June 1919, Stone Park was turned into a welcome home celebration for hoards of United States servicemen returning from World War I. The statue in this picture was a centerpiece of decorations added to the park for events, which drew thousands to park and waterway. *Courtesy of the Sargeant Memorial Room, Norfolk Public Library.*

the scene of bands playing as United States Navy gig boats tied up and relieved load after load of white-suited naval officers in search of freshly starched and behatted young ladies.

Repairs and improvements to The Hague were conducted on a steady basis between 1902 and 1912. In the spring of 1912, drainage work was done in the vicinity of the gas plant, visible in many early photographs of the area, to reclaim a considerable portion of marshland and at the same time relieve the city of one of the worst eyesores on the upper branches of Smith's Creek. The bridge at Monticello Avenue provided passage over the creek's northern branch, while the Duke Street Bridge was used by residents to traverse the southern branch or Pudding Creek, as the locals called it.

According to city of Norfolk records, the greater portion of The Hague's bulkhead was built in 1919. Three years later, a circular bulkhead was added at the Yarmouth Street end. That area was improved further in the late 1920s in connection with the development of the Norfolk Museum of Arts and Sciences. The late Mary Chamberlaine Reid was active in the beautification of Stone Park at the Olney Road head.

The Hague has changed through the years. In a public hearing concerning projected navigation and sanitation

Looking north from Botetourt Apartments, an unknown photographer captured this view of Ghent in 1922. The apartment building at the end of the footbridge is the Holland Apartments, still standing today and on the National Register of Historic Places. Holland Apartments is believed to be located on the original site of the Drummond farmhouse. The streetcars going over the bridge came up Dunmore Street, crossed The Hague and turned right on Mowbray Arch. *Courtesy of the author.*

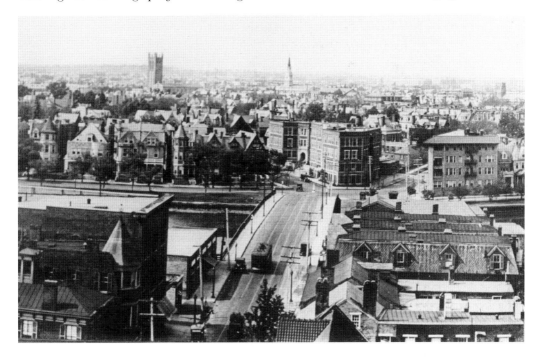

improvement, which was conducted in November 1945, a person who had lived in the vicinity for fifty years testified that the waterway was becoming narrower and shallower. He pointed out that the bottom had been rising gradually as the result of the pressure of buildings and earth on filled land and the oozing or sliding of the soft land under pressure into a low area. Along with the filling in of the bottom of The Hague, there had been a subsiding of the high land on the shore, the resident explained. He also warned that frequent dredging of The Hague would only undermine the lateral support of the land upon which the houses along the water were built.

Even if The Hague's shape has fluctuated, however, one distinctive quality was present for many years. Once described in a *Ledger-Dispatch* editorial as "the plague of The Hague," this quality was the pervasive odor The Hague and its environs emitted during summer months. A dredging that took place between 1945 and 1946 cost the city of Norfolk $64,982 and failed to mitigate the smell. By the late 1940s engineers from three public agencies—the Departments of Public Works and Health and the Hampton Roads District Sanitation Commission—discovered that most of the odor came from sewage becoming septic. Chlorinators were installed to resolve the problem.

This photograph was taken by Frank J. Conway, circa 1920, of The Hague on a hot summer's day. The view is looking toward Olney Road. The large cedar shake structure, far right, behind the two sailboat masts, is the Ghent Club. Note the trolley passing down Olney. *Courtesy of the author.*

The Hague also had a drawbridge across the water at Atlantic City that at one time clanged warnings that it was letting a motor yacht or sailboat pass into the protected waters between the head of Yarmouth Street and Stone Park. For many years in the spring and summer The Hague was an attractive haven for yachts from up and down the East Coast. Surrounded by its large stone seawall, its appearance was an enticing inducement to anchor on The Hague's still, smooth waters. Encircled on every side by land, there was rarely a ripple to disturb the smallest boat. With the exception of fifty yards that were entirely landlocked, there was only a short span of water that separated the West Side—then called the "West End"—from Atlantic City. To mariners who had long taken shelter here, the thought of not being able to use the waterway again was a disturbing prospect. But in the late 1950s, as plans were drawn for Redevelopment Project Number 2, the Norfolk Redevelopment and Housing Authority (NRHA) proposed construction of a permanent highway bridge traversing the opening of The Hague.

Opposition to NRHA plans to close off the opening of The Hague with a permanent bridge took shape quickly in several quarters. Both business interests along The Hague

The Hague, shown about 1920, was densely populated on its Atlantic City shoreline. Mowbray Arch is barely visible right, center. *Courtesy of the author.*

Mayor Stockton Heth Tyler presents the key to the city of Norfolk to King Neptune at the opening of the first Norfolk Regatta-Carnival, held August 18 to 21, 1926. During the 1926 event, King Neptune arrived in The Hague—the backdrop of this photograph—at half past two on the afternoon of August 18, accompanied by a military, civic and fraternal parade. A dinner was held later that evening at the Ocean View Hotel. Virginia Beach Night was held two days later, and featured a carnival and Mardi Gras at the beach. The final day of the regatta-carnival focused on speedboat races, by far the biggest day of the festival, with all activities on the Eastern Branch of the Elizabeth River. Biscayne Babies, boats up from Florida, came for the 1926 festivities. Participants included hydroplanes of 510 and 151 Class, too. The final event was a dinner at the popular Ghent Club, followed by a fireworks display. *Courtesy of the Norfolk and Western Historical Photograph Collection, Virginia Polytechnic Institute and State University.*

and transient boaters who stopped there on their way north or south mounted a protest against its closure. Although the NRHA had not released detailed information on its Atlantic City project in late June 1956, sources had already told boaters and businessmen that the city was contemplating either a causeway or low-level bridge spanning The Hague's entryway. This structure would carry an extension of Brambleton Avenue toward a connection with a relocated Hampton Boulevard. Beyond the causeway York Street would be widened to accommodate increased traffic flow. Some business owners like George R. Russ, who owned Russ Equipment Company and Hague Marina inside The Hague, did not believe Norfolk would make the mistake of closing off the waterway. "No person familiar with The Hague's advantages to the waterways system would even consider the plan a possibility," Russ observed. Russ's business serviced large numbers of transient yachts passing through Norfolk on their way to or from Florida through the Intracoastal Waterway.

But Russ's belief that Norfolk would leave the waterway open, as it had always been, was wishful thinking. Harry M. Thompson, then executive vice-president of the Hampton Roads Maritime Association, stated in a letter to the Norfolk Chamber of Commerce that he understood clearly that the proposed changes to bridging over The Hague carried

with it "certain changes in the present access to The Hague, which may eliminate this body of water for commercial use." Thompson also remarked that the facilities of the Norfolk Yacht and Country Club and Lafayette Yacht and Country Club were in all likelihood too far from a regular route to be a service to the large number of vessels transiting the area en route to and from Florida.

Within a month of initial indications of Norfolk's plans to close The Hague to commercial use, editorials appeared and letters to the editor arrived in a steady stream to the Norfolk newspapers, and letters from politicians, the United States Army Corps of Engineers, yachtsmen and mariners of all description and experience were received by city offices. W.C. Hughes wrote a letter to the editor of the *Virginian-Pilot* published on July 12, 1956, that was titled, "Don't spoil The Hague." "The matter I am referring to is the thought of destroying The Hague. I think it is deplorable that practically all of 'old Norfolk' and especially the limited amount of downtown waterfront residential property is steadily being destroyed…Practically the only remaining residential property on open water in the old section of Norfolk is that which faces The Hague, from the museum around to Christ Church." Opposition to closing off The Hague was just warming up, and the

Governor John Garland Pollard of Virginia and Mrs. Pollard are welcomed to the city of Norfolk at Stone Park, The Hague, on April 26, 1930. John Pollard was governor of Virginia from 1930 to 1934. After his death on April 28, 1937, Mrs. Pollard continued in politics, serving as a delegate to the Democratic National Convention from Virginia in 1944, 1948 (alternate) and 1952. Governor and Mrs. Pollard were headed to the Woman's Club of Norfolk on Fairfax Avenue for an event. *Courtesy of the Sargeant Memorial Room, Norfolk Public Library.*

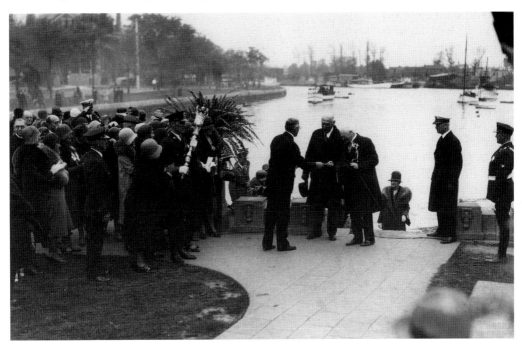

Norfolk Redevelopment and Housing Authority had not yet announced complete plans for the project.

Four years after the first indications that Norfolk intended to close off The Hague to commercial water traffic and yachters, the city moved forward with plans to construct a fixed bridge that would effectively put George Russ out of business. Letters poured into the Norfolk City Council. George D. Mead of Gloucester, Massachusetts, wrote from onboard his yacht *Berrian* on May 17, 1960, that he had been using the Hague Marina on his trips to and from Florida for three years, and in his opinion, The Hague provided the best protection in all weather for medium sized yachts.

Our Berrian *is a 42-foot motor sailer with masts 41 feet above the water level, and has a draft of four feet six inches. Last fall we weathered the gale that flooded Norfolk up to city hall. Any alternate location outside the bridge would be unsatisfactory as far as I am concerned due to its exposure to winds coming across the expanse of the Elizabeth River, the rough water attendant to winds of high velocity and the continuous wash of passing harbor traffic at high speeds which would be damaging to medium sized yachts.*

Virginia Governor John Garland Pollard posed for this photograph at the Woman's Club of Norfolk at 524 Fairfax Avenue on April 26, 1930. Alvah H. Martin, a banker and lawyer, built this residence. Martin was involved in the 1907 Jamestown Exposition, had been clerk of Norfolk County and remained for many years a powerful politician. He led the Fusionists, a combination of black Republicans and white politicians, largely Democrats, opposed to what were called straight-out Democrats, or those who refused to work with blacks. *Courtesy of the Sargeant Memorial Room, Norfolk Public Library.*

Letters also came from James Liebman, president of Sonar Radio Corporation, and Earle Cantor, president of Kings County Cold Storage, both of Brooklyn, New York; T.H. Belling, president of Fram Corporation, of Providence, Rhode Island; Captain J.K. DuPont, port captain, Captains Club, West Palm Beach, Florida; and dozens of others, all of whom objected to the construction of a permanent structure over the entranceway of The Hague.

Henry D. Gordon, president of Central Safety Equipment Company of Philadelphia, Pennsylvania, wrote the chief of engineers, United States Army Corps of Engineers in Washington, D.C., lodging a particularly strong protest. Other letters would address the secretary of the army, Washington, D.C., in the hopes of influencing the corps and Norfolk from building the bridge. William Wikoff Smith of Bryn Mawr, Pennsylvania, remarked that he had been cruising to Florida and returning in the spring and fall via the Hague Marina. His boat, with a mast of seventy-two feet, was automatically barred from future entrance to The Hague after construction of the Brambleton Avenue traffic bridge. "I am certain that I am not

The Hague flooded Mowbray Arch during the hurricane of August 22–23, 1933. This photograph was taken at the corner of Mill Street and Mowbray Arch; the Atlantic City Bridge is in the background. *Courtesy of the author.*

alone," he wrote to Norfolk City Council on May 23, 1960, "in my dismay at the idea of erecting such a bridge since the number of sailboats cruising the waterway seems to grow every year and most of them have masts that are at least 30 feet tall." C.R. Walgreen Jr., president of Walgreens Drug Stores, also wrote a letter to Norfolk City Council. In the letter, also dated May 23, Walgreen remarked that his ship, which was sixty-five feet in length and required an absolute minimum clearance of sixteen feet, was "no doubt…only one of a great many such vessels which would be concerned by this action, especially during their seasonal use of the Intracoastal Waterway."

But the city of Norfolk did close The Hague to Walgreen, Gordon, Smith and many others who had made seasonal use of its protected waters. Dramatic changes were in store for Ghent bordering The Hague, namely in the transformation of Brambleton Avenue and waterway's shoreline opposite Mowbray Arch's picturesque architecture commensurate

The 100 block of Olney Road flooded badly during and immediately after the August 22–23, 1933, hurricane. This photograph was taken by Charles S. Borjes. *Courtesy of the Sargeant Memorial Room, Norfolk Public Library.*

with construction of The Hague and Pembroke Towers high-rise apartment buildings. Brambleton Avenue had come into existence after development crept north from the city's downtown, toward Drummond's farm. Its western terminus was originally a finger of Newton's Creek west of Maltby Avenue. This end of the creek extended northward across what is today best known as West Princess Anne Road. Queen Street was on the opposite side of the creek, in existence since before 1800, and running westward across town to Boush Street. When part of George Bramble's farm was sold in 1870, a causeway was constructed over the remainder of this part of the creek, which was slowly

"Closing The Hague to commercial water traffic and palatial yachts and sailboats would permanently alter the character of the Ghent area from the shoreline opposite Mowbray Arch."

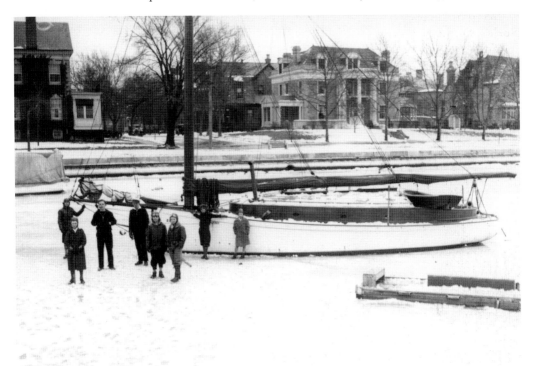

Yachts rested frozen in the ice and snow of The Hague along Mowbray Arch and its terminus with Pembroke Avenue on February 2, 1936. Youngsters—all boys—eagerly seized the moment to play the frozen yacht haven. The palatial columned home at 580 Mowbray Arch (center) is the George H. Lewis residence, built in 1900. The two-story cream-colored Ionic columns are set off the front elevation, making it the most imposing home on its end of the arch. The molding around the architrave, here the low end of the entablature immediately on the capital of the column, continues slightly beyond the portico to suppress the otherwise extreme verticality of the front edifice. The pair of windows over the entrance was not a common feature in formal homes built in that period. *Courtesy of the author.*

Wartime housing was built along both sides of Smith's Creek to accommodate the influx of defense workers to Norfolk during World War II. The barracks-style housing, shown here on November 9, 1944, was typical of the 6,472 temporary dwellings built north of the Elizabeth River, much of it dotting the shore of Smith's Creek. *Courtesy of the Sargeant Memorial Room, Norfolk Public Library.*

Norfolk's annual Cape Henry Day celebration was held on April 23, 1944, on The Hague. This photograph was taken by Charles S. Borjes. *Courtesy of the Sargeant Memorial Room, Norfolk Public Library.*

being filled in and connected with what was to subsequently become today's Brambleton Avenue. Now, for the first time, Norfolk could be entered from the east instead of the old Church Street route. The suburb grew rapidly and was annexed by Norfolk in 1877, as previously mentioned, a few years ahead of Ghent's first appearance, by name, in the city directory. The Queen Street–Brambleton Avenue route became an important east-west thoroughfare. After Norfolk's massive annexation of outlying areas in 1923, the city undertook the task of revising the names of streets in the city. It was thus decided to extend Brambleton Avenue to Boush Street and to eliminate old Queen Street. In the redevelopment of the downtown area in the 1950s and in order to expedite east-west traffic flow across town, Brambleton Avenue was extended west to connect with Hampton Boulevard at Redgate Avenue in Ghent. The work started around 1960, and as noted in reference to closing The Hague to commercial water traffic and palatial yachts and sailboats, the changes would permanently alter the character of the Ghent area from the shoreline opposite Mowbray Arch. The work began in earnest in 1960, even as letters continued to arrive on the desks of city leaders to spare their yacht haven.

Smith's Creek—The Hague—is shown in this aerial circa 1950 taken during boaters' off-season. H.D. Vollmer took the picture. *Courtesy of the author.*

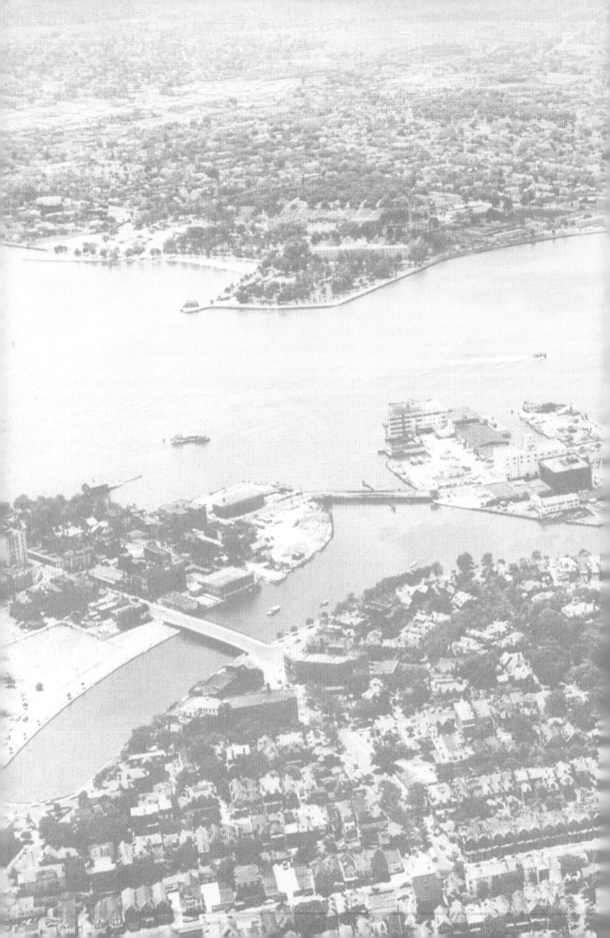

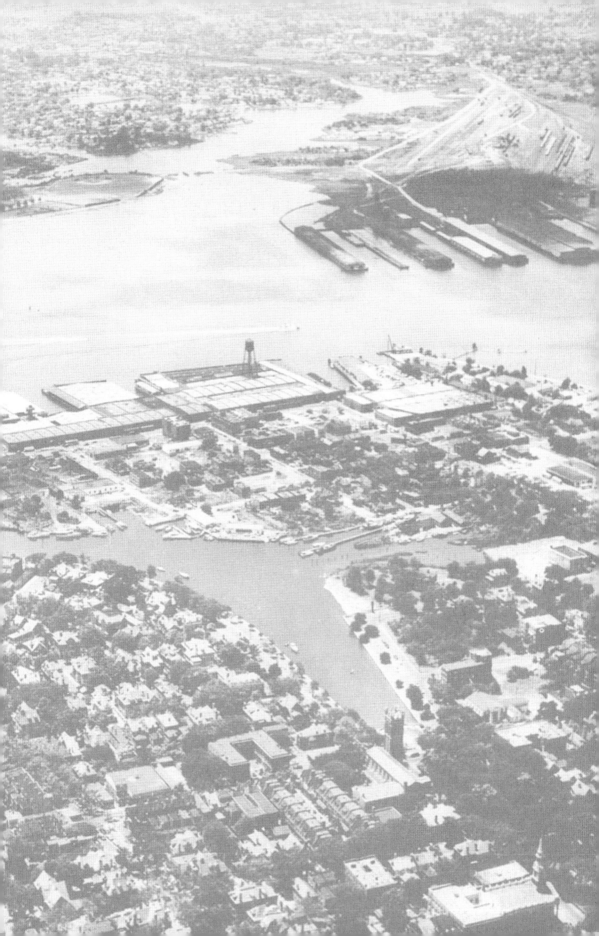

Chapter Six

YEARS OF CHANGE AND STRUGGLE

Ghent continued to attract upper-middle and upper-class residents to the community well into the twentieth century. The automobile's increasing popularity and improved transportation corridors led to development of suburbs beyond downtown Norfolk, eventually putting the stability of Ghent as a single-family residential neighborhood in jeopardy. During and after World War II many of Ghent's large townhouses—and some of its palatial residences—were converted to rooming houses. Commercial development along Ghent's major roads also began to creep into its residential enclave, further

Temporary wartime barracks cropped up in any location where there was a finger of land to build them, and having them populate stretches of available land in Ghent was not unusual during the Second World War. To the left of defense housing in this Charles S. Borjes picture is the Norfolk Museum of Arts and Sciences and 308 Mowbray Arch. The photograph was taken on November 9, 1944. *Courtesy of the Sargeant Memorial Room, Norfolk Public Library.*

endangering the integrity of the city's first planned suburb. School desegregation and urban renewal further fueled white flight.

East Ghent, generally east of Colonial Avenue nearly to Granby Street, extending from Olney Road to West Princess Anne Road, and spilling into numbered streets beyond, rapidly deteriorated after World War II. By the 1950s East Ghent had fallen victim to blight and neighborhood abandonment by families who saw suburbia as the Promised Land. East Ghent's spacious middle-class homes were bought by investors and realtors who converted them into multifamily complexes, increasing neighborhood density beyond what the area could bear and weakening the stabilizing influence of home ownership. East Ghent began to absorb many low-income black families displaced by the razing of old homes downtown. By 1964 East Ghent was 95 percent black and a place where hunger and despair were commonplace. In the summer of 1962 a storekeeper shot six East Ghent youngsters who had allegedly tormented him. One of the boys was killed. "Them Ghent boys is rough. Mean," a city recreation worker observed later of the neighborhood.

The first attempt at human renewal in East Ghent was planned in December 1962, the same month that President

"Before 1964 the East Ghent area laid almost unnoticed and deteriorating. Rumors were rife that a redevelopment project was scheduled for the neighborhood..."

Charles Borjes photographed the procession at Christ and Saint Luke's Episcopal Church for the ordination of Harris Bishop on April 17, 1945. The church is located on Olney Road at Stockley Gardens. *Courtesy of the Sargeant Memorial Room, Norfolk Public Library.*

John F. Kennedy asked his chief economist, John Kenneth Galbraith, to begin looking into the poverty problem in the United States. Out of that research initiative eventually came President Lyndon B. Johnson's war on poverty, begun in September 1964. But a pilot project to rehabilitate just two blocks of East Ghent's dilapidated housing in the early to mid-1960s failed. The Norfolk Health Department had spent most of 1964 working to force improvements, using the city's then minimum housing code to do so.

Before 1964 the East Ghent area laid almost unnoticed and deteriorating. Rumors were rife that a redevelopment project was scheduled for the neighborhood, but no formal pronouncement had yet come from Norfolk Redevelopment and Housing Authority. Housing code enforcement generally was concentrated in more promising blocks of East Ghent, but two projects took place—a human renewal project started in 1963 and the health department's pilot enforcement effort. The human renewal project began with a $15,000 grant from the Norfolk Foundation and was in full

Charles S. Borjes took this picture of Olney Road at Manteo Street on February 10, 1948, after a heavy snowfall. *Courtesy of the Sargeant Memorial Room, Norfolk Public Library.*

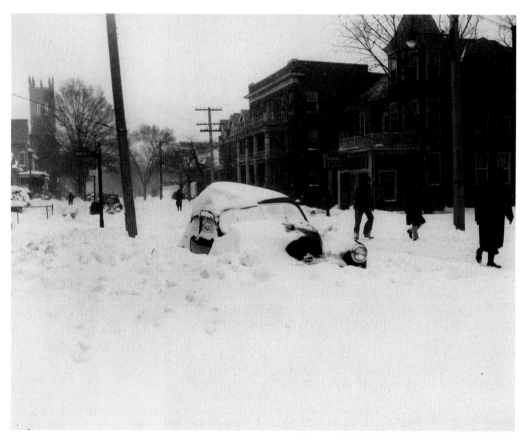

146

swing by late 1964. Neighborhood fix-up campaigns were pressed, the East Ghent Civic League won recognition and the East Ghent project director, George C. Crawley, was prodding residents and absentee landlords to take renewed interest in their homes and properties, respectively. The Norfolk Health Department's initiative, headed by sanitary engineer Dorsey Tisdale, selected the aforementioned two-block intensive enforcement effort. One block was bounded by Moran, Franklin and Duncan Avenues and Duke Street; the other by Westover, Duke, Llewellyn and Graydon. The two blocks had 109 family units in forty-five structures. All but one of the units was in violation of the city's minimum housing code. Jack C. Burgess, a field sanitarian for the Norfolk Environmental Health Bureau, set out first to persuade landowners, most living well out of East Ghent, to repair their property. Several did. Some borrowed heavily to do so. A widow and absentee landlord actually borrowed $2,000 to install new bathroom fixtures in her unit, but the fixtures were ripped out and carried off before

The northwest corner of Colonial Avenue at Washington Park was photographed by Charles S. Borjes after fire damaged several storefronts about 1950. Located only two blocks from Twenty-first Street, Washington Park, as its name implies, has a wide green space splitting traffic on either side. With the expansion of Blair Middle School, Washington Park between Manteo Street and Colley Avenue has been closed, leaving only the portion from Manteo Street to Colonial Avenue intact. *Courtesy of the Sargeant Memorial Room, Norfolk Public Library.*

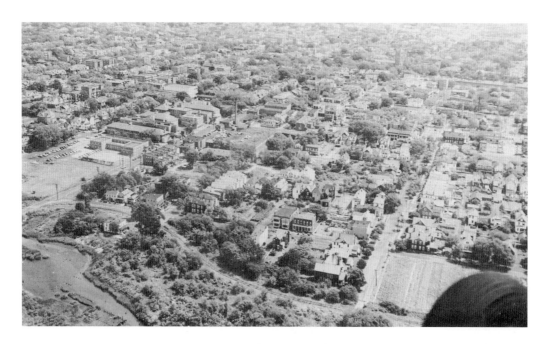

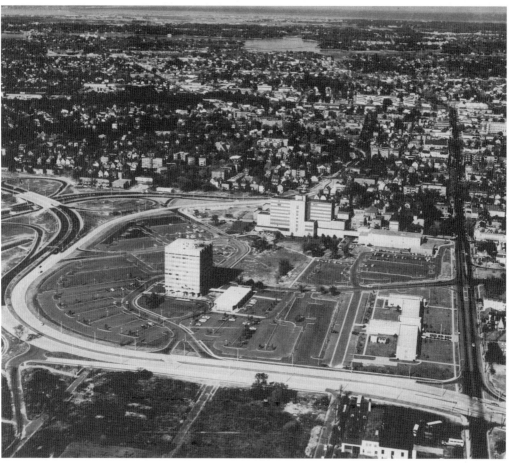

the first tenant had moved in to use them. The tenants, shifting homes at a rate of more than 100 percent a year, often tore out improvements and created problems nearly as fast as repairs could be made. The widow's failed effort to rehabilitate her property was not out of the ordinary.

In the early 1960s Norfolk city officials were hopeful that East Ghent might be rehabilitated. East Ghent was part of a 165-block neighborhood named one of twenty poverty pockets selected for action by the Southeastern Tidewater Opportunity Program (STOP), which meant that a host of federal projects, supervised by professional STOP staff and sparked by a corps of neighborhood counselors, would start working with tenants and landlords to improve the conditions in which people had been living. Furthermore, the Housing Act of 1965 appeared to proffer federal assistance that would make intensive enforcement akin to that given the pilot blocks available on a far wider scale. With the housing code pushing for building renewal and STOP advocating human renewal, progress was thought within reach. But the STOP program had had little impact by the mid-1960s. "Little has changed in the total environment," said Burgess, whose bureau had concentrated heavily on East Ghent since 1964, to a *Virginian-Pilot* reporter in October 1965. "The effect of the project has not been noticeable among the

"The East Ghent area, by 1970, was at the heart of Norfolk's Model City program, one of the most extensive federal programs in which the city became involved in the late 1960s and 1970s."

Facing page: The medical center complex bordered by Brambleton Avenue, Hampton Boulevard, Colley Avenue and a small finger of Redgate Avenue is shown here in extraordinary before and after photographs. The before view shows the medical center area before redevelopment. At left center is the old Norfolk General Hospital (formerly Norfolk Protestant Hospital) and in the foreground, a residential slum. In the 1940s Norfolk General Hospital was already recognized as a regional facility and, by 1950, the hospital was on its way to creating the medical center that Norfolk has today—a nationally and internationally acclaimed tertiary care facility with few equals in the nation's mid-Atlantic. In the after view, taken about 1967, the $10 million addition to the medical center, clearly visible, was virtually complete when this photograph was taken. In the foreground is the $2.8 million Medical Tower containing one hundred suites for doctors and dentists, completed in 1962. To the right was the then new $1 million Public Health Center, consolidating all of Norfolk's health bureaus under one roof for the first time. In the background was the $6 million central wing of Norfolk General Hospital and to the right of it the $1 million Children's Hospital of the King's Daughters. Norfolk General Hospital continued to plan and build additional buildings on the site, and had begun at that time to contemplate a medical college collocated with its facilities. *Courtesy of the author.*

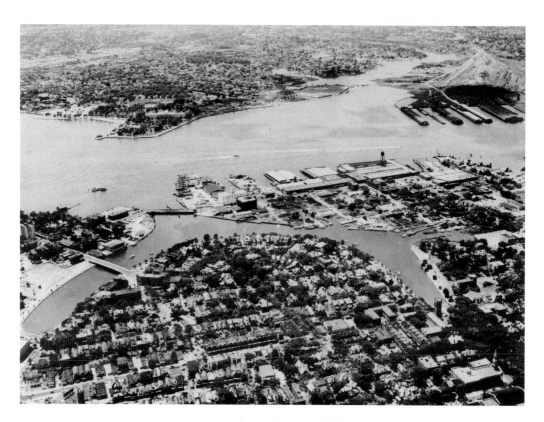

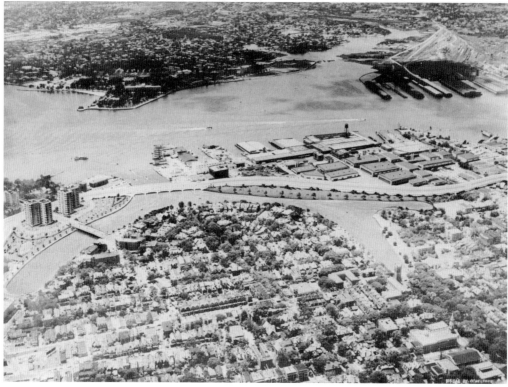

mass of people. Apathy and indifference reign supreme." And while he could see change in some people, and the STOP project had demonstrated what could be achieved with more money and staff involvement, East Ghent overall had not made significant progress.

By late 1968 the situation in East Ghent had reached the breaking point between poor, largely black residents and their respective landlords. On November 8 of that year residents living in cluttered, rundown apartments in dilapidated rowhouses received notices to vacate within twenty-four hours as ordered by the judge of the Norfolk Civil Court. One tenant, Gladys Moreland, a forty-four-year-old food handler, received her notice, dated October 23, that the court had rendered a civil judgment against her for back rent owed to her landlord, Morris Comess. Moreland told a *Ledger-Star* reporter on the day she received the eviction notice in November, "Mr. Comess and Mr. (William R.) Hemingway, his agent, came around last week for their money, and I told them to just bear with me, that I was starting a job with STOP on the 11th (of November), and to please bear with me a little longer." STOP was sponsoring, at that time, an on-the-job training program for the city's poor, a program that would provide training and a sixty-four-dollar-per-week job for Gladys Moreland after a three-week orientation period. As she told her story to the reporter, Moreland was flanked by young men from BLAC, the Black Liberation Action Council, a group described as young militants organizing the community in East Ghent. Conflicts between landlords and tenants often turned ugly. Comess owned ten two-family buildings in East Ghent. He had several tenants who had moved out of

"The East Ghent area was the last parcel of land in the city suitable for development as a mid- to upper-income neighborhood."

Facing page: The Hague South before and after reveals dramatic changes in store for Ghent's southern exposure. The photograph, taken about 1955, shows the southern residential areas of the city, largely Ghent (foreground) abutting The Hague and the Elizabeth River. The city of Portsmouth is across the river in the upper half of the picture. This is before Brambleton Avenue was extended and the turnstile bridge over The Hague's entrance closed to Intracoastal Waterway traffic. The conceptual rendering illustrates a widened Brambleton Avenue and permanent highway bridge over the mouth of The Hague. In the left, center of this image was superimposed what the Hague Towers and a similar high-rise apartment building would look like when complete. The second tower, to the right of the Botetourt Street (or Ghent) Bridge, was not built at that time. *Courtesy of the author.*

his properties owning him money; Gladys Moreland was not alone in owing him back rent. Moreland did receive help from George Crawley, by then STOP's executive director, who sent neighborhood representatives to pick her up, and she was then processed for emergency public housing by the NRHA.

With nearby Ghent already a conservation area, East Ghent's days were numbered. "The East Ghent area was the last parcel of land in the city suitable for development as a mid- to upper-income neighborhood," said Jack Shiver, then executive director of NRHA, in January 1975. "This fact, plus the loss of federal low-income housing subsidy programs, led us to commission a second study, conducted by Vismor, McGill and Bell, which explored the feasibility of developing and marketing a planned, higher-income residential community in East Ghent." The city of Norfolk had already removed, for safety reasons, a number of vacant houses it owned near Maury High School in 1969, but the housing authority took nearly another year to move into systematic clearance within its East Ghent redevelopment project. Beginning that year the federal government, the city of Norfolk and the Norfolk Redevelopment and Housing Authority entered into a partnership called the East Ghent Project North and South.

The East Ghent area, by 1970, was at the heart of Norfolk's Model City program, one of the most extensive federal programs in which the city became involved in the late 1960s and 1970s. Over two hundred American cities applied to participate in the program, but Norfolk emerged as one of only sixty-three that were chosen. The basic objective of the Model City initiative was to improve the quality of life for people residing within the city's corporate boundary, which for Norfolk was a crescent-shaped area around its downtown, including Berkley, Campostella,

"Henry Clay Hofheimer II, Norfolk businessman, real estate developer and philanthropist, had seen Ghent's ups and downs, but by the early 1970s he also understood implicitly that Ghent's success was tied to Norfolk's struggling downtown."

Facing page: **Two views of Brambleton Avenue demonstrate the transformation of one of Norfolk's most important transportation corridors. The first view shows Brambleton Avenue, formerly Queen Street, and Boush Street looking west before expansion and extension of the street to Hampton Boulevard. The street in the center is Dartmouth Street, which was later eliminated. Eugene G. Vickhouse took this photograph on January 27, 1960. The second picture is Brambleton Avenue looking toward The Hague, on the right. George Haycox of Haycox Photoramic took this picture on February 28, 1964.** *Courtesy of the author.*

Brambleton, Huntersville and East Ghent. The federal government put up the funds to provide, across the board, coordinated attacks on blight and underscore social service requirements in the core metropolitan area. In East Ghent demolition began with three houses on West Sixteenth Street in late February 1970, marking a token beginning in a plan by Norfolk Redevelopment and Housing Authority to develop a model residential community. With money markets tight at that time, however, apartments and houses for displaced East Ghent residents were somewhat hard to find; relocation of families meant long periods of delay between razing dilapidated houses and clearing parcels for private development and public improvements. Eventually a sixty-five-acre parcel of land in East Ghent was razed for redevelopment by year's end. The NRHA controlled private development of the land—zoned for single-family, detached townhouse residences made to appeal to middle- and upper-income families. Called Ghent Square, this area would be built east of Colonial Avenue. Four years

Brambleton Avenue is shown newly widened and surrounded by ongoing redevelopment. This was an interim period before further razing took place, as many of the buildings clearly visible in this photograph are now long gone. *Courtesy of the author.*

after forming the East Ghent Project North and South, a progress report indicated that all individuals and businesses within East Ghent had been relocated with the exception of a handful of families, the Salvation Army and numerous businesses along Granby Street.

With relocations completed, NRHA went about the process of executing plans to sell property within parts of East Ghent, largely to private developers. All residential development was set to occur in the area west of Llewellyn Avenue in the project's initial phases. In addition to residential construction, Maury High School and its grounds were expanded. By late October 1974 the Norfolk Redevelopment and Housing Authority announced an ambitious residential community plan for the sixty-five-acre parcel once occupied by some of Norfolk's worst slums. The plans for the cleared East Ghent slum provided land for the NRHA-controlled private development of the land into homesites for single-family detached and townhouse residences for middle and upper income families. Years of planning by NRHA staff and consultants would culminate in Ghent Square. Henry Clay Hofheimer II, Norfolk businessman, real estate developer and philanthropist, had seen Ghent's ups and downs, but by the early 1970s he also understood implicitly that Ghent's success was tied to Norfolk's struggling downtown. He bought land in Ghent Square for development. In the summer of 1975 the lifelong Ghent resident unveiled plans to build

The corner of Olney Road and Mowbray Arch was a very different place when this picture was taken on October 8, 1960. Mowbray Arch is in the foreground, and Olney Road is the thoroughfare passing left to right in the photograph. This is the portion of Olney Road and Mowbray Arch by today's Chrysler Museum of Art. Most of this area was once part of Smith's Creek, which extended nearly all the way to Church Street. After the creek was filled in, streets paved and buildings went up, storm rains still flooded this area. The apartment building in the center of this picture was situated on Hamilton Avenue, which no longer exists. The price of gasoline on the Esso station sign left foreground is worth noting—not quite twenty-two cents for regular and almost twenty-five cents for Esso extra. *Courtesy of the author.*

The Colley-Mottu-Johnson House, shown here as it appeared about 1959, just a
few short years before being razed in 1961 for Pembroke Towers's construction,
had been a residence, hospital, school and boardinghouse in its colorful
history. The house was built by John P. Colley before 1850 on land between
Smith's Creek—later The Hague—and Fort Norfolk Road, today called Colley
Avenue. During the yellow fever of 1855, Colley and three of his children died
of the disease within a few weeks. The house became a hospital in 1896, when
the Retreat for the Sick moved from its quarters on Holt Street to the larger
Colley home. The name of the hospital was thus changed to Norfolk Protestant
Hospital. Norfolk Protestant Hospital would move again to larger facilities and,
in 1936, become Norfolk General Hospital. The Colley house was subsequently
acquired by J.P. Andre Mottu, partner in the development of Ghent, who had
purchased property in the city's then newest suburb. The Mottu, formerly
Colley, property was bounded approximately by Redgate, Thetford (later
Hampton Boulevard), Raleigh and Colley Avenues. Because the hospital wished
to expand and Mottu wanted to acquire their waterfront property, an exchange
was arranged. Although Ghent was developing rapidly, Mottu turned his land
to farming. As an aside, the Dutch flag always flew from a flagpole on the
property. During the 1920s Mottu's farm changed hands again, serving as a one-
time boys' school and then a boardinghouse. Thomas G. Johnson, a prominent
Norfolk businessman and sportsman, bought the house in about 1948.
Johnson lived there until about 1961, when his home was acquired by Norfolk
Redevelopment and Housing Authority for development. Pembroke Towers
and its nearby Hague Towers significantly changed the view along The Hague.
Courtesy of the author.

The Hague Towers was the most significant new residential development post realignment of Brambleton Avenue. Opened at the end of May 1965 and the largest of the high-rise apartments managed by S.L. Nusbaum and Company at that time, Hague Towers is located on Brambleton Avenue overlooking The Hague and the Elizabeth River. Columbia Realty Associates of Washington developed the $4.5 million, twenty-story apartment project on land acquired from the Norfolk Redevelopment and Housing Authority. This view, taken about the time the building opened, was taken from the front drive of The Chrysler Museum of Art, formerly the Norfolk Museum of Arts and Sciences. The museum's iconic sculpture, *The Torchbearers*, by Anna Hyatt Huntington (1876–1973), was gifted to the city by the artist in 1954. *Courtesy of the author.*

thirty-eight townhouses and eight carriage-style houses in redeveloped parts of the neighborhood. Using nineteenth-century pattern books to guide the design of the townhouses, Hofheimer's development fit both the economic and mixed-use development objectives of the housing authority.

The centerpiece of the Ghent Square development remains the old Norfolk-Portsmouth ferry terminal concession building, which had been a landmark on Norfolk's downtown waterfront. Rather than destroy it, NRHA carefully prepared drawings, numbered each part, disassembled it and stored it in a warehouse. Ben Weese Associates eventually prepared site plans for the reconstructed terminal. In 1974 NRHA's central maintenance department dusted off a portion of the dismantled terminal and practiced reassembling it on a vacant lot fronting Granby Street. The terminal was subsequently erected in Ghent Square and dedicated to Frederic C. Heutte, Norfolk's one-time superintendent of Parks and Forestry.

Most of the concern about blight in the early 1960s and 1970s, the impetus for Norfolk's Model City initiatives, focused on the slum areas north of Olney Road, where rundown housing was bulldozed to build new developments

Olney Road, between Moran Avenue and Colonial Avenue, looking toward Moran, is shown here as it appeared May 20, 1954. Many lovely old homes and apartments had been converted to storefronts. *Courtesy of the Sargeant Memorial Room, Norfolk Public Library.*

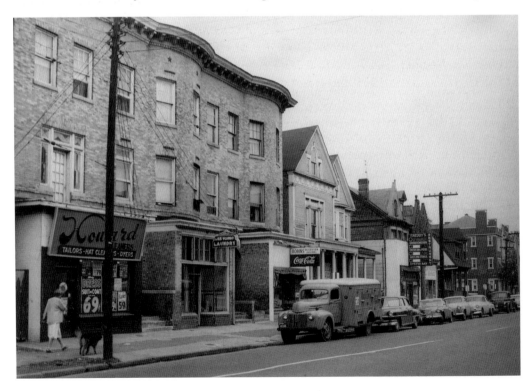

in East Ghent. But East Ghent had its impact on Ghent below Olney Road, too. Many of Mowbray Arch's grandest homes had been partitioned into apartments and stood, generally, in terrible condition, and while Ghent had also been declared a conservation area in 1964 by Norfolk Redevelopment and Housing Authority, despite this designation, approximately two hundred buildings, largely single-family homes and attached rowhouses, were demolished in the period between 1964 and 1970.

The Ghent Neighborhood League, begun in 1962, grew to more than five hundred members in its first year, a potent force working for the improvement of one of Norfolk's most strategically important residential areas. Due to its closeness to downtown Norfolk, the city's overall comeback was hinged, in many respects, on Ghent's survival. Planning experts across the country had already linked urban cities' renewal plans to the willingness of people to live in or within close proximity near the central business district. "One of the ultimate factors determining the long-range success of what we're doing in Ghent is what happens downtown," observed George A. Reif, then Ghent League president, in late March 1963. "Only the revitalization of downtown is going to make living in Ghent worthwhile," he continued. "That's a complete answer to those downtown who've been watching us. We've been watching them." Many people throughout Norfolk had been watching Ghent since the city decided in April 1961 to undertake a neighborhood conservation project in an attempt to halt deterioration that had appreciably nibbled away at the edges of the area.

The Ghent Neighborhood League had come to life to keep Norfolk Redevelopment and Housing Authority's conservation project going after the 1962 Virginia General Assembly killed a Norfolk-supported bill that would have allowed so-called spot-blight demolition in conservation areas. Ghent had been a patrician witness for the Thomas-Pilcher-Roberts Bill for slum prevention before the Virginia House Committee on Counties, Cities and Towns. Housing commissioner and former Norfolk Mayor Pretlow Darden spoke the words, "We have slums developing in the Ghent section, where some of our finest homes are located. Unless we find some means to deal with this problem, the area will go into slums within a year or so." Darden knew whereof he spoke. The testimony was given with the consent of Ghent

"Planning experts across the country had already linked urban cities' renewal plans to the willingness of people to live in or within close proximity near the central business district."

One of Norfolk's—and Hampton Roads's—greatest attractions is Doumar's curb service restaurant, located on Monticello Avenue at Twentieth Street on the fringe of what was once East Ghent. In this photograph, taken on a hot summer's day in 1957, George Doumar serves an ice cream cone to waitress Inez Cuthrel as sons Al, John and Victor look on. George's brother Abe introduced the world to the ice cream cone at the Saint Louis Exposition of 1904. Though the circumstances surrounding his invention of the ice cream cone have not always been clear, Abe Doumar is the cool confection's true creator. It was coincidence that Abe, a relatively new immigrant from Lebanon, met up with Ernest Hamwi, a Syrian vendor who had only been in the country one year. Hamwi was selling *zalabia*, a Persian wafer-thin waffle. Next to Hamwi was a vendor selling ice cream. When the ice cream man ran out of bowls to serve his cold confection, Abe suggested making a cone from the waffles and filling them with ice cream. He called it the "World's Fair Cornucopia" and sold it for ten cents. The ice cream cone was born. Abe Doumar returned home to New Jersey, and with the help of a nearby foundry, developed a four-iron baking machine to make the cones. By 1905 he was selling his cones at New York's Coney Island. George Doumar and two other brothers arrived from Lebanon and were put to work at stands in other locations. Abe was initially drawn to Norfolk by the Jamestown Exposition of 1907, but could not secure a vending location on the exposition grounds; he found the perfect spot, however, at Ocean View Amusement Park, and later opened a second location on Virginia Beach's original boardwalk. Since 1934 the only Doumar's location is on Monticello Avenue. The restaurant building on this site was built in 1949; Abe Doumar's original cone-making machine is still used to make handmade cones at Doumar's. *Courtesy of the author.*

residents, who were then doing their best to hold up the old standards of the neighborhood. Ghent was an eloquent witness, too, of efforts to bring itself back. Pembroke Towers, a $3 million apartment building on the Brambleton Avenue side of The Hague, had already become an anchor for improvements still to come. Old Pelham Place was also rehabilitated.

In late March 1962 George Reif and three other residents had begun talking to property owners about a civic league in the area. An organizational meeting brought two hundred residents together and the Ghent Neighborhood League was born. Reif and his original executive board plus a high-powered advisory board composed of prominent citizens, all of whom lived in Ghent, began working on the conservation program, both behind the scenes and in full public view. Tied to the league's efforts were significant advances in city codes and policies that would impact not only Ghent but also other Norfolk neighborhoods. The city issued a new, beefed up minimum housing code to fight blight citywide within a year of the league's formation. The Ghent League teamed up with the Build Norfolk Better Committee of the Real Estate Board and the Public Health Department, which administers the code, to rewrite the ten-

"Ghent today is a living monument to suburbia as its founders intended, its rich architectural character and streetscape largely preserved by the efforts of successive generations of city and community leaders..."

First occupied by railroader William Whaley, the house at 317 Colonial Avenue was built about 1892 for Helen Reid, Fergus Reid's sister. Because she died before seeing the home completed, Whaley and his family took possession on completion. At the time this photograph was taken in 1979, the home was occupied by Norfolk Shipbuilding and Drydock Company executive George H. Curtis III. *Courtesy of the author.*

year-old ordinance and successfully press for its unanimous adoption by the city council.

The league generated interest in Ghent by upgrading the prestige of the area through summer band concerts on The Hague, reminiscent of concerts held regularly in Stone Park through the 1930s. The group further worked on other civic projects that drew attention to the neighborhood's conveniences. Behind the scenes intervention by the league in the battle over the fate of the Botetourt Street Bridge, popularly called the Ghent Bridge, helped remove a potential roadblock to the NRHA's $10 million high-rise apartment project on the banks of The Hague. Through the league's efforts a compromise resulted in the use of the old bridge as a pedestrian walkway. Within its first year as a league, real estate leaders praised the group. Robert P. Albergotti Jr., then assistant vice-president of Baldwin Brothers and Taylor, remarked that the general situation had improved a

Looking north on Colonial Avenue from Redgate Avenue, this photograph was taken on April 10, 1981. *Courtesy of the author.*

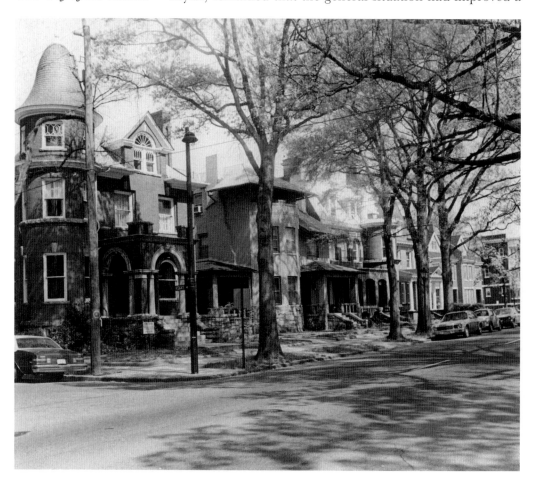

great deal and certainly credit for part of this improvement went to the Ghent League. Albergotti added that he had people waiting in line for Ghent property, which was not the case just a couple of years earlier. "Ghent's large homes have attracted some large families and young couples are coming back to Ghent, too," Albergotti told a *Virginian-Pilot* reporter.

Those who chose to purchase homes in Ghent at that time knew it was risky business. Norfolk attorney Vincent J. Mastracco Jr. bought his first Ghent home in 1967. He told a *Virginian-Pilot* reporter in 1982, "People look at you kind of strange (in reference to buying a home in Ghent), because it was a time when everyone was leaving the neighborhood for Virginia Beach." Forrest Clay, a former president of the Ghent Neighborhood League, once observed that anyone who bought property before 1968 took a great risk because there was no guarantee East Ghent

The Frank S. Royster house on Colonial Avenue at the corner of Warren Crescent was photographed on March 1, 1984. Note dramatic differences from earlier views of the Royster residence; conspicuously absent is the wraparound porch. *Courtesy of the author.*

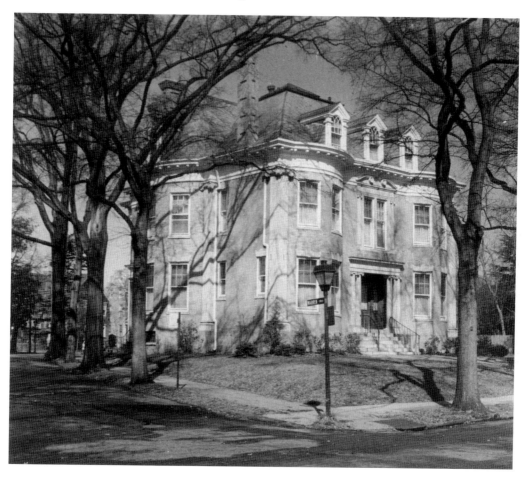

Decades later, Charles Wesley Fentress's house at 621 Colonial Avenue had been converted for commercial uses, obvious in this contemporary view. This two-and-a-half-story brick house has a corner entry with round arches supported on a brick base. On the Colonial Avenue façade the arch is accented by raised stonework supported by consoles. A two-story circular bay with a flat roof appears on the main façade. Transoms are used over the windows in the bay. The front gable has a triple-arched window and dentils along its edge. The Boissevain Avenue side features two rectangular stained-glass windows and a recessed entry. Pedimented dormers and two chimneys punctuate the roofline. *Courtesy of the author.*

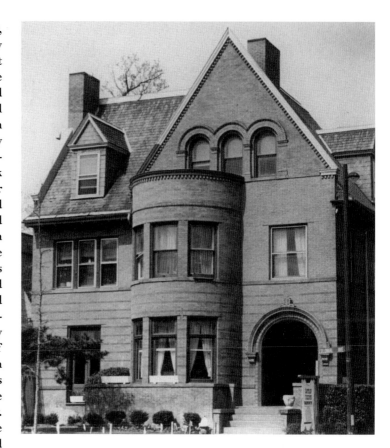

would be torn down. While hard to imagine today, in 1962 or 1972 Ghent homeowners were nearly giving away some of their properties. Mastracco paid $22,000 for a Tudor-style home on Mowbray Arch that he sold in the early 1980s for $185,000. Elsewhere in the Ghent neighborhood houses could be purchased in the 1960s into the early 1970s for $15,000 to $20,000, but refurbished, at the time, with cheap federal money, by the 1980s, the same homes were already worth ten times what their owners had paid for them.

The mid-1970s brought important improvements to the original Botetourt Street Bridge, best known to Norfolk residents as the Ghent Bridge, which got a much-needed facelift. The city of Norfolk, not wanting to lose Graham's original steel-riveted bridge—a landmark—altogether opted to make it a footbridge, incorporating parts of the old bridge within a new structure. The old bridge had already been limited to pedestrians and cyclists since 1963, but had continued to deteriorate. In the summer of 1974 Charles H. Thayer Jr., a structural engineer contracted by the city to

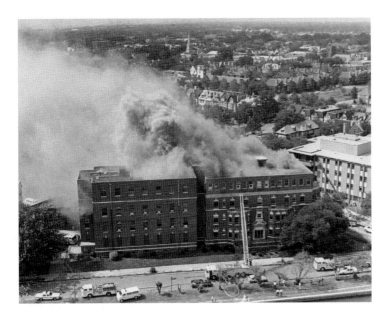

The old Leigh Memorial Hospital building was ravaged by fire in June 1987 and subsequently razed. After Dr. Southgate Leigh's death in 1936, Sarah Leigh Hospital was reorganized as a nonprofit institution and renamed Leigh Memorial Hospital. In 1972 Norfolk General Hospital and Leigh Memorial Hospital merged to form Medical Center Hospitals and, by combining resources, were able to broaden the scope of medical care to the community. Leigh Memorial Hospital moved to its present site on Kempsville Road in 1977 and debuted as Sentara Leigh Hospital. The new $21 million facility was positioned on 23.5 acres and featured all private rooms. *Courtesy of the author.*

evaluate the bridge and come up with a new one, stated that some of the original bridge's wooden piles on which the pile caps and the pedestals rest had rotted. The steel girders and other metal parts of the frame were rusting. "The pile caps, made of cast iron and filled with sand and oyster shells, and the pedestals, made of cast iron, are still solid," observed Thayer. "But the steel and concrete frame has disintegrated badly. The steel and concrete of the 1890s, when the bridge was built, was not very weather resistant." The new bridge was constructed along the same line as the old, but since the footbridge was to be only eighteen feet wide with two sets of pedestals, none of the old pilings that the piling caps and pedestals rested on could be used. During construction old pile caps, pedestals and the ironwork hand railing were able to be reused.

Like the old Botetourt Street Bridge, much about Ghent has been conserved, saved for subsequent generations to appreciate and marvel at—the vision of John R. Graham Jr. and all of those early Ghent residents whose collective contribution has endured far beyond individual achievements and events that have populated its history. Ghent today is a living monument to suburbia as its founders intended, its rich architectural character and streetscape largely preserved by the efforts of successive generations of city and community leaders, preservation organizations and activists and, most importantly, its resident property owners.

BIBLIOGRAPHY

PRIMARY SOURCES

Bowman, Samuel W., lithographer. "Map of Norfolk." Norfolk, 1891.

Deeds, maps, surveys, original photographs and floor plans, postcards and memorabilia.

Ghent National Register of Historic Places nomination form, 1980.

"Ghent: Proposed zoning for historic and cultural conservation zoning," document promulgated by Norfolk Department of City Planning, 1975.

Hopkins, G.H. *Atlas of Norfolk*. Philadelphia, 1889.

Margolius, Elise L. "March of Time: Norfolk Section, National Council of Jewish Women, 1905–1945." Report delivered to the council.

North Ghent National Register of Historic Places nomination form, 2001.

"Preserving Norfolk's heritage: Proposed zoning for historic and cultural conservation." Document produced by the Norfolk Department of City Planning, December 1965.

Sanborn fire insurance maps for Norfolk, Virginia.

United States Coast Guard and Geodetic Survey. "Norfolk Harbor and Vicinity." Chart Number 404, T.C. Mendenhall, January 1891.

BOOKS

Armstrong, George D. *The Summer of Pestilence: A History of the Ravages of the Yellow Fever in Norfolk, Virginia, AD 1855*. Philadelphia: J.R. Lippincott & Company, 1856.

Art Works: Norfolk, Virginia, and Vicinity. Chicago: W. Kennicott and Company, Publishers: 1895, 1902.

Downing, Andrew Jackson. *The Architecture of Country Houses*. Reprint of 1850 edition. New York: Da Capo, 1968.

Early, James. *Romanticism and American Architecture*. New York: A.S. Barnes, 1965.

Forrest, William S. *Historical and Descriptive Sketches of Norfolk and Vicinity*. Philadelphia: Lindsay and Blakiston, 1853.

Greeley, Horace, et al. *The Great Industries of the United States*. Hartford, Connecticut: J.B. Burr and Hyde, 1873.

Hofheimer, Jo Ann Mervis. *Annie Wood—a Portrait*. Norfolk, Virginia: The Irene Leache Memorial, 1996.

McNaughton, Arnold. *The Book of Kings: A Royal Genealogy*, volume 1. London: Garnstone Press, 1973.

Sentara Norfolk General Hospital Public Affairs Office. *Words of Honor: The Story of Sentara Norfolk General Hospital's 100-Year Long Commitment to Excellence*. Norfolk: Sentara Norfolk General Hospital, 1988.

The Story of Jews in the United States. New York: National Jewish Welfare Board, 1942.

Walker, Carroll H. *Carroll Walker's Norfolk: A Tricentennial History*. Virginia Beach: Donning, 1981.

———. *Norfolk: A Pictorial History*. Virginia Beach: Donning, 1975.

Wertenbaker, Thomas J. *Norfolk: Historic Southern Port*. Durham: Duke University Press, 1931.

Whichard, Rogers Dey. *The History of Lower Tidewater Virginia, Volumes I–III*. New York: Lewis Historical Publishing Company, 1959.

Withey, Henry F., and Elsie Withey. *Biographical Dictionary of American Architects*. Los Angeles: New Age Publishing Company, 1956.

Yarsinske, Amy Waters. *The Jamestown Exposition: American Imperialism on Parade, Volumes I and II*. Charleston: Arcadia, 1999.

———. *The Martin Years: Norfolk Will Always Remember Roy*. Gloucester Point, Virginia: Hallmark Publishing, 2001.

———. *Norfolk, Virginia: The Sunrise City By the Sea*. Virginia Beach: Donning, 1994.

———. *Summer on the Southside*. Charleston: Arcadia, 1998.

———. *Winter Comes to Norfolk*. Charleston: Arcadia, 1997.

Articles, Oral Histories, Pamphlets, Papers and Speeches

There were numerous articles, brochures, pamphlets, meeting minutes and organization papers and broadsides that informed the author; some were dated, some not, while others had been carefully cut out and slipped into the vertical files of the Sargeant Memorial Room, Norfolk Public Library. As many as possible are listed below while others are sporadically included as textual reference.

Allgood, Don. "East Ghent aid showdown nears," *Ledger-Star*, July 25, 1968.

Armstrong, George D. "The early history of the First Presbyterian Church of Norfolk, Virginia."

Bacon, Jim. "Old Ghent Bridge to be made new," *Virginian-Pilot*, July 21, 1974.

Baldridge, Gay. "Norfolk potential Venice of America," *Virginian-Pilot*, March 11, 1951.

Baldwin, Ken. "Ghent: 'Real opportunity,'" *Ledger-Dispatch*, April 5, 1962.

Bancroft, Raymond L. "Ghent over hump on way back to respectability," *Virginian-Pilot*, March 6, 1964.

Blackford, Staige D. "Pleas made for Ghent homes," *Virginian-Pilot*, July 27, 1968.

————. "RHA to ask $5 million," *Virginian-Pilot*, January 7, 1969.

Bolinaga, Shirley. "East Ghent dirt nurtures hope," *Virginian-Pilot*, December 29, 1969.

Bushnell, David. "The quiet rejuvenation of the stately Hague," *Virginian-Pilot* and *Ledger-Star*, August 8, 1982.

Christ Church Chronicle, June 1930.

Cobb, Richard. "Ghent acreage to fill quickly," *Virginian-Pilot and Ledger-Star*, May 25, 1980.

Coleman, Sharon. "Neighborhood asks for city help in keeping out condos," *Norfolk Compass*, June 22–23, 1983, published as part of *Virginian-Pilot*.

Davis, Julia Johnson. "Recollections: Ghent a generation ago," *Virginian-Pilot*, August 8, 1954.

"The development of Ghent: A chronology." Unpublished paper bearing no date or authorship, Kirn Memorial Library, Sargeant Memorial Room, Norfolk, Virginia.

Editorial. "Ghent testimony for anti-slum bill," *Virginian-Pilot*, February 24, 1962.

Editorial. "More townhouses started in Ghent," *Virginian-Pilot* and *Ledger-Star*, May 7, 1978.

Editorial. "A Virginia bill to prevent slums," *Virginian-Pilot*, February 14, 1962.

Ferguson, Anna Lawrence. "Norfolk homes, gardens open," *Virginian-Pilot*, April 17, 1966.

First Presbyterian Church, Norfolk, Virginia, Centennial Sunday, October 15, 1961, program.

Gretes, Frances. "New life for an old neighborhood: A historical and architectural analysis of Ghent, 1890–1970." Fine Arts 402, May 15, 1970, provided by the Norfolk Redevelopment and Housing Authority (NRHA).

Harris, Brenda. "Ghent: Still area's prime attraction," *Virginian-Pilot*, December 16, 1995.

Hill, Don. "Renewal plan reverses," *Virginian-Pilot*, October 11, 1965.

Hull, Robert R. "Miss Lela M. Hine—an oral history." July 10, 1997, The Hermitage Foundation.

Kelley, George M. "Condemnation right cut out of blight bill," *Virginian-Pilot*, March 3, 1962.

Kirkpatrick, John. "Quaint Ghent setting lures people, money," *Norfolk Compass*, March 11, 1977, published as part of *Virginian-Pilot*.

Ledger-Dispatch, "Battle line drawn to Hague, spread of blight in Ghent," April 26, 1961.

Ledger-Dispatch, "Bill to remove 'spot decay' in neighborhoods studied," February 23, 1962.

Ledger-Dispatch, "House committee interested in Ghent blight prevention," April 27, 1961.

Ledger-Dispatch, "Housing bill would affect Ghent area," February 13, 1962.

Ledger-Dispatch, "A new day dawning for Ghent?" May 6, 1961.

Ledger-Dispatch, "Save Ghent, Cox asks realtors," March 9, 1962.

Ledger-Dispatch, "'Save Ghent,' League sets election," April 3, 1962.

Ledger-Dispatch, "'Spot blight' bill axed by senate," March 9, 1962.

Ledger-Dispatch and Star, "International flavor found in West Ghent area," August 23, 1956.

Ledger-Star, "Majestic Ghent United Methodist Church was organized in 1902," July 24, 1971.

Ledger-Star, "Now in its 127th year, Ohef Sholom Temple is 'a house of prayer for all peoples,'" June 26, 1971.

Levin, John. "Missing walls mean progress in Norfolk," *Ledger-Star*, August 22, 1968.

Lewis, Nancy. "A Home for the ages," *Norfolk Compass* 21, number 48, published as part of *Virginian-Pilot*, December 12, 1996.

Mather, Carol. "Old houses up for adoption," *Virginian-Pilot*, August 2, 1973.

Moore, Marie Justice. "Ghent: A state of mind," *Virginian-Pilot*, August 30, 1970.

The Norfolk City Union of the King's Daughters, 1897–1947. Published by the same.

Norfolk Compass, "Ghent parking ban eyed," April 7, 1978, published as part of *Virginian-Pilot*.

Norfolk Dispatch, Jamestown Exposition edition, 1904.

Norfolk Virginian Illustrated Edition, "J.P. Andre Mottu," 1897.

Notice for auction of Pleasant Point, Merit M. Robinson, trustee, *Norfolk Gazette and Public Ledger*, December 18, 1811.

Ohef Sholom Temple: Our first century and a half—1844–1969, Norfolk, Virginia, 1969.

Parish bulletin, Christ and Saint Luke's Church, October 17, 1976.

Parker, John. "It might have been swell, but it sure was dull," *Virginia Magazine*, November 7, 1982.

Reilly, Tom. "Fate of 'spot blight' bill hangs on committee's decision today," *Ledger-Dispatch*, February 27, 1962.

Roderick, Charlene. "Bulkhead slipping into Hague," *Norfolk Compass*, November 7–8, 1990.

Rosenfeld, Raymond A. "Urban renewal: Whatever happened to East Ghent?" *Ledger-Star*, March 7, 1974.

Sacred Heart, Norfolk, Virginia, 1894 to 1974, commemorative history.

Scott, Glenn. "Council backs Ghent renewal," *Virginian-Pilot*, April 26, 1961.

Scott, Margaret. "Ghent cements young and old," *Virginian-Pilot*, October 10, 1971.

Smith, Robert C. "Brambleton went, Ghent to follow northward surging commerce," *Virginian-Pilot*, June 28, 1955.

Smith, Robert H. "General William Mahone, Frederick J. Kimball and others—a short history of the Norfolk and Western Railway," address delivered by president, Norfolk and Western Railway Company, Roanoke, Virginia, National Newcomen Luncheon of The Newcomen Society of England, New York City, October 28, 1949.

Squires, William H.T. "Norfolk in by-gone days," *Norfolk Ledger-Dispatch*, January 26, 1939.

Stern, Malcolm H. "Moses Myers and the early Jewish community of Norfolk," *Journal of the Southern Jewish Historical Society* 1, no. 1 (November 1958).

————. "Some notes on the history of the organized Jewish community of Norfolk, Virginia," *Journal of the Southern Jewish Historical Society* 1, no. 3 (November 1963).

Sullivan, Frank. "Seedy Ghent houses may bloom in spring," *Virginian-Pilot*, February 2, 1964.

Tazewell, William L. "City's pull pushes revival of old residential area," *Virginian-Pilot*, June 9, 1960.

Tunstall, Robert B. "About the history of Ghent," *Virginian-Pilot*, March 18, 1951.

Virginian-Pilot, "Beauty spot—the new Stockley Gardens," November 7, 1937.

Virginian-Pilot, "Beginning in East Ghent," February 22, 1970.

Virginian-Pilot, "Ghent bad boys before bar of commission," December 28, 1906.

Virginian-Pilot, "Ghent renewal hindered, Cox laments bill's defeat," March 10, 1962.

Virginian-Pilot, "Ghent renewal supported," April 26, 1961.

Virginian-Pilot, "Ghent resident power thrifty," April 17, 1977.

Virginian-Pilot, "Ghent testimony for anti-slum bill," February 24, 1962.

Virginian-Pilot, "Ghent turns, runs uphill," October 23, 1964.

Virginian-Pilot, "Ghent will have a grocery store," February 23, 1907.

Virginian-Pilot, "The houses of Ghent and a face-lifting," April 27, 1961.

Virginian-Pilot, "Its vitality may be captured," September 22, 1974.

Virginian-Pilot, "League hoped for Ghent," March 12, 1962.

Virginian-Pilot, "Neighborhood charm makes the work worth it," October 10, 1971.

Virginian-Pilot, "New Christ Church," October 29, 1909.

Virginian-Pilot, "Norfolk's yacht haven: The Hague," June 2, 1912.

Virginian-Pilot, "Rumored closing of The Hague opposed in several quarters," June 26, 1956.

Virginian-Pilot, "'Spot blight' measure revived and reported," March 1, 1962.

Virginian-Pilot and Ledger-Star, "New conveniences and old elegance," July 20, 1980.

Virginian-Pilot and Norfolk Landmark, "Ghent: The beautiful residential section of Norfolk," March 21, 1912.

Virginian-Pilot and Norfolk Landmark, "Hospitals of Norfolk," June 9, 1912.

Virginian-Pilot and Norfolk Landmark, "North Ghent has become a community of beautiful homes," October 13, 1912.

Virginian-Pilot and Norfolk Landmark, "The Norfolk Protestant Hospital," public report, June 2, 1912.

Wauchope, Dorothy Thompson. "Guide to Ghent," Ghent Neighborhood League, 1962.

Woodlief, Wayne. "Ghent survey to clear way for new code to fight blight," *Ledger-Dispatch*, June 6, 1962.

———. "You're hereby notified to vacate the premises," *Ledger-Dispatch*, November 7, 1968.

Zarakov, Barry N. "Ghent: Splendid monument to suburban planning," *Ledger-Star*, May 21, 1980.

Index

D

H

O

S

ABOUT THE AUTHOR

Amy Waters Yarsinske's familial ties to the Ghent suburb are as old as the suburb itself. A nationally known author of narrative nonfiction, Amy Yarsinske received her Bachelor of Arts degrees in economics and English from Randolph-Macon Woman's College in Lynchburg, Virginia, and her Master of Planning degree from the University of Virginia School of Architecture, where she was a DuPont Fellow. Yarsinske is also a 1998 graduate of the prestigious CIVIC Leadership Institute, a member of Investigative Reporters and Editors (IRE), Authors Guild and is currently involved in a wide range of current community-based organizations and committees, public and private sector projects. Yarsinske is also a past president of the Norfolk Historical Society and Norfolk Historical Foundation. She is the author of many books, including *No One Left Behind: The Lt. Comdr. Michael Scott Speicher Story*, *Rendezvous with Destiny: The FDR Legacy*, *Mud Flat to Master Jet Base: Fifty Years at NAS Oceana*, "Memories and Memorials" in *Naval Aviation*, *Forward for Freedom: The Story of Battleship Wisconsin* (BB-64) and *Wings of Valor, Wings of Gold: An Illustrated History of U.S. Naval Aviation*.